SEARCHING FOR

MARY MAGDALENE

SEARCHING FOR

Mary Magdalene

a journey through art and literature

JANE LAHR

welcome
BOOKS

new york · san francisco

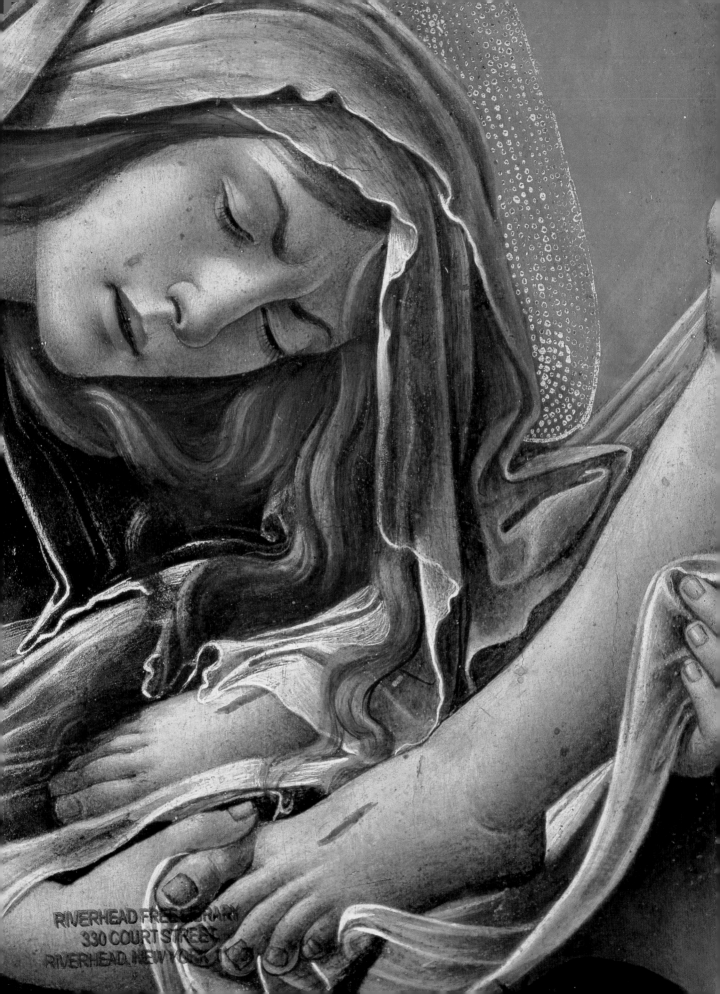

Acknowledgments

Creating a visual book is not unlike making a film or mounting a show: it is a production. At worst, it can be a nightmare; at best, a glorious team effort. This book is the outcome of many gifted collaborators and has been a splendid journey over many, many months.

My deepest thanks and appreciation to Katrina Tabori Fried for her adept guidance and vision as editor and her impeccable sense of pacing as well as her spark of enthusiasm that infused the book; to Maren Gregerson, whose many talents in clearing rights and wrestling images from impossible sources and excellent, thorough attention to detail contributed enormously; to Clark Wakabayashi for his elegant design of a very complex visual volume; to Jon Graham of Inner Traditions for help paving the way for the wonderful Leloup material; and friends Catherine Shainberg, Krystyna Celichowski, Beth Walker, Sophia Rosoph, Nicola Bennett, and Peg Streep for their friendship, interest, and feedback throughout the process; and to Lena Tabori, publisher, for her insistence on seeing the book through and her years of commitment to publishing exquisite volumes in an industry often bent on compromise; to the Stonington Library for putting up with my abuse of their books, and last, but never least, to my husband, Sherman Crites, for his support in the initial days of this journey when I was tempted to call it quits.

Thank you all.

Published in 2006 by Welcome Books®
An imprint of Welcome Enterprises, Inc.
6 West 18th Street, New York, NY 10011
(212) 989-3200; Fax (212) 989-3205
www.welcomebooks.com

Publisher: Lena Tabori
Editor: Katrina Fried
Designer: H. Clark Wakabayashi

Library of Congress Cataloging-in-Publication Data

Searching for Mary Magdalene : a journey through art and literature / edited by Jane Lahr.-- 1st ed.
 p. cm.
 ISBN 1-932183-89-2 (hardcover)
 1. Mary Magdalene, Saint. 2. Mary Magdalene, Saint--Legends. 3. Mary Magdalene, Saint--Art. 4. Mary Magdalene, Saint--In literature. I. Lahr, Jane.

BS2485.S42 2006
226'.092--dc22

2005035892

ISBN 10: 1-932183-89-2 / ISBN 13: 978-1-932183-89-4
Printed in Singapore FIRST EDITION 10 9 8 7 6 5 4 3 2 1

Pgs. 2–3: *The Lamentation of Christ* (detail), Sandro Botticelli, c.1490

ART CREDITS:
Pgs. 10, 84, 95, 130, 147, 164, 178, 181, 192, 213, 221: The Bridgeman Art Library; Pgs. 13, 33, 35, 38, 52, 64, 70, 79, 90, 100, 103, 112, 115, 120, 124, 132, 143, 155, 161, 162, 165, 171, 191, 203, 204, 209, 227, 230, 232, 236: Scala/Art Resource, NY; Pgs. 15, 16, 19, 27, 28, 30, 36, 44, 54, 58, 62, 80, 83, 89, 107, 111, 116, 127, 137, 151, 152, 156, 159, 160, 177, 186, 188, 206, 218: Erich Lessing/Art Resource, NY; Pgs. 20, 21, 41, 67, 76, 104: Alinari/Art Resource, NY; Pgs. 22, 69, 108, 123, 129, 201, 210: © Cameraphoto Arte, Venice/Art Resource, NY; Pgs. 23, 91: Giraudon/Art Resource, NY; Pg. 24: The Metropolitan Museum of Art, Fletcher Fund, 1933 (33.92ab) Photograph © 1998 The Metropolitan Museum of Art; Pgs. 26, 87, 135: Art Resource, NY; Pgs. 43, 75, 119: Bildarchiv Preussischer Kulturbesitz/ Art Resource, NY; Pgs. 47, 217, 228, 230: © Tate Gallery, London/Art Resource, NY; Pg. 48: The Royal Collection © 2005, Her Majesty Queen Elizabeth II; Pgs. 51, 92, 148, 166, 182, 224: Reunion des Musees Nationaux/Art Resource, NY; Pg. 57: Kavaler/Art Resource, NY; Pg. 61: © York City Art Gallery, North Yorkshire, UK/The Bridgeman Art Library; Pg. 96: Alisa Mellon Bruce Fund, Image © 2005 Board of Trustees, National Gallery of Art, Washington; Pgs. 103, 227 Marc Chagall, The Prophet Isiah and Descent from the Cross © 2006 Artist Rights Society (ARS), New York; Pg. 139: © Fitzwilliam Museum, University of Cambridge/The Bridgeman Art Library; Pg.140: © Nicolo Orsi Battaglini/Art Resource, NY; Pg. 144: © Walker Art Gallery, National Museums Liverpool/The Bridgeman Art Library; Pg. 169: Timothy McCarthy/Art Resource, NY; Pg. 173: HIP/ Art Resource; Pg. 174: © Norfolk County Council, U.K./The Bridgeman Art Library; Pg. 185: © Joan Baker Brooks, 2004.

TEXT CREDITS:
Scripture taken from the New King James Version®. Copyright © 1982 by Thomas Nelson, Inc. Used by permission. All rights reserved.

Excerpts from "Joseph of Arimathea" reprinted by permission of Boydell & Brewer Ltd. From *Merlin and the Grail* by Robert de Boron and translated by Nigel Bryant (D.S. Brewer, 2005) pp 16-20. • Excerpts from *The Gospel of Thomas: Unearthing the Lost Words of Jesus* by John Dart and Ray Riegert copyright © by Ulysses Press. Used by permission of Ulysses Press. • Excerpt from *Parzival* by Wolfram von Eschenbach, translated by A. T. Hatto (Penguin Classics, 1980). Copyright © A. T. Hatto, 1980. Excerpts from *Jesus the Son of Man* by Kahlil Gibran, copyright © 1928 by Kahlil Gibran and renewed 1956 by Administrators C.T.A. of Kahlil Gibran Estate and Mary G. Gibran. Used by permission of Alfred A. Knopf, a division of Random House, Inc. • Excerpt from *Speaking from the Heart* by Joan Grant to be published by Overlook Press in 2007. © Joan Grant. • Excerpt from *The Last Temptation of Christ* by Nikos Kazantzakis. Reprinted with permission of Simon and Schuster Adult Publishing Group. Translated from the Greek by P.A. Bien. English translation copyright © 1960 by Simon & Schuster, Inc. Copyright renewed © 1988 by Faber & Faber. • Excerpts from *The Gospel of Mary Magdalene* translated by Jean-Yves Leloup. Copyright © by Inner Traditions. Used by permission of Inner Traditions. • Excerpts from *Holy Blood, Holy Grail* by Henry Lincoln, Michael Baigent, and R. Leigh, copyright © 1983 by Henry Lincoln, Michael Baigent, and Richard Leigh. Used by permission of Dell Publishing, a division of Random House, Inc. • Excerpt from *The Grail* by Roger Sherman Loomis.© 1991 Princeton University Press. Reprinted by permission of Princeton University Press. • Excerpts from *The Gospels of Mary: The Secret Tradition of Mary Magdalene, The Companion of Jesus* by Marvin Meyer. Copyright © 2004 by Marvin Meyer. Reprinted by permission of HarperCollins Publishers. • Excerpt from *The Letters of Abelard and Heloise* translated and introduced by Betty Radice (Penguin Classics, 1974). Copyright © Betty Radice, 1974. • "I Don't Know How to Love Him" by Andrew Lloyd Webber, Tim Rice © 1971, renewed 1999, renewed 1999 by MCA Music Ltd. All rights in the United States administered by Universal Music Corp./ASCAP. Used by permission. All rights reserved. • Excerpt from *The Golden Legend* by Jacobus de Voragine. © 1993 Princeton University Press, 1995 paperback edition. Reprinted by permission of Princeton University Press.

This one's for you, Maya:

The daughter, whose name means Mary in many

languages around the globe, and whose poetry, sensitivity,

and compassion as well as crowning chestnut hair remind

me of the other Mary—the Magdalene.

Contents

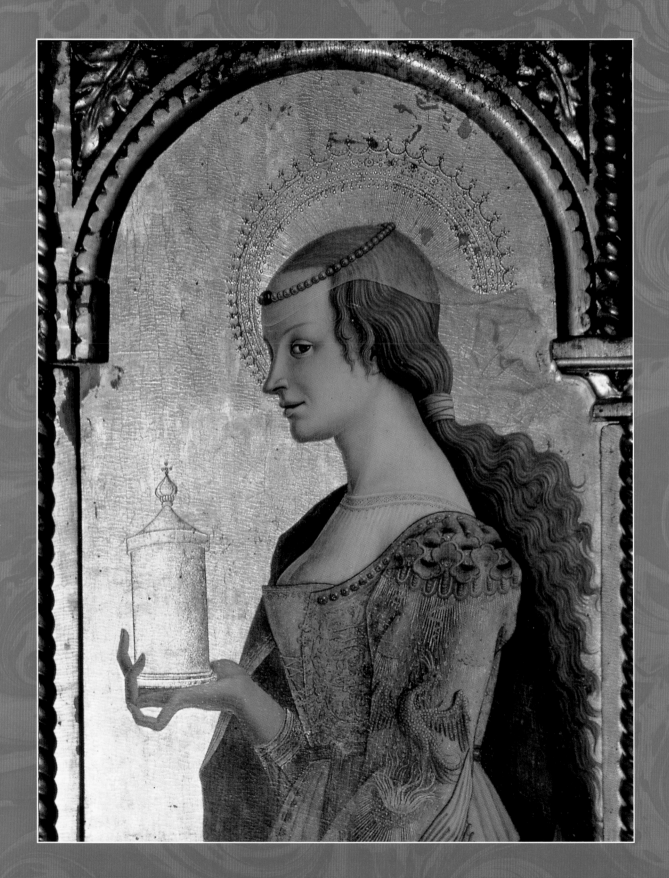

Introduction

CHASING AN ENIGMA—the essential Mary Magdalene—over the last several years, has challenged me in a variety of ways, the most critical being that my faith in organized religion has been called into question. My belief in a historical Jesus has undergone profound scrutiny. And, any clarity of vision as to which Mary was and is the true Mary (metaphorically and literally) has been an ongoing exercise in frustration. How does one take hold of a spirit that continues to morph from one form to another with the subtlety of an apparition? One thing is certain: she has drawn me deeper and deeper into her world, and as I sit here surrounded by piles of notes and papers, apocryphal texts and bibles, and copies of pictures of art that span the centuries, I realize I am not alone in this enthrallment. Hidden deep within this bounty of literature and extraordinary art that she inspired, lives the vibrant Magdalene, awaiting discovery.

St. Mary Magdalene (detail), Carlo Crivelli, 15th century

As I examine the magnificent paintings and sculptures in her name I am reminded that she has captured the souls of artists who have rendered her as no other woman in the bible. Unlike Mary the mother—who is often expressed as an archetype, an ideal—the Magdalene is virtually always drawn as an individual—a woman of flesh and blood with feelings and emotions. Even in the earliest images we will see her at the foot of the cross—in deep crisis at the loss of her Beloved. It is as if these artists carried her in their hearts and rendered her honestly and compassionately, whatever their point of view. When the clerics devalued her, the artists constantly and consistently championed her.

Emperor Constantine's universal Roman Church (est. 325 C.E.), however, was not so kind. In the earliest 1st- and 2nd-century Christian apocrypha Mary is portrayed as a woman of great spiritual authority, but under Constantine we see her transformed into a marginalized figure, in a structure that underplays what can only be seen as her privileged relationship

to Jesus. But then why would a Roman emperor and soldier, who worshipped in a male-oriented religion—"Sol Invictus"—and who murdered his wife and son in terrible ways, be responsible for a religion that valued and honored women?

In my research I found that in the transition from Jesus the Nazarene to the Christ, many ancient ideas were integrated into his image. Many of the doctrines of Sol Invictus, including the belief in a god who was born of a virgin and died and rose again, go back as far as ancient Egyptian and Sumerian cultures. But my greatest concern was finding the historical Jesus and Mary Magdalene. So I focused on the earliest material from the Nag Hammadi Library and Dead Sea Scrolls that could shed light on Jesus and his followers prior to the patina of the Roman influence. My faith was restored by a journey through these early gospels and codices.

Recently I was at the 50th wedding anniversary celebration of a dear friend and neighbor—and embarked on a conversation with one of the guests, who happened to be a priest. When I mentioned that I was working on a book about the Magdalene he said, "Why the Magdalene? She is barely mentioned in the New Testament." This is true. She is mentioned in the New Testament a mere thirteen times, but Jesus' mother is named

only nineteen times. The priest focused on the thirteen references as an example of her lack of relevance, but I saw it—given her company—as proof positive that she was highly crucial to Jesus and important in his life. These two Marys are the most influential female figures in the New Testament and the most mentioned.

As we discuss the references to the Magdalene in the New Testament, it should be clear there are two kinds. The words "Mary Magdalene" are used only during the crucifixion, the deposition, at the burial tomb, the resurrection, and in one other case. In each of these occurrences there is absolutely no ambiguity. However, in Bethany at the house of Simon the Leper and at the raising of Lazarus, there are references to Martha and her sister Mary. In the search for the essential Magdalene, the question inevitably arises: Is this the Magdalene or another Mary in the company of Jesus? If you join me on my journey we may or may not arrive at the same conclusions. It is a slippery slope from the "Penitent Sinner" weeping for her sins and drying Jesus' feet with her tear-stained hair to a sensuous prostitute and an adulteress. These women seem quite different from the Magdalene at the foot of the cross, the first witness to the resurrection. This is the Mary Magdalene that resonates for me. She is the Mary who at first light, after Sabbath,

Christ as Sun God—Invincible Sun, artist unknown, 3rd century

bravely hurries to the tomb. In my inner ear I can hear those tender phrases— "Jesus saith unto her, 'Mary.' She turned herself, and said unto him, 'Rabboni': which is to say, Master." (John 20:16). It is a moment of heightened sensitivity and intimacy. This Mary seems to reemerge in all the Gnostic texts I have included in this book. In the *Gospel of Mary*, written in the early 2nd century and attributed to the Magdalene, we see a woman of compassion, leadership, and wisdom, the most gifted disciple of Jesus, the one who understands the subtlety of his teachings and the esoteric truths that they embody. Here we see her stand up to Peter and hold the Apostles together with insight and vision after Jesus has ascended. This is the Mary that resounds throughout the pages of the Gnostic manuscripts and at key moments in the four canonical gospels.

To return to the dialog at the anniversary reception, when I mentioned these early works from the Nag Hammadi Library which reflect thoughts reaching back as far as the 1st-century followers of Jesus, the priest looked at me and said one word: "Heresy!" I was, of course, immediately thrown into another time, another place. Heresy is a word that I equate with trials and inquisitions of the Middle Ages. But, on reflection, Christian heresy came into being after the 318 bishops created the Nicene Creed under Constantine.

There needs to be a codified religion before there can be a heretic to oppose it. It is well known that Jesus and most of his followers were Jews and his teachings reflect these roots. It is less well known that there was a fount of diverse and vibrant communities and knowledge that have been recently categorized under headings like Gnosticism and Jewish Christianity and others. It is in this context that the ideas of orthodoxy and heresy emerged. In the 1st century, as Karen L. King reminds us in her outstanding book *The Gospel of Mary of Magdala*, "The prevailing orthodox view about the relationship of Christianity to Judaism…was far from obvious to those by and for whom the Gospel of Mary was written. Because Christian identity had not yet been fixed in an orthodox form, alternative interpretations of Jesus' teachings were simply a part of the dynamic processes by which Christianity was shaped." In other words, how can these texts be considered heresy? They were set down before any fixed orthodoxy had occurred. This is heresy as hindsight.

Our Lady dramatically shifts shape once heresy enters the Magdalene story and a great polarization occurs. Codices that suggest a fully human Jesus, with family and relationships become odious to the Orthodoxy. Theologians whose ideas differ from canon are burned as heretic

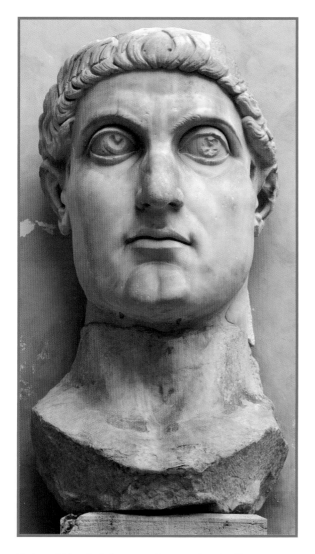

Colossal Head of Emperor Constantine the Great
artist unknown, 4th century

tells us that beyond the Holy Land she preaches, heals, and lives out her final days as a hermit in a cave eating nothing and ecstatically ascending to the heavens supported by angels almost daily. As early as the Crusades we find veiled aspects of her in the Black Madonnas that pepper the Languedoc.

By the 14th century the paintings and sculptures of the Magdalene and Jesus become increasingly humanistic and reveal the deep humanity of the Nazarene and his companion, a consequence of an exciting rebirth of interest in classical Greek, Roman and Gnostic philosophy among the powerful Italian families such as the Medicis of Florence. Beginning in the early Renaissance, paintings depict her on a boat traveling to the South of France with some of Jesus' followers. Like a rose sprouting new growth after a severe pruning, the legends and tales of the Magdalene multiply. The Grail story travels with her to France. The legends of Joseph of Arimathea and others emerge, and with each new tale a subtle aspect of her essence is revealed. "Myth is what never was—yet always is," said Joseph Campbell.

And so the Magdalene is still with us, to be discovered hidden deeply within the literature and art that she so exquisitely inspired. I challenge and invite you to join me in my search for her.

along with their works. In order to preserve these manuscripts, the desert fathers hid them in the Egyptian earth. The Magdalene likewise retreats underground into legend and myth.

In the Middle Ages we find her life story in *The Golden Legend* by Jacobus de Voragine the Bishop of Genoa, which has placed her solidly near Marseilles. He

CHAPTER ONE

The Indisputable Mary Magdalene

I N THE MULTITUDE of paintings and sculptures inspired by the scriptures we see the Magdalene most often represented on the day that signifies the holiest day in the Christian calendar— Easter. It is the day that celebrates the moment when the Magdalene discovers the empty tomb where Jesus has been laid. In the gospels of the New Testament "Mary Magdalene" is stage center in the drama that unfolds in the death and resurrection of the Nazarene—the culmination of the gospels, the central event in Christianity. In this moment she is uncontrovertibly the Apostle's Apostle, and the first to bring the news of Jesus' Resurrection—the privileged companion whom he addresses at the tomb.

The following chapter contains this essential core of the Christian story, the good news of Resurrection, and for Mary, reunion. The Mary Magdalene of this essential kernel is not necessarily to be confused with the Mary of the traditional

Saint Mary Magdalen
Bartolomeo Bulgarini, 14th century

associations—Mary the sister of Martha of Bethany or the woman who washes Jesus' feet with her tears, etc. In the Easter events she is always indisputably referred to as "Mary Magdalene."

Here in the New Testaments' Easter tale the gospels may only provide us with fleeting glimpses of the Magdalene, but they contain a critical clue in our search for her true place in the Christian narrative. You will come to know a "Mary Magdalene" who is loyal, never leaving the cross while Peter and the male disciples flee; brave, risking discovery as she searches out the burial place; and loving in her response to the savior at the tomb. She may have been mentioned only a few times, but what we do know from the four gospels is that Jesus, contrary to the Judaic traditions of his times, surrounded himself with women. These women were courageously at the foot of the cross when he was crucified, they supported his mission with money and care, they anointed him, were taught by his parables, and met him when he gloriously appeared after his

crucifixion and death. They were essential ingredients in his story.

Given the inclusivity of women in the Nazarene's spiritual family, we are forced to wonder why, by the 4th century, women have become an anathema to the orthodoxy. This is a key question in the search for the Magdalene. The answer may lie not only in the revolutionary nature and character of Jesus but also in the politics of those who "fixed" and solidified the canon of this fledgling religion. There was a seismic shift in the emphasis and values from the 1st century to the 4th. We can with much certainty lay these changes at the feet of the Roman emperor Constantine.

Mary Magdalene with Ointment Pot
artist unknown, c.1370

The four evangelists Matthew, Mark, Luke and John rendered Mary Magdalene briefly but in an important and critical context—placing her at the core of the Good News, and here she is placed at the center of the wheel of Christianity.

When Constantinius Victor Augustus Maximus succeeded in becoming the sole emperor of Rome in the year 324 C.E. he embraced Christianity as a means of unifying his empire. It should be understood that Constantine, also a zealous warrior, was a follower of Mithras, a powerful all-male cult that had been merged with Sol Invictus or sun worship in 274 C.E. This male oriented initiatory mystery religion honored the god Mithras who had a virgin birth on December 25 that was facilitated by shepherds, includes a ritual in which water was turned into wine, and had elevated adepts called "Pater" or Father, who carried staffs and wore rings and Mitres as symbols of their lofty grade (rank). If much of this sounds familiar it is because Constantine conjoined these essentials of Mithraicism or Sol Invictus to the budding religion that had emerged around the Nazarene. Even Easter was named after a pagan fertility goddess of rebirth and spring, Eastre. And so the cult of the Invincible Sun whose image was stamped on the coins of the empire became the very armature of Constantine's version of Christianity. Mithric forms and ideas were insinuated into the new religion. And the role of women in this new religion reflected not Jesus' point of view, but the Mithric roots at the center of Constantine's world, a world that simply did not honor or include the feminine.

In reading the excerpts that follow, you

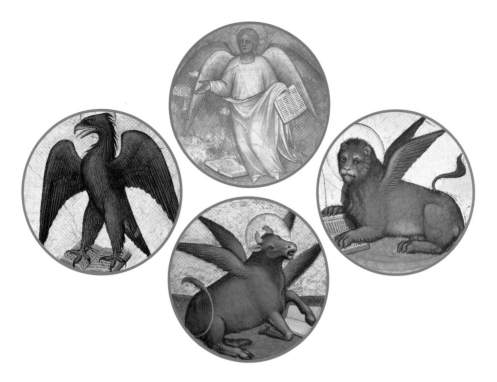

Symbols of the Evangelists, Giusto dei Menabuoi, 14th century

Iconographically, the Evangelists are symbolized as the four creatures that surround the throne of God in Revelations 4:7—Matthew the Angel/human, Mark the Lion, Luke the Ox, and John the Eagle. Scholars have long disagreed about which gospel came first. It seems the pendulum is swinging toward Mark, to be followed by Matthew, then Luke, and finally John. The gospels are divided into two groups. Those called synoptic are Matthew, Mark and Luke, because their narratives correspond. The fourth Gospel, John, is quite different and complements the other three.

will immediately notice that there are contradictions and inconsistencies implicit in the different gospels. Mark tells us the women visited the tomb at dawn, while John informs us it was in the evening. Although the Magdalene is repeatedly named as one of the women to visit the tomb, Salome, Mary the mother of James and Joanna appears at random. Matthew describes the tomb as closed and Luke writes that it was open. Was an angel at the tomb or a young man, or two angels or two men? These are just a few of the differences that arise from the numerous conflicting details. It must be understood that between oral traditions and the many decades that transpired from the historical events and the transcription, there can and will be inconsistencies. However, in spite of editing, copying, and translating, there is a dramatic thread that remains vivid and compelling and the inconsistencies become irrelevancies.

mark 15:25

And it was the third hour, and
they crucified him. ✑

they crucified him

Crucifix, Cimabue, 1285

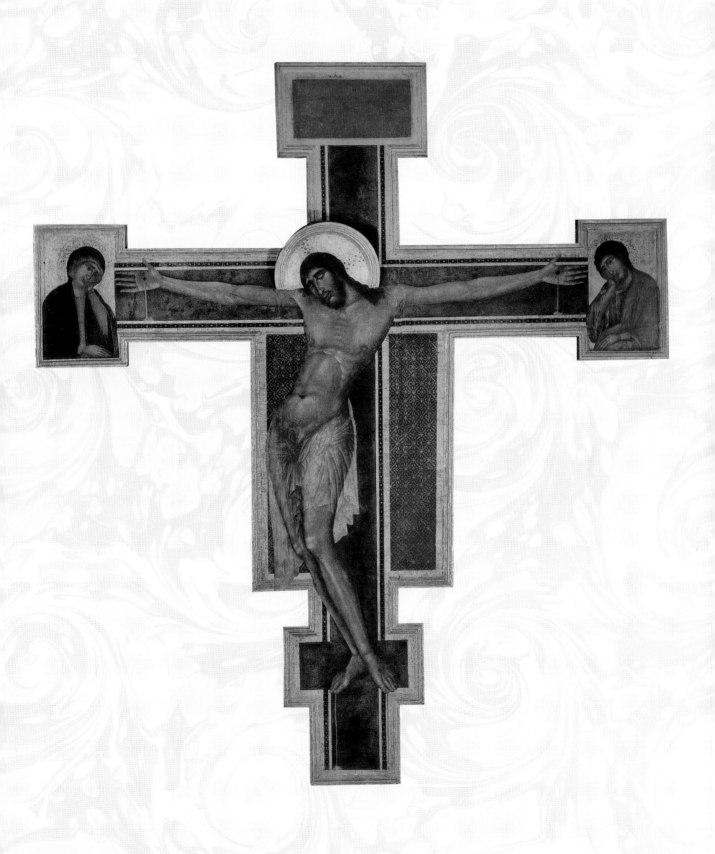

he gave up the ghost

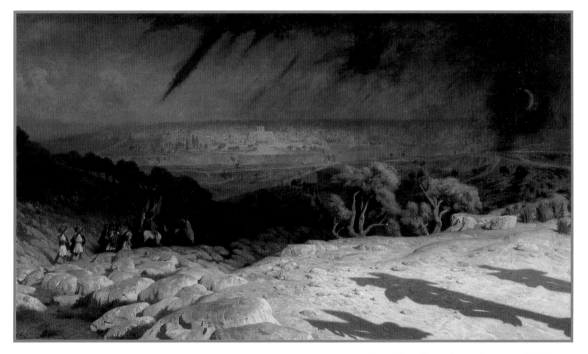

Jerusalem, Jean Leon Gerome, 1867

luke 23:44–46

And it was about the sixth hour, and there was a darkness over all the earth until the ninth hour.

And the sun was darkened, and the veil of the temple was rent in the midst.

And when Jesus had cried with a loud voice, he said. Father, into thy hands I commend my spirit: and having said thus, he gave up the ghost.

Crucifixion, Giovanni Battista Piazzetta, 18th century

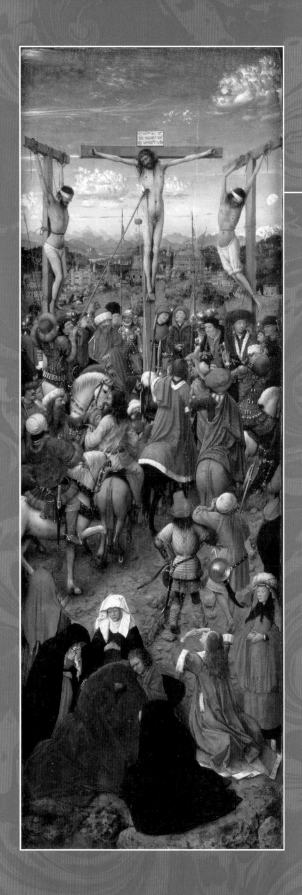

THE INDISPUTABLE MARY MAGDALENE

matthew 27:55–56

And many women were there beholding afar off, which followed
Jesus from Galilee, ministering unto him:

 Among which was Mary Magdalene, and Mary the mother of
James and Joses, and the mother of Zebedee's children. ✍

The Crucifixion: The Last Judgment, Jan Van Eyck, 1430

*Jan Van Eyck's (1390–1441) two-panel masterpiece
The Crucifixion: The Last Judgment was painted in
1430 and is one of the great examples of Northern
Renaissance art. The left panel has been beautifully
composed in three segments from top to bottom. The
first shows the crucified Jesus and his two companions
in death. The middle section dramatizes the crush of
soldiers among the Pharisees and citizens beneath the
cross. The third section is reserved for the women
"watching from afar." The Magdalene can be found
anchoring the bottom right along with what appears to
be an older, possibly pregnant woman in rust colored
robes. Mary stands out in her green mantle, a color that
purposely complements Van Eyck's brooding autumnal
palette and is traditionally associated with Aphrodite,
the Greek goddess of love and fertility. However, the*

*artist's choice of this color is more than likely an aes-
thetic consideration used to focus our attention on the
grief and love of Mary Magdalene for her "Beloved
Teacher"—one of the most important elements in the
drama of the Passion of Christ. Van Eyck's device
utterly succeeds. Mary's robes stand out because they
are finely and expensively made with what appears to
be ermine trim on her sleeve—a fur reserved only for
royalty in the Middle Ages. In contrast the Virgin
Mother is depicted in drab apparel at the bottom left
of the panel surrounded by a gathering of women simi-
larly clad. Together they form a dark cluster, whom we
notice only as an afterthought—our focus is on the
Magdalene, a consequence of her placement, emo-
tional intensity, and vibrant robes in a monochromatic
field.*

✍ 25

john 19:25

Now there stood by the cross of Jesus his
mother, and his mother's sister, Mary the
wife of Cleophas, and Mary Magdalene. ✎

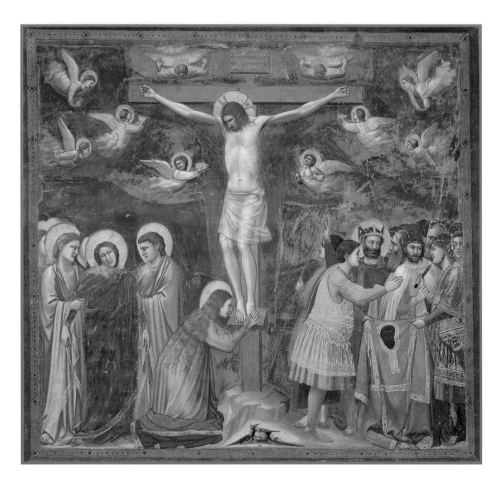

Crucifixion, Giotto, 1306

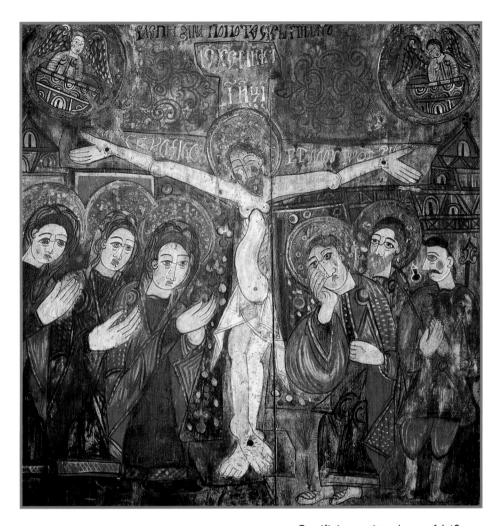

Crucifixion, artist unknown, 1640

mark 15:40–41

There were also women looking on afar off: among whom was Mary Magdalene, and Mary the mother of James the less and of Joses, and Salome;

(Who also, when he was in Galilee, followed him, and ministered unto him;) and many other women which came up with him unto Jerusalem. ✍

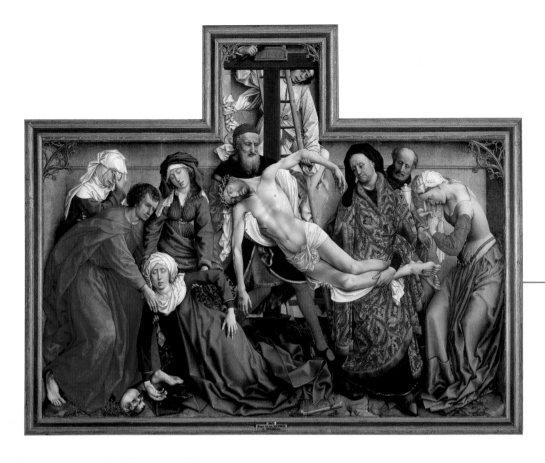

Deposition, Rogier van der Weyden, 1435

In 1427 Rogelet de la Pasture or "Little Roger of the Meadow" (1399–1464) joined Robert Campin's Tournai workshop as an apprentice. At twenty-eight years, he was more advanced in age than the typical neophyte, but within five years he had been accepted into the painters guild as a master. Despite his late start, he was to become one of the most important European painters of the 15th century and his Deposition is among the greatest in the history of Western art.

Painted in Rogier's thirty-sixth year, this work now resides in the Prado. The painting startles us with its frieze-like horizontal composition in which all the action takes place in a shallow space within the proscenium of the frame. Much closer in style to Medieval painting, Rogier may have traveled only once to Rome in his entire lifetime. The influence of the Renaissance masters did not affect his oeuvre as effec-

tively as it did with later Netherlandish artists.

Here we see Jesus gently held from behind by Nicodemus or possibly Joseph of Arimathea as he is being taken down from the cross. To the left we see a gracefully swooning Mary the mother and at her left a Skull representing Golgatha—the place of the Skull and the crucifixion. Though she is a deeply moving figure, the emotional focus of this work is the collapsing Mary Magdalene at the far right. She appears to be contracting from her solar plexus as though she has taken a violent blow. Compositionally Jesus' legs seem to take the shape of an arrow that could pierce her at this most vulnerable psychic center as she crumbles from the profound pain of her loss. The painting expresses a wealth of emotions from pathos to grief and great despair. Rogier's craftsmanship is without equal as is the heartrending intensity communicated in this sublime masterpiece.

mark 15:42–47

And now when the even was come, because it was the preparation, that is, the day before the sabbath,

Joseph of Arimathaea, an honourable counsellor, which also waited for the kingdom of God came, and went in boldly unto Pilate, and craved the body of Jesus.

And Pilate marvelled if he were already dead: and calling unto him the centurion, he asked him whether he had been any while dead.

And when he knew it of the centurion, he gave the body to Joseph.

And he bought fine linen, and took him down, and wrapped him in the linen, and laid him in a sepulchre which was hewn out of a rock, and rolled a stone unto the door of the sepulchre.

And Mary Magdalene and Mary the mother of Joses beheld where he was laid. ✑

And now when the even was come

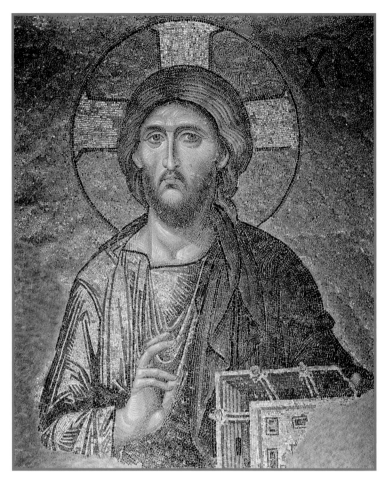

Christ, artist unknown, 12th century

There is little reason to believe that the "seven devils" referred to in Mark and Luke are connected to the concept of sin or unchastity. More likely the healing that transpired between Jesus and the Magdalene was psychological and initiatory in nature. The Latin word used here from St. Jerome's Vulgate Bible is *daemonia*, a derivation of the Greek word *daimon*. In Greek and in Latin, this word does not connote evil but is a neutral word referring to unconscious impulses revealed to us in dream and vision. Not attending or recognizing the daimon could have a negative effect, but essentially the word is associated with intermediary and guardian spirits replete with knowledge.

There are also interesting associations with the number seven. In astronomy and astrology, seven is the number of the heavenly objects in our solar system that are visible to the naked eye, the classical "planets" of the Moon, Mercury, Venus, Mars, Jupiter, Saturn and the Sun. This highly symbolic number in the Book of Genesis reflects the day in which God rested—the sabbath. Seven is the also the number of notes in the musical scale and of colors in the rainbow. It is likely that the idea of the Seven Deadly Sins of lust, avarice, envy, pride, sloth, gluttony and anger developed from the knowledge and misuse of these energy centers. The "daimon" in this case becomes the "demon."

Another interesting correspondence can be found in The Woman's Encyclopedia of Myths and Secrets by Barbara G. Walker. Walker suggests that the "seven devils" could well represent the seven spiritual gatekeepers of the pagan mysteries to whom the temple priestess gave her veils. The veils represented "the

he appeared first to Mary

mark 16:9

Now when Jesus was risen early the first day of the week, he appeared first to Mary Magdalene, out of whom he had cast seven devils. ✍

luke 8:2

And certain women, which had been healed of evil spirits and infirmities, Mary called Magdalene, out of whom went seven devils. ✍

earthly appearances or illusions falling away from those who approached the central mystery. Isis too had seven stoles with the same mystical significance." Isis is the Egyptian Goddess, wife of Osiris and mother of Horus. She was worshipped in the Greek and Roman world and in the Roman Mysteries she was called "the One who is All." Clement of Alexandria, in a report on the Evangelist Mark inscribed in the Monastery Mar Saba near Jerusalem, adds some insight to these issues and writes, "…during Peter's stay in Rome…[Mark] wrote an account of the Lord's doings, not however declaring all of them, nor yet hinting at the secret ones…Mark came over to Alexandria, bringing both his notes and those of Peter…Thus he composed a more spiritual Gospel for the use of those who were not perfected. Nevertheless, he yet did not divulge the

things not to be uttered, nor did he write down the hierophantic teachings of the Lord, but to the stories already written he added others and, more over, brought in certain sayings of which he knew the interpretation would, as a mystagogue, lead the hearers into the innermost sanctuary of that hidden by seven veils…He left his composition to the church of Alexandria, where it even yet is most carefully guarded, being read only to those who are being initiated into the great mysteries."

It would seem likely that the Magdalene was among those the Galilean initiated into the "great mysteries" and that the "seven devils" were the illusions that blind us from the radiance of the Central Mystery. The Magdalene was "healed," or opened, to these greater truths.

he is risen;
he is not here

mark 16:1–8

And when the sabbath was past, Mary Magdalene, and Mary the mother of James, and Salome, had bought sweet spices, that they might come and anoint him.

And very early in the morning the first day of the week, they came unto the sepulchre at the rising of the sun.

And they said among themselves, Who shall roll away the stone from the door of the sepulchre?

And when they looked, they saw that the stone was rolled away: for it was very great.

And entering into the sepulchre, they saw a young man sitting on the right side, clothed in a long white garment; and they were affrighted.

And he saith unto them, Be not affrighted: Ye seek Jesus of Nazareth, which was crucified: he is risen; he is not here: behold the place where they laid him.

But go your way, tell his disciples and Peter that he goeth before you into Galilee: there shall ye see him, as he said unto you.

And they went out quickly, and fled from the sepulchre; for they trembled and were amazed: neither said they any thing to any man; for they were afraid. ✍

Maries at the Tomb, Duccio, 13th or 14th century

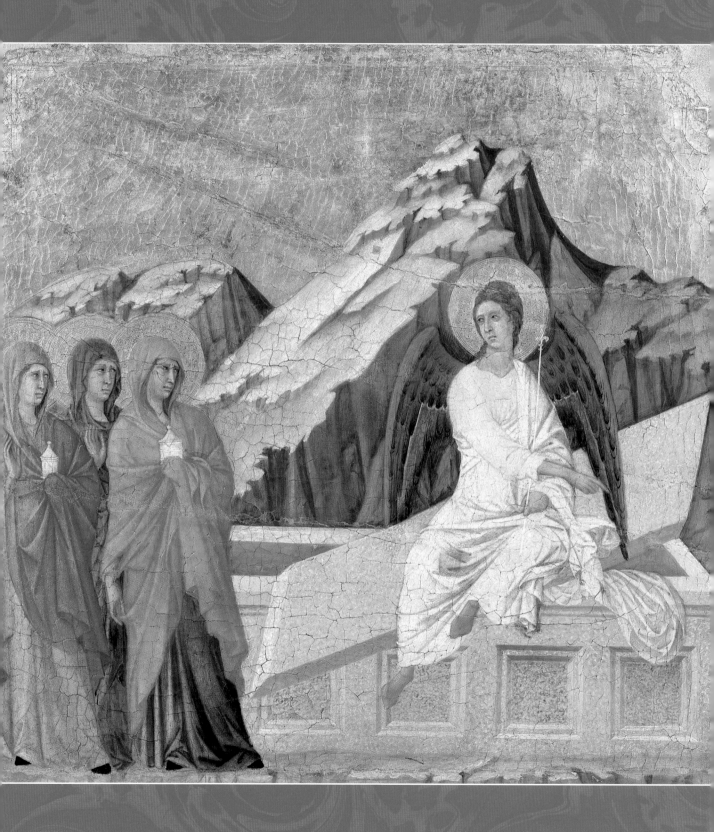

Why seek ye the living

luke 24:1–11

Now upon the first day of the week, very early in the morning, they came unto the sepulchre, bringing the spices which they had prepared, and certain others with them.

And they found the stone rolled away from the sepulchre.

And they entered in, and found not the body of the Lord Jesus.

And it came to pass, as they were much perplexed thereabout, behold, two men stood by them in shimmering garments:

And as they were afraid, and bowed down their faces to the earth, they said unto them, Why seek ye the living among the dead?

He is not here, but is risen: remember how he spake unto you when he was yet in Galilee,

Saying, The Son of man must be delivered into the hands of sinful men, and be crucified, and the third day rise again.

And they remembered his words.

And returned from the sepulchre, and told all these things unto the eleven, and to all the rest.

It was Mary Magdalene, and Joanna, and Mary the mother of James, and other women that were with them, which told these things unto the apostles.

And their words seemed to them as idle tales, and they believed them not. ✒

among the dead?

Mary Magdalene from *Braque Triptych* (detail), Rogier van der Weyden, 15th century

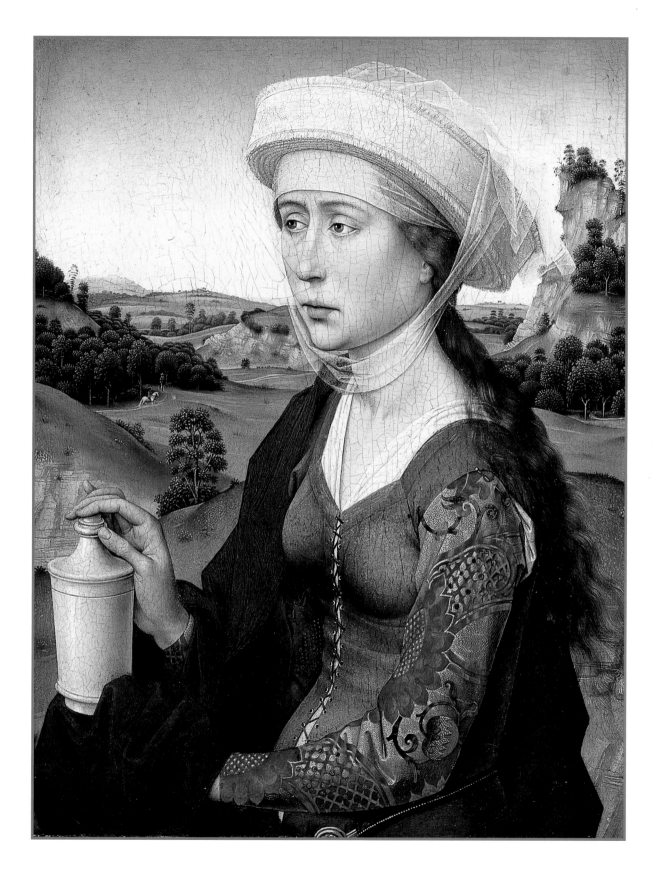

Two Women and the Angel, artist unknown, 6th century

matthew 28:1

In the end of the sabbath, as it began to dawn toward
the first day of the week, came Mary Magdalene and
the other Mary to see the sepulchre.

His countenance was like lightning,

matthew 28:2–6

And, behold, there was a great earthquake: for the angel of the Lord descended from heaven, and came and rolled back the stone from the door, and sat upon it.

His countenance was like lightning, and his raiment white as snow:

And for fear of him the keepers did shake, and became as dead men.

And the angel answered and said unto the women, Fear not ye: for I know that you seek Jesus, which was crucified. He is not here: for he his risen, as he said, Come, see the place where the Lord lay. ✍

and his raiment white as snow

Angel and Mary Magdalene at the Tomb, artist unknown, 11th century

And there was Mary Magdalene

matthew 27:59–61

And when Joseph had taken the body, he wrapped it in a clean linen cloth,

And laid it in his own new tomb, which he had hewn out in the rock: and he rolled a great stone to the door of the sepulchre, and departed.

And there was Mary Magdalene, and the other Mary, sitting over against the sepulchre. ✍

Resurrection, Piero della Francesca, c.1460

Here in Piero della Francesca's (1420–1492) fresco Resurrection we see Jesus wearing the spotless linen cloth he had been wrapped in by Joseph of Arimathea. As he rises from the "new tomb" one responds in a visceral way to Piero's geometric composition with its powerful central triangle. Gardner, in Art Through the Ages, reminds us that "Piero's art is the projection of a mind cultivated by mathematics and convinced that the highest beauty is found in those forms that have the clarity of pure geometrical figures." His dense yet luminous forms create a "fearful symmetry" for the eye. Although forgotten for centuries after his death, he is undeniably one of the greatest masters of the Renaissance.

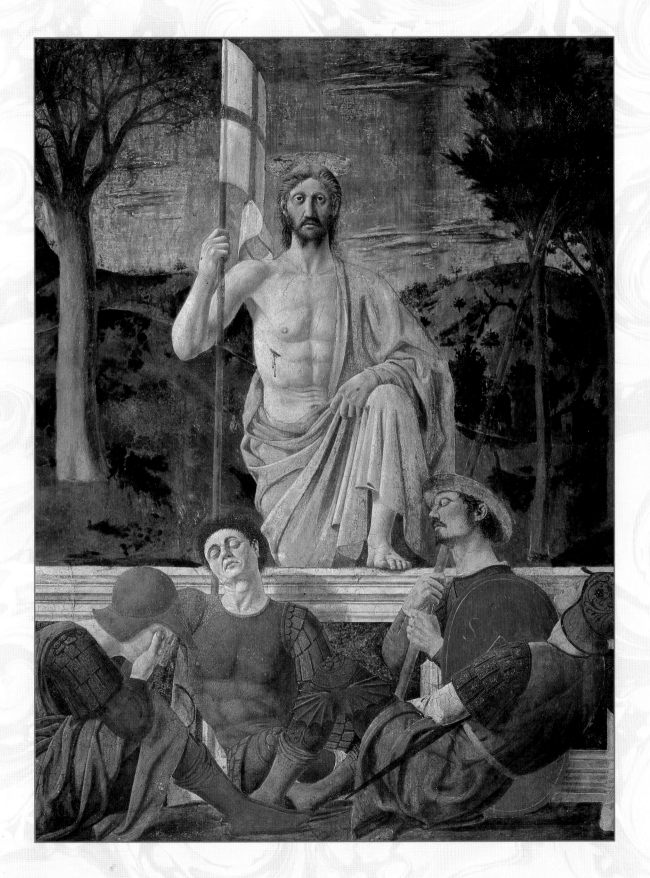

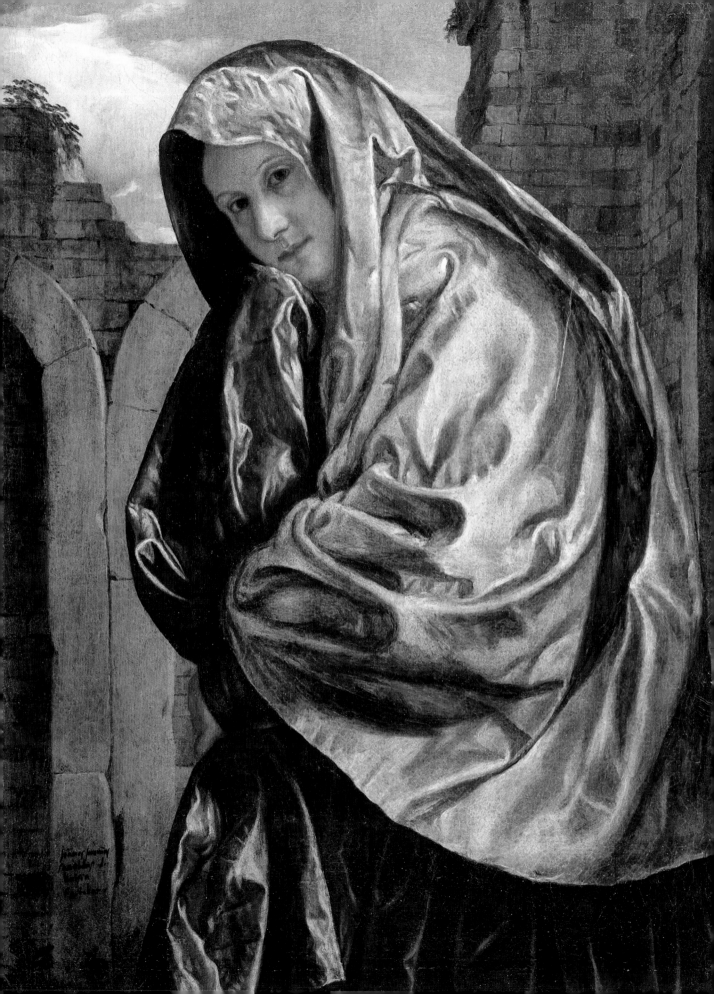

go quickly, and tell his disciples

matthew 28:7–8

And go quickly, and tell his disciples that he is risen from the dead; and, behold, he goeth before you into Galilee; there shall ye see him: lo, I have told you.

And they departed quickly from the sepulchre with fear and great joy; and did run to bring his disciples word. 🖎

A Venetian Woman (Saint Mary Magdalen), Girolamo Savoldo, 16th century

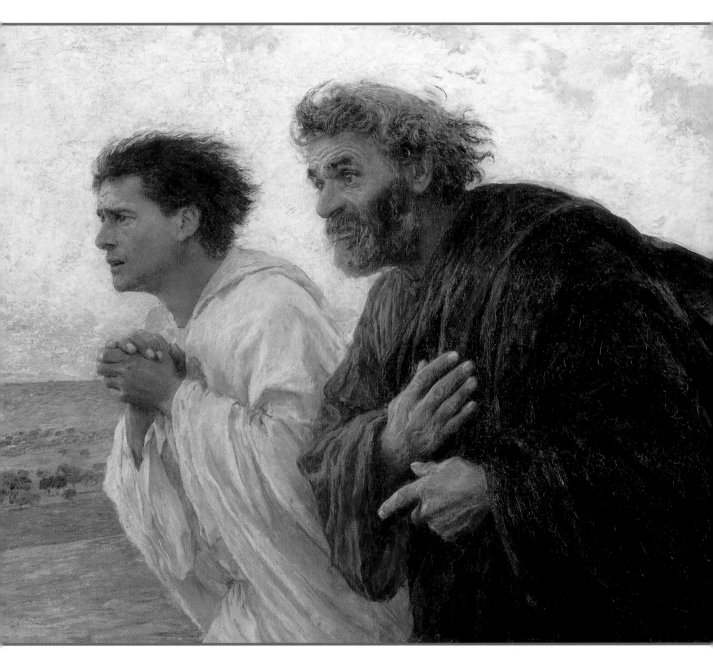

Apostles Peter and John Hurry to the Tomb on the Morning of the Resurrection, Eugene Burnand, 1898

They have taken away

john 20:1–4

The first day of the week cometh Mary
Magdalene early, when it was yet dark,
unto the sepulchre, and seeth the stone
taken away from the sepulchre.

Then she runneth, and cometh to Simon
Peter, and to the other disciple, whom Jesus
loved, and saith unto them, They have
taken away the Lord out of the sepulchre,
and we know not where they have laid him.

Peter therefore went forth, and that
other disciple, and came to the sepulchre.

So they ran both together: and the other
disciple did outrun Peter, and came first to
the sepulchre. ✍

the Lord

Woman, why weepest thou?

john 20:11–14

But Mary stood without at the sepulchre weeping: and as she wept, she stooped down, and looked into the sepulchre,

And seeth two angels in white sitting, the one at the head, and the other at the feet, where the body of Jesus had lain.

And they say unto her, Woman, why weepest thou? She saith unto them, Because they have taken away my Lord, and I know not where they have laid him.

And when she had thus said, she turned herself back, and saw Jesus standing, and knew not that it was Jesus. ✎

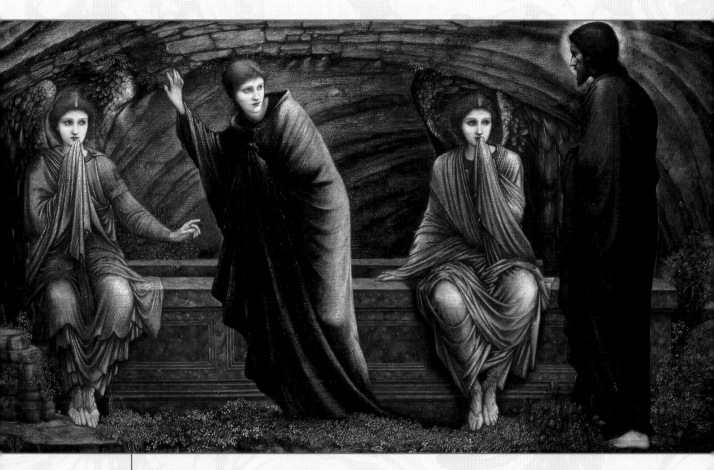

The Morning of the Resurrection, Edward Burne-Jones, 1886

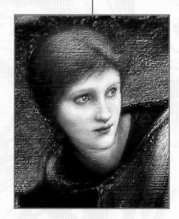

In this dramatic painting by Edward Burne-Jones (1833–1898) we see in muted tones the Magdalene as eyewitness to the Resurrection. Burne-Jones has chosen to illustrate this moment from the Gospel of St. John—which we know by the presence of the two angels that compositionally place Mary at the epicenter of this miracle. One wonders if the loss of Burne-Jones's mother as a consequence of his birth has subtly influenced this placement of Mary as the focal point, instead of the Galilean.

The Magdalene's expression reveals her surprise, her disbelief, and a touch of fear (even the angels that flank her show astonishment). The event of Jesus' Resurrection lifts his followers from the depths of despair to absolute wonderment to glorious joy. Here, Burne-Jones has chosen to paint the moment of awe and discovery that proceeds the elation. It should not go unnoticed that the artist was originally destined for the ministry but, unlike Fra Angelico, changed course.

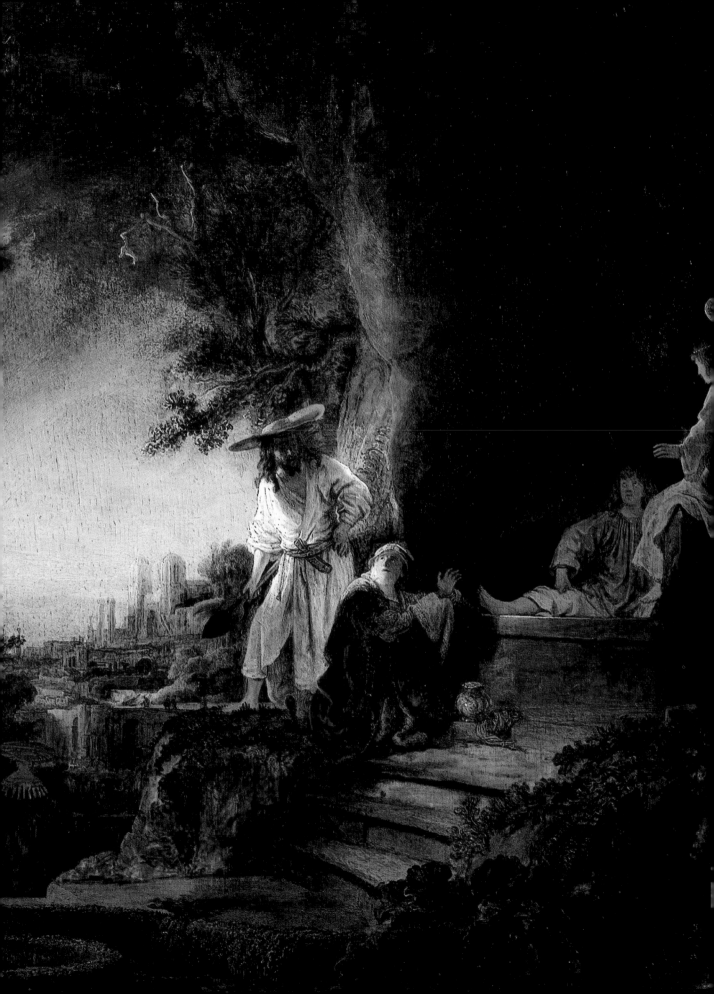

Whom seekest thou?

john 20:15

Jesus saith unto her, Woman why weepest thou?
Whom seekest thou? She supposing him to be the
gardener, saith unto him, Sir, if thou have borne
him hence, tell me where thou hast laid him, and
I will take him away. ✑

The Risen Christ Appearing to Mary Magdalene, Rembrandt, 1638

Rembrandt Harmensz van Rijn (1606–1669) is unequivocally the finest Dutch master of the 17th century and one of the greatest Western artists. He was also one of the most profound interpreters of biblical narrative. His dramatic paintings resound with emotional honesty and compassion for the human condition. By the late 16th century the Dutch were Protestant, and Rembrandt's work accordingly reveals a more human Jesus with no emphasis on elaboration, grandeur, or idolization.

His paintings require us to turn inward, to contemplate the meaning of the rendered moment. He is the "everyman's" artist and his paintings awaken in us a humanity and stillness. The spiritual message of John 20:15 is addressed in plain terms with feeling and sensitivity —these are not the images of a triumphant Christian church. In his inspired handling of light and shadow, he craftily blends every nuance of light into another without the violent transitions of, say, a Carravagio. He has taken chiaroscuro to its penultimate and most subtle evocation.

In this revelatory moment we see Mary Magdalene and Jesus at the tomb centered in the composition. Rembrandt renders the climactic moment without artifice. It is dawn; and an aureole of light frames Jesus as he speaks to Mary for the first time since his crucifixion. But she mistakes him for a gardener by the hat he wears, and with her back turned away, she has not yet seen him clearly. She is about to come face to face with the miracle of "resurrection" (a word that in the Greek of early Christianity also can be translated as "awaken")—that death is dead in awakening to the inner Christ. This great spiritual message is translated into the more literalist message of the Canon.

john 20:16

Jesus saith unto her, Mary. She turned

herself, and saith unto him, Rabboni;

which is to say, Master. ✍

Noli Me Tangere, Lambert Sustris, 16th century

Lambert Sustris (1515–1568), a Dutch painter who was born and trained in Amsterdam, spent over thirty years living in Italy. Art historians believe that he worked in Titian's studio specializing in landscapes and gardens for the Master. His paintings are considered examples of the Mannerist style, which rejected the balance and harmony associated with the Renaissance for an emotional intensity that ultimately gave way to the Baroque.

His painting, Noli Me Tangere (Do Not Touch Me) belies the meaning of its title, for here two souls are shown to be deeply connected. His painting per-fectly illustrates the critical moment in the Gospel of John and in the New Testament when the risen Jesus is recognized by his beloved disciple the Magdalene. Jesus calls her "Mary," and this tender expression of her name resounds throughout the history of Christianity. They are truly in dialog, intimately engaged. She replies to him, "Rabboni," meaning "My Beloved Teacher." Sustris has impeccably captured this moment of heightened emotion with elegance and grace, and he has brought them into his garden— a very Eden.

Jesus saith unto her,

Mary

Touch me not

john 20:17

Jesus saith unto her, Touch me not; for I am not
yet ascended to my Father: but go to my brethren,
and say unto them, I ascend unto my Father, and
your Father; and to my God, and your God.

Noli Me Tangere, artist unknown, 16th century

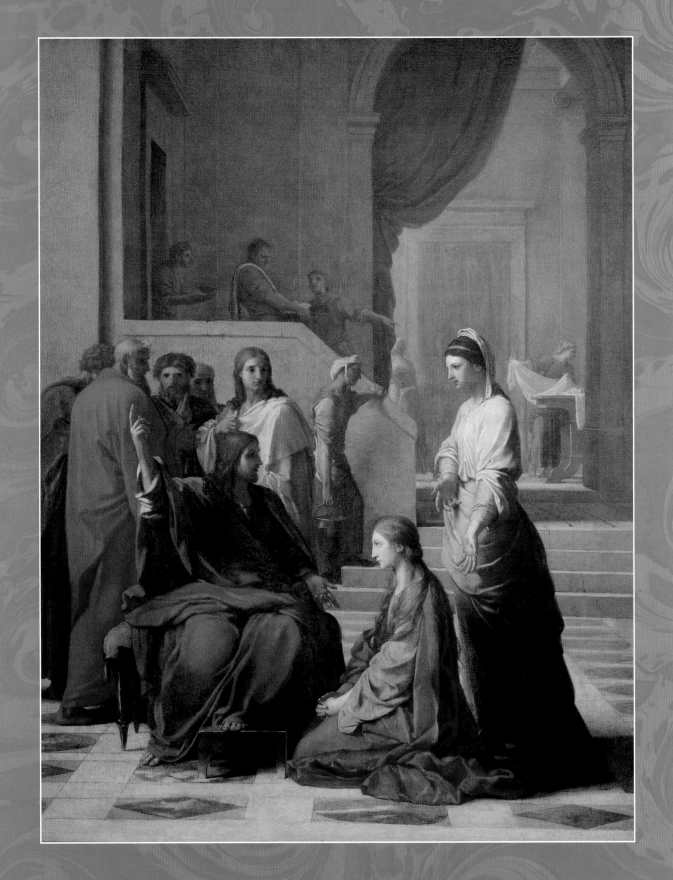

CHAPTER TWO

Mary and the Traditional Associations

IN THE PREVIOUS chapter we examined the definitive references to Mary Magdalene in the New Testament. There are, however, other gospel references that have traditionally inspired associations with the Magdalene, but which may or may not be her. In Eastern Christianity, Mary, the sister of Martha of Bethany, the unnamed woman "who was a sinner" (Luke 7:37–50), and Mary Magdalene have always been treated as three very different individuals. In fact, for many early fathers of the church such as Augustine, Jerome and Ambrose, the identities of these women were unclear and they preferred to leave the question undecided.

Toward the end of the 6th century, however, Pope Gregory the Great (540–604 C.E.) settled it for his orthodoxy when he combined them and declared them one and the same woman. Ultimately a fourth—"the woman taken in adultery" (John 8:3–11) came to be included in this over-arching persona.

Jesus in the House of Martha and Mary
Eustache Lesueur, 17th century

She whom Luke calls the sinful woman, whom John calls Mary, we believe to be the Mary from whom seven devils were ejected according to Mark. And what did these devils signify, if not all the vices?...It is clear, brothers, that the woman previously used the unguent to perfume her flesh in forbidden acts.

—Homily XXXIII, 591 A.D., Pope Gregory

In linking the Marys together, Pope Gregory, a greatly respected figure in ecclesiastical history, transformed the Magdalene from the loyal, courageous disciple and herald of the resurrection into a redeemed sinner—a repentant whore. The reason for this decision is unclear. It could appear that this was a willful form of identity theft, a political act. It may also have simply been the need to make things tidy—tie up loose, bothersome ends. Or perhaps it was simply a misunderstanding about the meaning of "seven devils," interpreting Jesus' healing, or possibly a rite of initiation, as an exorcism—we all

know that "devils" and sin go hand in hand. Whatever Pope Gregory's motivation, the result was definitive and relegated Mary Magdalene to the role of repentant prostitute in the doctrines of Christian culture for 1400 years. It was not until 1969 that this label was finally repealed by Rome.

It should be mentioned that as the Magdalene became polarized and identified with the sin of lust and carnality, the Virgin Mary was on the ascendant. However, either as whore or Virgin, the result was the same—these women were untouchable—above or below the radar of the patriarchal orthodoxy. Adored, worshipped from afar, they were enthroned in heaven or hidden to repent in a cave, but sadly they could not be brought "into the room."

This chapter contains all the excerpts from the New Testament which reference these women who have been traditionally associated with Mary Magdalene. They are the texts that influenced Pope Gregory to write his historic homily that ultimately compromised the Magdalene's role. Here you will find Mary of Bethany who listens to Jesus while her sister Martha busies herself with work; Mary at the raising of her brother Lazarus from the dead; the unnamed woman who anoints Jesus with costly ointment; the sinner who washes his feet with her tears and finally the woman taken in adultery.

Saint Gregory and Saints Adoring the Madonna
Pieter Paul Rubens, 1607

St. Gregory the Great is the focus of this painting by a 30-year-old Pieter Paul Rubens, the 17th century Flemish master. Gregory, the son of a 6th century Roman senator, is centered between two well-born 1st-century Roman saints. St. Domitilla, an imperial Christian matron, was banished from Rome when her husband was martyred for his Christian beliefs. St. Papianus, in Roman armor, is pictured opposite St. Domitilla looking heavenward. St. Maurus, resembling John the Baptist and positioned just behind St. Papianus, a contemporary of Pope Gregory, was a son of a Roman nobleman. Here, Rubens has aggrandized not only Pope Gregory—who as a child saw his beloved city conquered by "barbarians" and his family and friends massacred—but also three other Romans who witnessed treachery in Rome.

In this gifted work we see Pope Gregory's gaze raised to the image of the Virgin Mary who is framed at the peak of the arch. His loyalty to her is referenced as an aside to the "miracle" that occurred when Rome was beset with plague. Gregory, himself stricken, gave a sermon that comforted the people. He asked that everyone pray to God and the Mother and join a procession to the Basilica of the Virgin, to virtually storm the heavens with their admonitions. They marched together—monks, widows, children, and victims of the plague. While passing over the bridge to St. Peter's, it is said the Archangel St. Michael appeared over the tomb of Emperor Hadrian, putting his fiery sword back into his scabbard as if to say the pestilence was over. At that moment Gregory heard angels singing "Queen of Heaven, Rejoice!" The plague had ended.

A great theologian, Pope Gregory had a profound and long-lasting impact on medieval thought. This Rubens painting is a consummate expression of his idealization of the Virgin Mother, a preference that had significant implications for Mary Magdalene, whom he branded a reformed sinner, marginalizing her forevermore in the eyes of the Church.

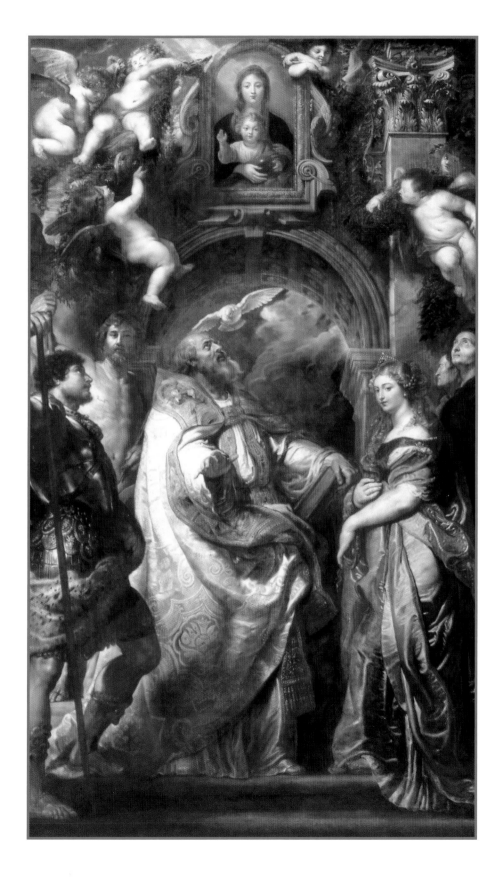

Now a certain man was sick

john 11:1

Now a certain man was sick,
named Lazarus, of Bethany,
the town of Mary and her
sister Martha.

Jesus and His Disciples on the Way to Bethany, Henry Ossawa Tanner, 20th century

john 11:2

(It was that Mary which anointed the Lord with ointment, and wiped his feet with her hair, whose brother Lazarus was sick.)

john 11:3–5

Therefore his sisters sent unto him, saying, Lord, behold, he whom thou lovest is sick.

When Jesus heard that, he said, This sickness is not unto death, but for the glory of God, that the Son of God might be glorified thereby.

Now Jesus loved Martha, and her sister, and Lazarus.

Now Jesus loved Martha,

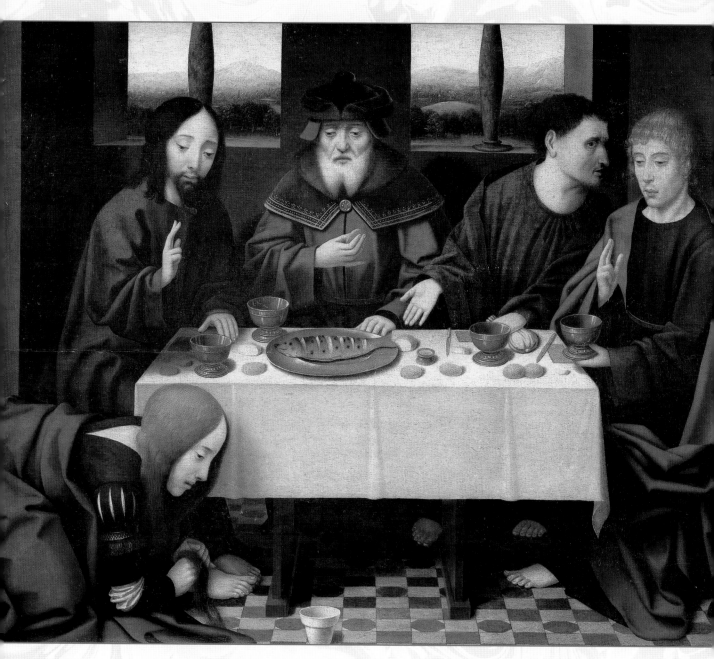

Christ in the House of Simon the Pharisee, Dieric Bouts the Elder, 15th century

and her sister, and Lazarus

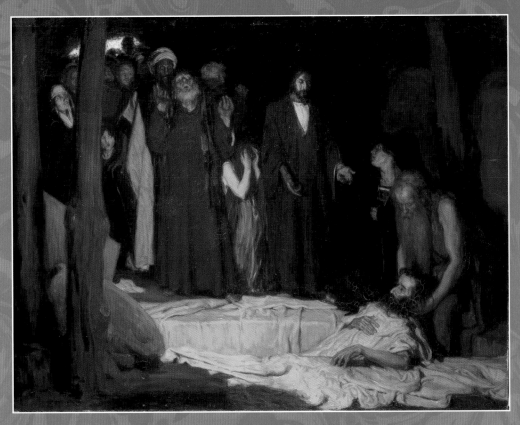

The Resurrection of Lazarus, Henry Ossawa Tanner, 20th century

Henry Ossawa Tanner (1859–1937) was the first African-American artist to achieve international acclaim. born in Pittsburgh to a black scholar and minister of the African Methodist Episcopalian Church and a former slave, Tanner enrolled in the prestigious Pennsylvania Academy of Fine Arts when he was twenty-one to study under the great American realist painter Thomas Eakins. The only African-American student attending the academy, he withdrew after being seized by his classmates and tied to an easel in a mock crucifixion.

After years of struggling to make a living as an artist in America, he moved to Paris, where he enrolled at the famous Acadamie Julian to study with Jean Paul Laurens and Bouguereau. France presented Tanner with an atmosphere of support and respect free from prejudice. His success grew and in 1923 he was made an honorary chevalier of the Order of the Legion of Honor, the highest accolade in France.

Tanner's Christian roots drew him to paint biblical themes. In The Resurrection of Lazarus we see the influence of Eakins as this dramatic scene realistically unfolds. The darkened cave reveals Lazarus, who after four days dead is now being blessed by Jesus with a grieving Magdalene at his side. One can imagine life beginning to stir within Lazarus. The idea of dying and being reborn in a cave or tomb was part of the rites of initiation in ancient Mediterranean cultures from Egypt to Malta. This episode in Jesus' drama evokes these rituals and raises the question: Is this part of the Lazarus narrative an example of a rite of initiation in early pre-orthodox Christianity? It seems quite appropriate that Tanner chose to illustrate this particular moment, as he had faced a personal death and transformation from the humiliation of racism to dignity and the flowering of his personal and artistic success. He was a Lazarus indeed.

said Jesus unto them plainly

john 11:6–15

When he had heard therefore that he was sick, he abode two days still in the same place where he was.

Then after that saith he to his disciples, Let us go into Judaea again.

His disciples say unto him, Master, the Jews of late sought to stone thee; and goest thou thither again?

Jesus answered, Are there not twelve hours in the day? If any man walk in the day, he stumbleth not, because he seeth the light of this world.

But if a man walk in the night, he stumbleth, because there in no light in him.

These things said he: and after that he saith unto them, Our friend Lazarus sleepeth; but I go, that I may awake him out of sleep.

Then said his disciples, Lord, if he sleep, he shall do well.

Howbeit Jesus spake of his death: but they thought that he had spoken of taking of rest in sleep.

Then said Jesus unto them plainly, Lazarus is dead.

And I am glad for your sakes that I was not there, to the intent ye may believe; nevertheless let us go unto him. ≈

Lazarus is dead

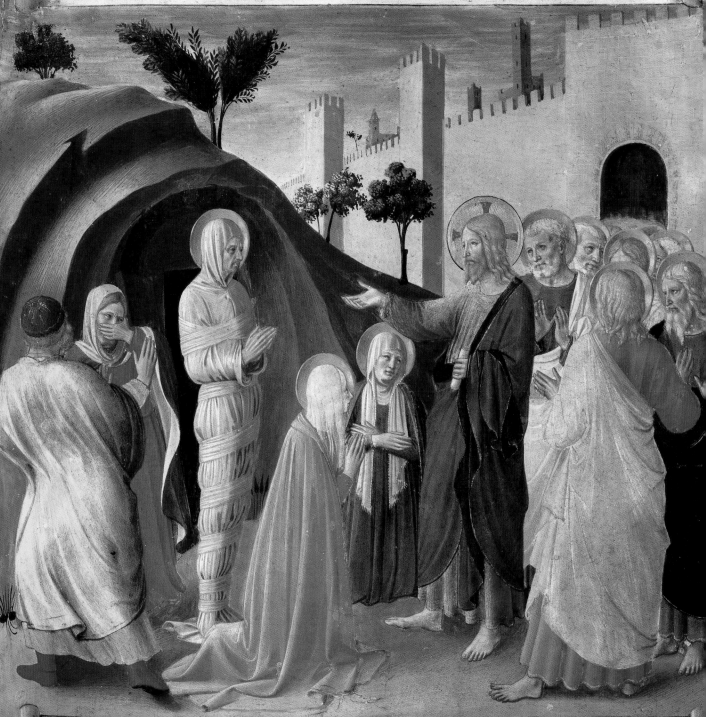

DVCAM VOS DESEPVLCRIS POPVLVS MEVS. EÇECHIEL. XXXVII. C.

ÇIAMVIT ỸHS VOCE MAÇ IAÇERE VENI FORAS. ZSTATIM PRODIIT Ø ERAT MORTVVS. IO. II. C.

I am the resurrection, and the life

john 11:16–46

Then said Thomas, which is called Didymus, unto his fellow disciples, Let us also go, that we may die with him.

Then when Jesus came, he found that he had lain in the grave four days already.

Now Bethany was nigh unto Jerusalem, about fifteen furlongs off:

And many of the Jews came to Martha and Mary, to comfort them concerning their brother.

Then Martha, as soon as she had heard that Jesus was coming, went and met him: but Mary sat still in the house.

Then said Martha unto Jesus, Lord, if thou hadst been here, my brother had not died.

But I know, that even now, whatsoever thou wilt ask of God, God will give it thee.

Jesus saith unto her, Thy brother shall rise again.

Martha saith unto him, I know that he shall rise again in the resurrection at the last day.

Jesus saith unto her, I am the resurrection, and the life: he that believeth in me, though he were dead, yet shall he live:

Resurrection of Lazarus, Fra Angelico, 15th century

The Master is come

And whosoever liveth and believeth in me shall never die. Believest thou this?

She saith unto him, Yea Lord: I believe that thou art the Christ, the Son of God, which should come into the world.

And when she had so said, she went her way, and called Mary her sister secretly, saying, The Master is come, and calleth for thee.

As soon as she heard that, she arose quickly, and came unto him.

Now Jesus was not yet come into the town, but was in that place where Martha met him.

The Jews then which were with her in the house, and comforted her, when they saw Mary, that she rose up hastily and went out, followed her saying, She goeth unto the grave to weep there.

Then when Mary was come where Jesus was, and saw him, she fell down at his feet, saying unto him, Lord, if thou hadst been here, my brother had not died.

When Jesus therefore saw her weeping, and the Jews also weeping which came with her, he groaned in the spirit, and was troubled,

And said, Where have ye laid him? They said unto him, Lord, come and see.

Jesus wept.

and calleth for thee

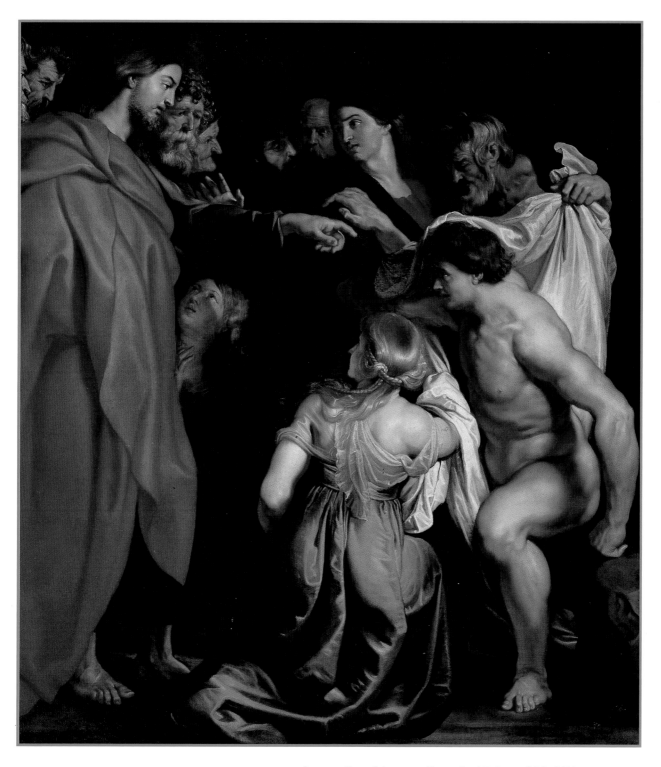

Resurrection of Lazarus, Pieter Paul Rubens, 16th–17th century

Then said the Jews, Behold how he loved him!

And some of them said, Could not this man, which opened the eyes of the blind, have caused that even this man should not have died?

Jesus therefore again groaning in himself cometh to the grave. It was a cave, and a stone lay upon it.

Jesus said, Take ye away the stone. Martha, the sister of him that was dead, saith unto him, Lord, by this time he stinketh: for he hath been dead four days.

Jesus saith unto her, Said I not unto thee, that, if thou wouldest believe, thou shouldest see the glory of God?

Then they took away the stone from the place where the dead was laid. And Jesus lifted up his eyes, and said, Father, I thank thee that thou hast heard me.

And I knew that thou hearest me always: but because of the people which stand by I said it, that they may believe that thou hast sent me.

And when he thus had spoken, he cried with a loud voice, Lazarus, come forth.

And he that was dead came forth, bound hand and foot with graveclothes: and his face was bound about with a napkin. Jesus saith unto them, Loose him, and let him go.

Then many of the Jews which came to Mary, and had seen the things which Jesus did, believed on him.

But some of them went their ways to the Pharisees, and told them what things Jesus had done. ☙

Lazarus, come forth

Resurrection of Lazarus (detail), Leandro Bassano, 16th century

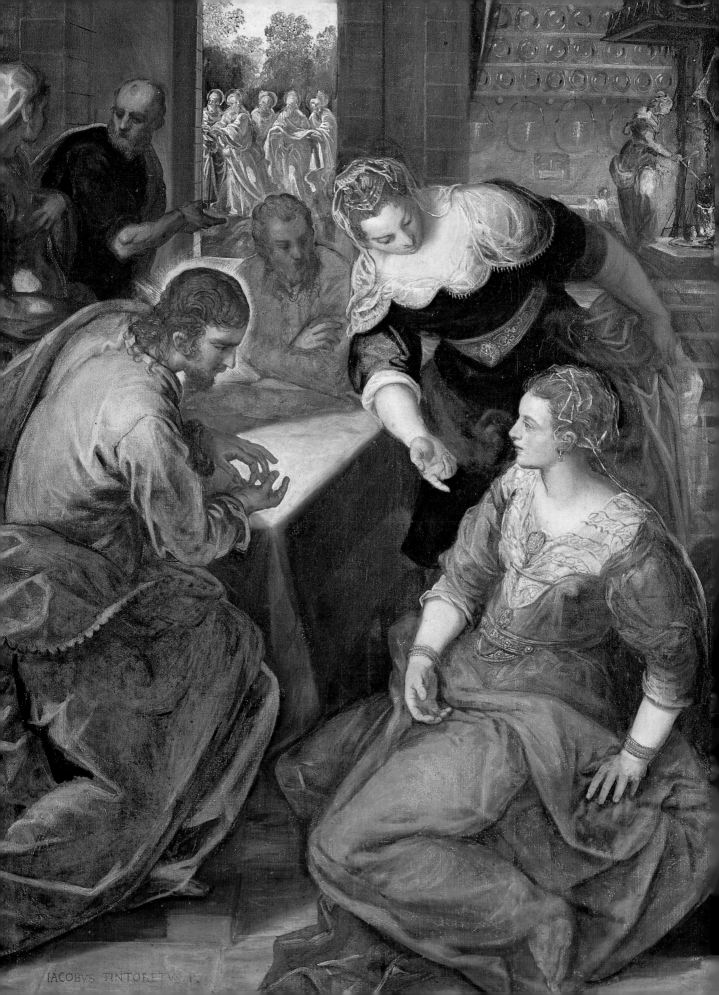

IACOBVS TINTORETVS F.

Mary hath chosen

luke 10:38–42

Christ in the House of Mary and Martha
Jacopo Robusti Tintoretto, 16th century

Tintoretto (1518–1594) was a student of Titian. Unfortunately his apprenticeship ended abruptly due to some jealousy between the two, resulting in an animosity that continued through-out both artists' careers. Hugely energetic and productive, he was not called Robusti for noth-ing! His outpouring of work was produced solely for Venice and the Venetian State.

In this masterpiece his proclivity for dramatic modeling of light and dark is apparent. He idealized the drawings of Michelangelo as well as the coloring of Titian. He was composi-tionally attracted to the diagonal, which emphasized the dynamism of his compositions. He worked by daylight and torchlight, master-ing the theatrical play of illumination. These tendencies enhance the sibling tension when a disgruntled Martha overwhelmed with house-work complains to Jesus about her sister Mary's penchant for learning at the feet of the Savior. Jesus responds by supporting Mary's choice: "Mary has chosen the good part, which shall not be taken away from her." If you knew noth-ing of this episode in the Gospel of Luke, the meaning is clearly expressed in the composition, with Martha inserting herself between Teacher and disciple and briefly disrupting the balance.

Now it came to pass, as they went, that he entered into a certain village: and a certain woman named Martha received him into her house.

And she had a sister called Mary, which also sat at Jesus' feet, and heard his word.

But Martha was cumbered about much serving, and came to him, and said, Lord, dost thou not care that my sister hath left me to serve alone? bid her therefore that she help me.

And Jesus answered and said unto her, Martha, Martha, thou art careful and troubled about many things:

But one thing is needful: and Mary hath chosen that good part, which shall not be taken away from her. ✺

that good part

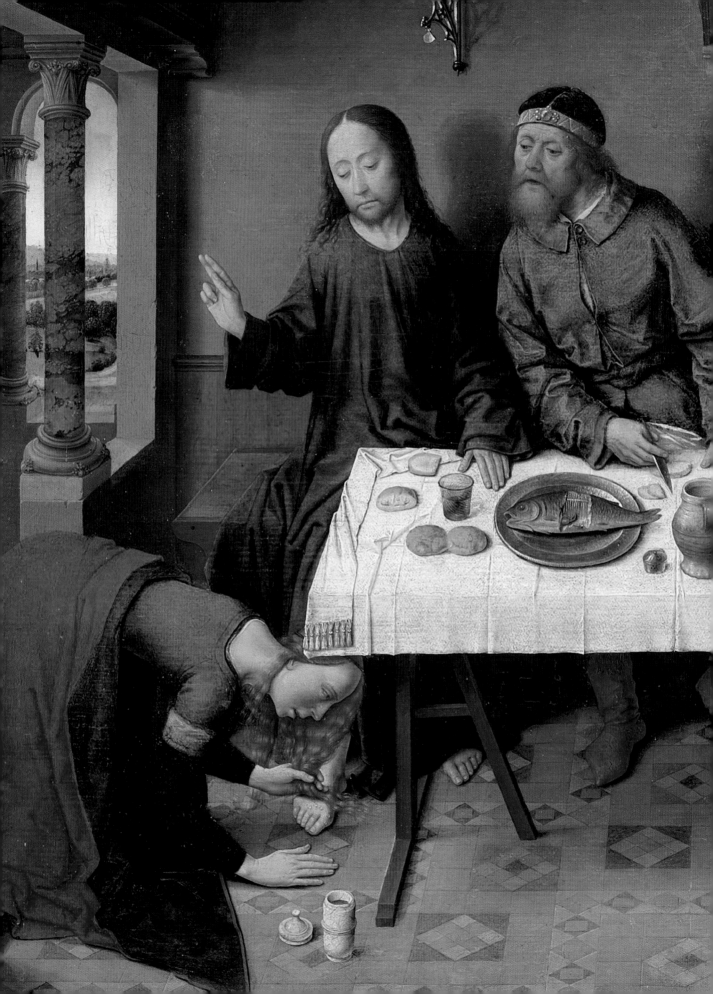

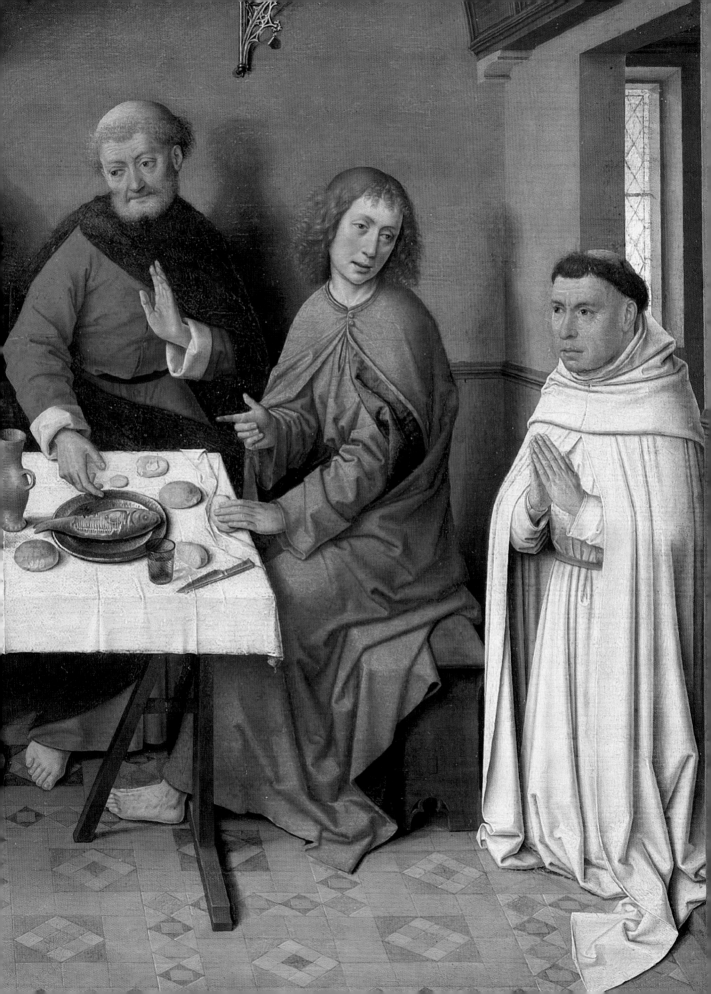

Thy sins are forgiven

luke 7:36–50

And one of the Pharisees desired him that he would eat with him. And he went into the Pharisee's house, and sat down to meat.

And, behold, a woman in the city, which was a sinner, when she knew that Jesus sat at meat in the Pharisee's house, brought an alabaster box of ointment,

And stood at his feet behind him weeping, and began to wash his feet with tears, and did wipe them with the hairs of her head, and kissed his feet, and anointed them with ointment.

Now when the Pharisee which had bidden him saw it, he spake within himself, saying, This man, if he were a prophet, would have known who and what manner of woman this is that touchest him: for she is a sinner.

And Jesus answering said unto him, Simon, I have somewhat to say unto thee. And he saith, Master, say on.

There was a certain creditor which had two debtors: the one owed five hundred pence, and the other fifty.

And when they had nothing to pay, he frankly forgave them both. Tell me therefore, which of them will love him the most?

Simon answered and said, I suppose that he, to whom he forgave the most. And he said unto him, Thou hast rightly judged.

Christ in the House of the Pharisee (detail, see previous spread), Dieric Bouts the Elder, 1460

And he turned to the woman, and said unto Simon, Seest thou this woman? I entered into thine house, thou gavest me no water for my feet: but she hath washed my feet with tears, and wiped them with the hairs of her head.

Thou gavest me no kiss: but this woman since the time I came in hath not ceased to kiss my feet.

My head with oil thou didst not anoint: but this woman hath anointed my feet with ointment.

Wherefore I say unto thee, Her sins, which are many, are forgiven; for she loved much: but to whom little is forgiven, the same loveth little.

And he said unto her, Thy sins are forgiven,

And they that sat at meat with him began to say within themselves, Who is this that forgiveth sins also?

And he said to the woman, Thy faith hath saved thee; go in peace. ✎

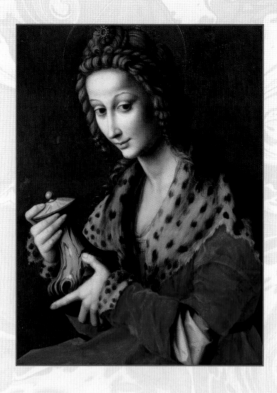

Saint Mary Magdalene, Bacchiacca, 16th century

Bacchiacca (1494–1557) was a Florentine artist who studied under Perugino and was a great friend of Andrea del Sarto. His eclectic decorative style borrowed heavily from Albrecht Durer as well as many Italian Mannerists like Jacopo Pontormo, among others. He painted a number of beautiful portraits of Florentine women in rich fabrics and later designed tapestries and decorated interiors for the wealthy and well-to-do. His work exhibits a gift for representing intricate textiles as here in his painting Saint Mary Magdalene.

The lady cast as Mary Magdalene in Bacchiacca's striking portrait is a woman of means, a fact revealed by her handsomely braided hair and exquisite gown of sumptuous red fabric. In the late Middle Ages it was forbidden for the peasantry and even some of the merchant class to don dresses made of certain expensive materials and skins. It was a rigid fashion caste system that was strictly followed and at the cusp of the 1500s was still respected. Another sign of her wealth and stature is the elegant alabaster container she holds. This vessel contains the ointment with which she will

anoint Jesus and is one of the iconic symbols by which we know how to identify the Magdalene. We understand from the Gospels that the women who traveled with Jesus were women of material substance who financially supported his mission—a portrayal that is consistent with the Bacchiacca's portrait of a well-heeled Magdalene.

Although the woman in Matthew is not formally identified as Mary Magdalene, she has become traditionally associated with her. In this selection from the Gospel she is using very costly ointment (spikenard) to anoint Jesus. This is a ceremonial act of purification, a kind of christ-ening in advance of his burial. We see Jesus respond to the entreaties and contempt of some of his followers as he offers that "she hath wrought a good work upon me." He expands upon this by adding "Wheresoever this gospel shall be preached in the whole world, there shall also this, that this woman hath done, be told as a memorial to her." It is a statement full of respect, admiration and authority, offered with a strength that reverberates down the centuries.

Why trouble ye the woman?

matthew 26:6–13

Now when Jesus was in Bethany, in the house of Simon the leper,

There came unto him a woman having an alabaster box of very precious ointment, and poured it on his head, as he sat at meat.

But when his disciples saw it, they had indignation, saying, To what purpose is this waste?

For this ointment might have been sold for much, and given to the poor.

When Jesus understood it, he said unto them, Why trouble ye the woman? for she hath wrought a good work upon me.

For ye have the poor always with you; but me ye have not always.

For in that she hath poured this ointment on my body, she did it for my burial.

Verily I say unto you, Wheresoever this gospel shall be preached in the whole world, there shall also this, that this woman hath done, be told for a memorial of her. ≈

she hath wrought a good work on me

mark 14:1–9

After two days was the feast of the passover, and of unleavened bread: and the chief priests and the scribes sought how they might take him by craft, and put him to death.

But they said, Not on the feast day, lest there be an uproar of the people.

And being in Bethany in the house of Simon the leper, as he sat at meat, there came a woman having an alabaster box of ointment of spikenard very precious; and she brake the box, and poured it on his head.

And there were some that had indignation within themselves, and said, Why was this waste of the ointment made?

For it might have been sold for more than three hundred pence, and have been given to the poor. And they murmured against her.

And Jesus said, Let her alone; why trouble ye her? she hath wrought a good work on me.

For ye have the poor with you always, and whensoever ye will ye may do them good: but me ye have not always.

She hath done what she could: she is come aforehand to anoint my body to the burying.

Verily I say unto you, Wheresoever this gospel shall be preached throughout the whole world, this also that she hath done shall be spoken of for a memorial of her. ✎

St. Mary Magdalen, Domenico Puligo, c.1515

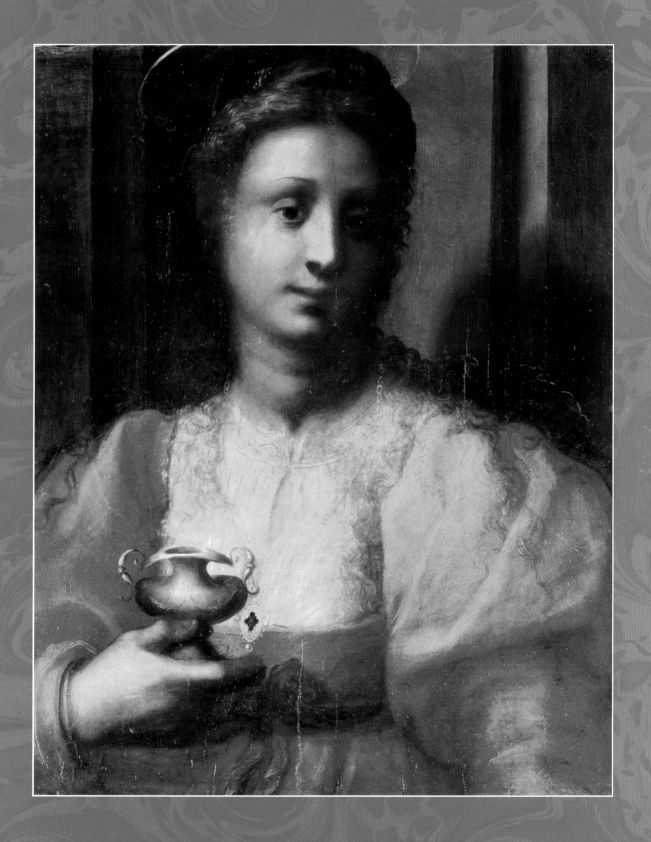

Mary Magdalen at the House of the Pharisee, Jean Beraud, 1891

French artist Jean Beraud (1849–1935) was known best for his paintings of everyday life in Paris during *La Belle Époque*. Along with Gustave Caillebotte, among others, he studied with Leon Bonnat and was also influenced by Degas and Manet, whom he greatly admired. His canvases, however, were not truly impressionistic, and they retained a naturalism that was appreciated at the conservative annual Parisian Salon.

Surprisingly, in the 1890s he began to paint religious themes from the New Testament. In Mary Magdalen in the House of the Pharisee he has rendered Mary of Bethany in Victorian fashions at the feet of Jesus in what appears to be a French café. The Pharisees in attendance correspond to contemporaries of Beraud—one, the famous writer Ernst Renan, is cast in the role of Simon. Only Jesus is dressed in the robes appropriate to the gospels of John and Mark. The painting caused a scandal in its day. The Galilean, in shaming of the Pharisees along with his compassion for Mary, inspired an even greater slander, one that contributed to his crucifixion.

john 12:1–8

Then Jesus six days before the passover came to Bethany, where Lazarus was which had been dead, whom he raised from the dead.

There they made him supper; and Martha served; but Lazarus was one of them that sat at the table with him.

Then took Mary a pound of ointment of spikenard, very costly, and anointed the feet of Jesus, and wiped his feet with her hair: and the house was filled with the odour of the ointment.

Then saith one of the disciples, Judas Iscariot, Simon's son, which should betray him,

Why was not this ointment sold for three hundred pence, and given to the poor?

This he said, not because he cared for the poor, but because he was a thief, and had the bag and bare what was put therein.

Then said Jesus, Let her alone: against the day of my burying hath she kept this.

For the poor always ye have with you; but me ye have not always. ✍

Then said Jesus, Let her alone

He that is without sin among you

john 8:1–11

Jesus went unto the mount of Olives.

And early in the morning he came again into the temple, and all the people came unto him; and he sat down, and taught them.

And the scribes and Pharisees brought unto him a woman taken in adultery; and when they had set her in the midst,

They say unto him, Master, this woman was taken in adultery, in the very act.

Now Moses in the law commanded us, that such should be stoned: but what sayest thou?

This they said, tempting him, that they might have to accuse him. But Jesus stooped down, and with his finger wrote on the ground, as though he heard them not.

So when they continued asking him, he lifted up himself, and said unto them, He that is without sin among you, let him first cast a stone at her.

And again he stooped down, and wrote on the ground.

And they which heard it, being convicted by their own conscience, went out one by one, beginning at the eldest, even unto the last: and Jesus was left alone, and the woman standing in the midst.

When Jesus had lifted up himself, and saw none but the women, he said unto her, Woman, where are those thine accusers? hath no man condemned thee?

She said, No man, Lord. And Jesus said unto her, Neither do I condemn thee: go, and sin no more.

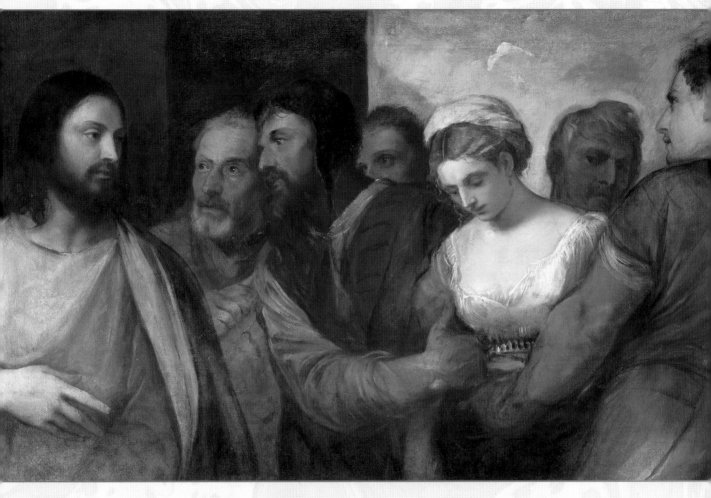

Christ and the Adulteress, Titian, 1515

The unidentified woman in this painting Christ and the Adulteress by Titian (1485–1576) could well be taken for the Magdalene—she wears her signature chestnut hair pulled back and is elegantly clad as a lady of substance. It was in 591 when Pope Gregory associated Mary Magdalene for the first time with "forbidden acts" and "vice" in his Homily XXXIII. Cast in this degrading role, she became the model for the woman sinner in the minds of artists and writers for centuries to come. And while Titian's adulteress may not be the Magdalene herself, she certainly came to be associated with her.

It is only in the last few decades that an alternate characterization of Mary Magdalene has come to light due to the translations of The Gospel of Mary and works from the Nag Hammadi Library, as well as such recent important scholarship as Elaine Pagel's The Gnostic Gospels. These texts defy the Magdalene's earlier debasement and portray her as the beloved disciple and companion of the Galilean.

let him first cast a stone at her

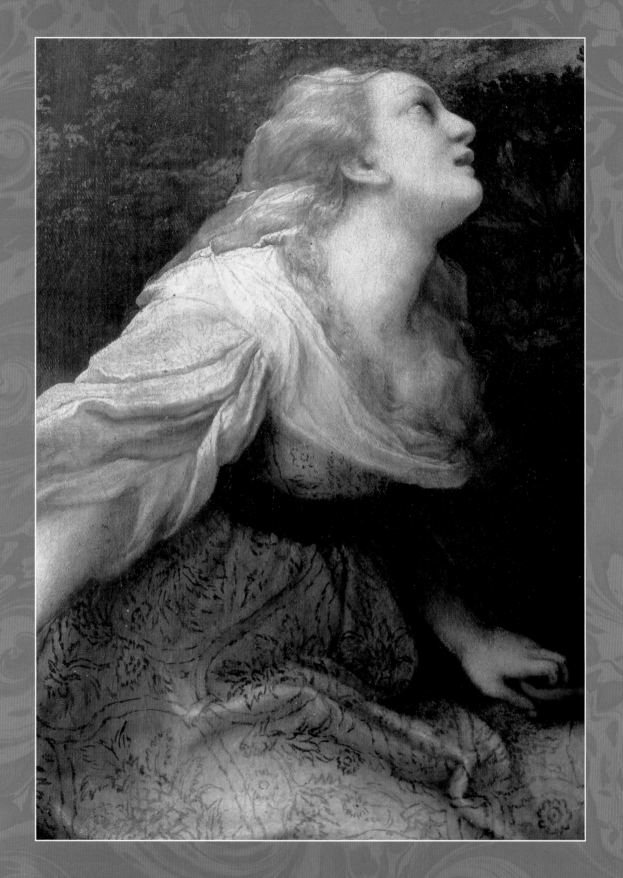

CHAPTER THREE

Mary of the Apocrypha

Do you not know that you are the temple of God, and that the Spirit of God dwells in you?

—1 Corinthians 3:16

O F THE NUMEROUS ancient Christian works—manuscripts, codices, and gospels—that were discovered in Upper Egypt from the late 1800s through the 1940s, many contain references to the Magdalene. Although these finds have not been accepted as canon, they are of tremendous importance in the study of early Christianity. It is critical to include them in our journey of discovery as they reveal a Mary Magdalene as she was seen in the very first days at the birth of what is now called Christianity. This section is a marvelous tapestry of early Christianity made vibrant by its variety of voices and content.

At the heart of *Searching for Mary Magdalene* is the *Gospel of Mary*—

Noli Me Tangere (detail), Correggio, c.1534

attributed to Mary Magdalene herself. It was purchased in Cairo in 1896 from a manuscript dealer and brought to Berlin by the German Scholar Dr. Carl Reinhardt. After many years of attempts and interruptions (World War II), what remains of the gospel was finally published in a German translation in 1955.

The additional excerpts and gospels in this chapter are from the Nag Hammadi Library. The Library is a collection of codices discovered in Upper Egypt in the year 1945 that had been hidden in the 4th century C.E. in earthen ware jars to protect them from destruction. They contain 52 scriptures translated from Greek into Coptic. These numerous texts are Gnostic works and reflect another approach to the early Christian religion. In the 1st, 2nd and 3rd centuries there were many expressions of the teachings of Jesus the Nazarene. Gnosticism flourished and functioned simultaneously with a wide variety of other early Christian sects. The Gnosticism with which we are most familiar is, in fact, an expression of esoteric

Jewish spirituality. As Stephan A. Hoeller reminds us in this excerpt from *The Inner West* by Jay Kinney, "[Gnosticism] was subsequently repressed by the self-declared orthodoxy that itself was originally but one of several variants within a diverse fold of the followers of the great Teacher of Nazareth."

The word *Gnosis* in Greek literally means "knowledge," but of a certain nature—insight or "knowledge of the heart," a complete comprehension that is known through intuitive as well as rational means. In Gnosticism the feminine aspect of Divinity plays a significant role and this lent weight and authority to the Magdalene. The key prerequisite for Gnosis is the recognition of a divine spark within, the immortal self, the "daemon." Gnostics of the 1st century C.E. often believed in a complex "Kosmos" in which each individual spark has been trapped, the aim being to liberate the spark. Valentinus (born around 100 C.E.), an astonishing Gnostic philosopher, claimed to have been taught by one of Jesus' Apostles and almost became Pope. Had he succeeded, these gospels would never have been considered heretical. Valentinian Gnosticism included a system of seven sacraments—baptism, anointing, the eucharist, "redemption," rites for the dying, and "the bridal chamber"—which is a possible reference to the female becoming male. This is directly related to the idea that we are divided and our purpose is to become whole again. But most importantly women enjoyed a crucial role in the seven sacraments as exemplified in Magdalene's relationship to the Galilean.

Also included at the end of this section is the *Gospel of Peter*, another work discovered in Upper Egypt in the late 1880s. Sadly, the entire manuscript was not preserved. The gospel is attributed to Peter and was read and disseminated by the Bishop of Antioch in and about the year 200 C.E. It is quite possible that it antedates the four canonical works. Philosophically the *Gospel of Peter* belongs with the canon. It exposes in high relief the difference in Peter's vision of Christianity from those that celebrate the Magdalene's role as beloved companion of Jesus and the "Gnostic" sensibility that emphasizes self-knowledge and direct knowing as referenced in the *Gospel of Mary* and the *Gospel of Thomas*.

Mary Magdalene, Pietro Perugino, c.1500

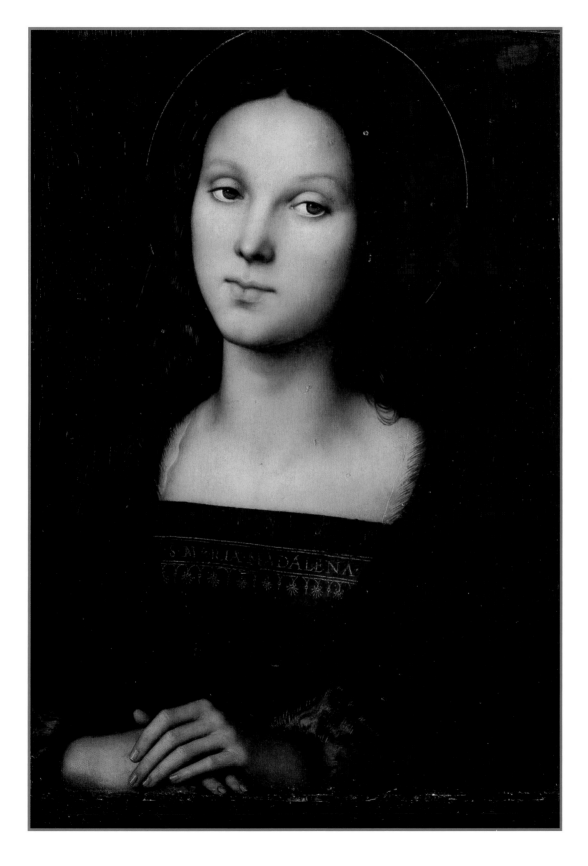

Whoever has ears to hear, let him hear

The Gospel of Thomas

Jesus said, "The Pharisees and scribes have taken the keys to knowledge and have hidden them. They have not entered, nor have they allowed those that want to enter to do so. As for you, be as clever as serpents and as innocent as doves."

—Saying 39, from the *Gospel of Thomas*

This first century text is a compilation of 114 sayings and parables attributed to Jesus. Some scholars believe that it predates the canonical gospels and may have been set down from oral tradition in and around 50 BC. It has been suggested that it might even be contemporaneous with the missing book "Q" thought to be an original source for the gospels of Matthew and Luke. Authorship is attributed to Didymos Judas Thomas, who was honored and revered in the early church in Syria, Asia Minor and Egypt and believed to be Jesus' twin brother. The names Thomas and Didymos both literally mean "twin." Scholars suggest that the form of Christianity embodied in this gospel is of a purer nature than that of later forms that have been colored by Pauline objectives.

"For every woman who makes herself male will enter the kingdom of heaven" are startling words of the Galilean. Gnostics hold that the potential for Gnosis is in every man and woman, and that the soul is androgynous—the indwelling spark is both male and female. Carl Jung, the great 20th-century psychiatrist, Gnostic scholar, and astrologer, believed that women have an inner spirit or Animus that is masculine and that men have an inner self that is feminine—the Anima. What Jesus suggests here is that without full integration of these inner aspects one cannot achieve salvation and ascend to the paradisiacal Fullness.

Mary said to Jesus, "What are your disciples like?"

He said, "They are like little children dwelling in a field that is not theirs. When the owners of the field come, they will say, 'Let us have our field back.' The disciples strip naked in front of the owners and give the field back to them.

"Therefore I say, if the owner of a house knows a thief is coming, he will stay awake and will not let the thief break into the house and carry away his goods.

"You must keep watch against the world. Arm yourselves with great power lest the robbers find a way to come upon you, because the difficulty you expect will materialize. Let there be a man of understanding among you.

"After the crop ripened, the owner came quickly with his sickle in his hand and reaped it. Whoever has ears to hear, let him hear."

Deploration (detail), Dieric Bouts the Elder, 15th century

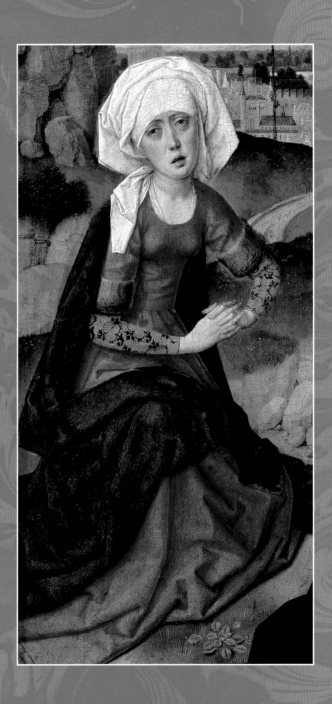

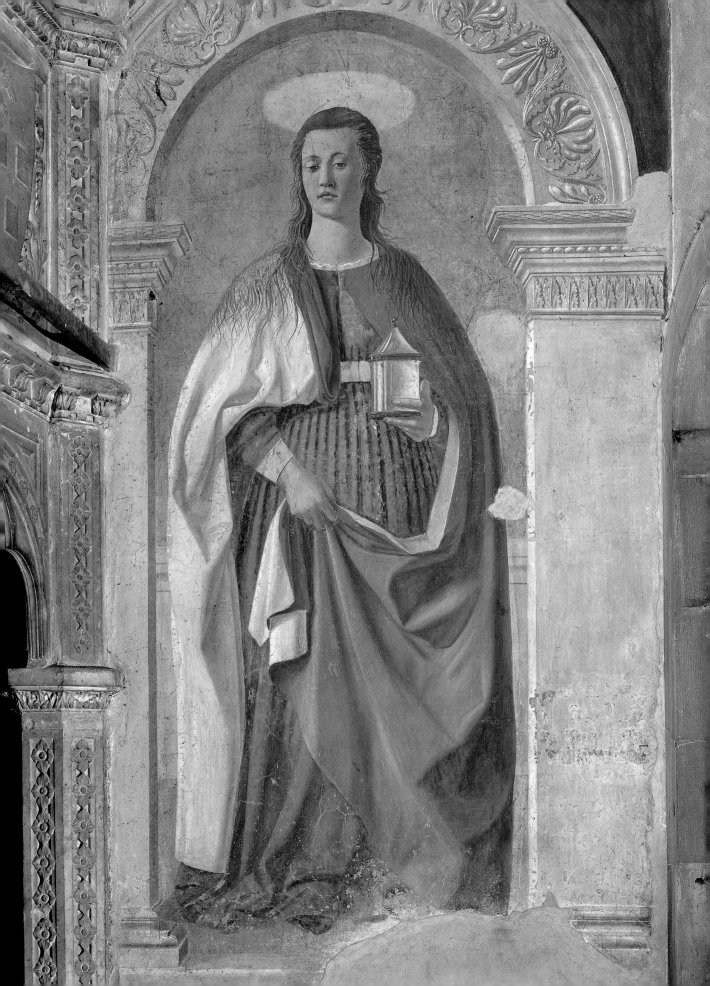

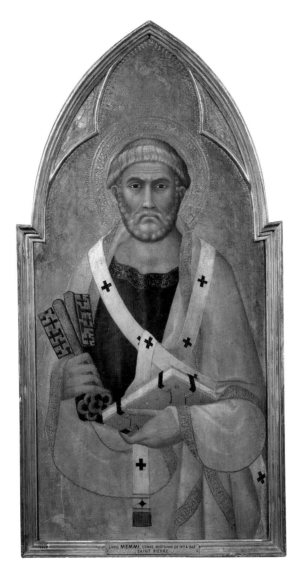

Saint Peter, Lippo Memmi, 14th century

Simon Peter said to them, "Let Mary leave us, because women are not worthy of life."

Jesus said, "Look, I shall lead her so that I can make her male in order that she also may become a living spirit resembling you males. For every woman who makes herself male will enter the kingdom of heaven." ✎

St. Mary Magdalen, Piero della Francesca, 15th century

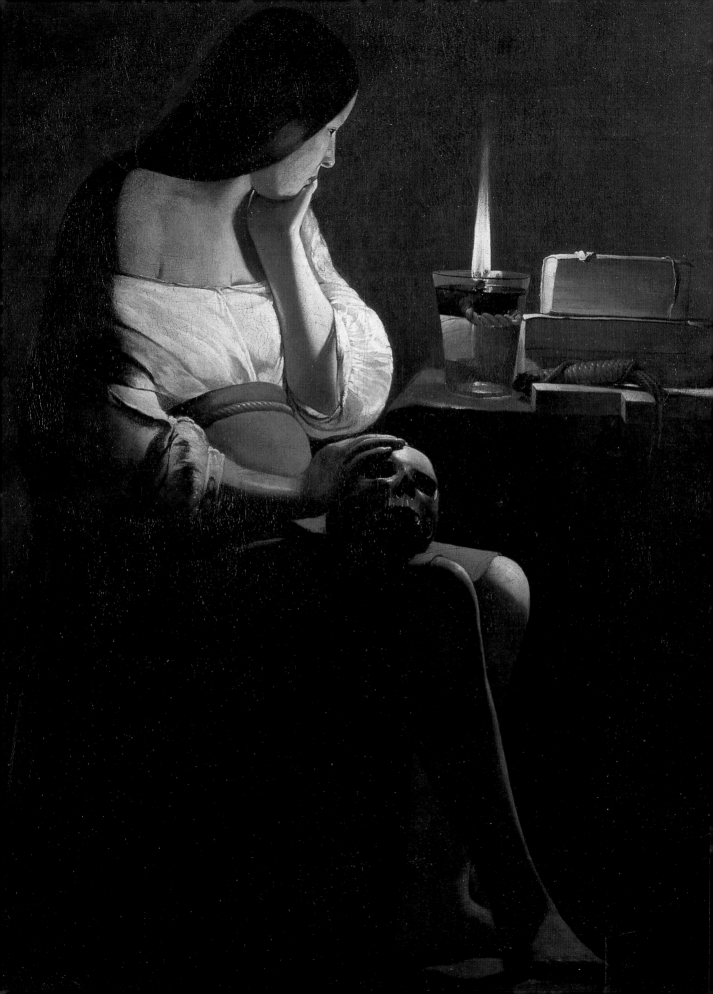

What is the sin of the world?

The Gospel of Mary

The Gospel of Mary, written in the second century, has been attributed to Mary Magdalene—a woman with intimate access to the sacred mysteries and esoteric teachings of the Galilean. Unfortunately, fewer than eight pages of the original text survived the centuries. This gospel, like the Gospel of Thomas and others, has Gnostic characteristics.

Although the Gospel of Mary makes clear references to a cosmological system, it is not as complex as other Gnostic works. To understand this gospel, one must first understand the Gnostic view of creation. The belief is that a transcendent God beyond the created universe brought forth the substance of all that is—the visible and invisible. In the process, portions of this original divine substance were propelled so far from the essential source that unhealthy changes ensued, a form of corruption occurred. This "corruption" can be identified with matter and the physical universe.

This cosmology also includes the existance of Aeons: intermediate deific spirits that exist between humans and the True God. Aeons and the True God comprise the Pleroma (The Fullness) where divinity emanates, and this Fullness is the goal of the spiritual journey.

This translation of the Gospel of Mary Magdalene by Jean-Yves Leloup perfectly expresses the flavor of the first and second centuries and the time when Jesus and Mary walked the shores of Galilee, without any hint of Constantine's Roman agenda.

... "What is matter?
Will it last forever?"
The teacher answered:
"All that is born, all that is created,
all the elements of nature
are interwoven and united with each other.
All that is composed shall be decomposed;
everything returns to its roots;
matter returns to the origins of matter.
Those who have ears, let them hear."
Peter said to him: "Since you have become the interpreter
of the elements and the events of the world, tell us:
What is the sin of the world?"
The Teacher answered:
"There is no sin.

The Penitent Magdalen, Georges de La Tour, c.1640

It is you that make sin exist,
when you act according to the habits
of your corrupted nature;
this is where sin lies.
This is why the Good has come into your
 midst.
It acts together with the elements of your
 nature
so as to reunite it with its roots."
Then he continued:
"This is why you become sick,
and why you die:
it is the result of your actions;
what you do takes you further away.
Those who have ears let, let them hear."

"Attachment to matter
gives rise to passion against nature."

Thus trouble arises in the whole body;
this is why I tell you:
'Be in harmony…'
If you are out of balance,
take inspiration from manifestations
of your true nature.
Those who have ears,
let them hear."
After saying this, the Blessed One
greeted them all, saying:
"Peace be with you—may my Peace
arise and be fulfilled within you!
Be vigilant, and allow no one to mislead you
by saying:
'Here it is!' or
'There it is!'
For it is within you
That the Son of Man dwells.

Magdalen and Two Flames, Georges de La Tour, c.1640

Magdalen and Two Flames, a painting by French artist Georges de La Tour (1593–1652) of a self-possessed, centered, and contemplative Magdalene, most eloquently evokes the woman I have discovered at the heart of the gospels—both canonical and apocryphal. De La Tour hailed from the Duchy of Lorraine—an area of eastern France made famous by another young woman of courage and spiritual authority—Joan of Arc. This profoundly beautiful image was painted in the 1630s just prior to France's golden age and the ascendancy of Le Roy Soleil, the Sun King, Louis XIV. It was a period in which Paris eclipsed Rome as the center of European culture, politically and artistically. It was Louis' taste and preference for cool classicism to the heat of the more emotional Italian Baroque that transformed French art and architecture.

De La Tour was fascinated with the Magdalene, painting her numerous times with transcendent attention to detail in a classical fashion that would have appealed to Louis XIV. Here we see the influence of Caravaggio's theatrical use of lighting. But de La Tour's work departs from Caravaggio's in that the source of illumination is within the scope of the canvas. The simplified, sculptural forms of the Magdalene are shown in high relief in the intensified light of the candle and its reflection. We see the long deep copper hair that dried the feet of her Rabboni; we see the golden mirror—a symbol of vanity also valued for its reflection and as a touchstone to meditation; and we see the dimly lit skull upon which Mary's hands gently rest. It is a painting imbued with symbolic meaning.

Sister, we know that the Teacher

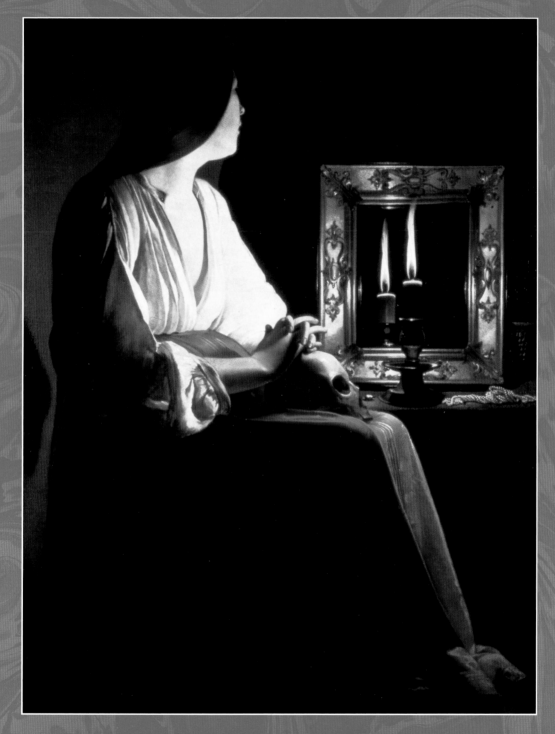

loved you differently from other women

The Repentant Magdalen, Georges de La Tour, c.1640

The skull is traditionally emblematic of the hermit, and we know from The Golden Legend that Mary ended her life as a recluse in a cave in southern France. Here it may also represent the skull of Adam, which the Jews in biblical times believed was buried at a place called Golgatha (an Aramaic word meaning "skull") in Palestine. Calvary and Golgatha—the two names of the place of Jesus' crucifixion—can both be translated to mean "Place of the Skull." (This is why the skull and crossbones are depicted in so many paintings of the crucifixion.) From these associations we may infer that the skull resting comfortably on Mary's knee may be a symbol of both mortality and her direct descent from Adam through her relationship to the Galilean.

Go to him,

for those who seek him, find him.

Walk forth,

and announce the gospel of the Kingdom."

Peter said to Mary:

"Sister, we know that the Teacher loved
 you

differently from other women.

Tell us whatever you remember

of any words he told you

which we have not yet heard."

Mary said to them:

"I will now speak to you

of that which has not been given to you to
 hear.

I had a vision of the Teacher,

and I said to him:

'Lord I see you now

in this vision.'

And he answered:

'You are blessed, for the sight of me does
 not disturb you.

There where is the nous, lies the treasure.'

Then I said to him:

'Lord, when someone meets you

in a Moment of vision,

is it through the soul [psyche] that they see,

or is it through the Spirit [Pneuma]?'

The Teacher answered:

'It is neither through the soul or the spirit,

but the nous between the two

which sees the vision, and it is this which
 [...]'"

"And Craving said:

'I did not see you descend,

but now I see you rising,

Why do you lie, since you belong to me?'

The soul answered:

'I saw you,

though you did not see me,

nor recognize me.

I was with you as with a garment,

and you never felt me.'

Having said this,

the soul left, rejoicing greatly.

Then it entered the third climate,

known as Ignorance.

Ignorance inquired of the soul:

'Where are you going?

You are dominated by wicked inclinations.

Indeed you lack discrimination, and you
 are enslaved.'

The soul answered:

'Why do you judge me, since I have made
 no judgment?

I have been dominated, but I myself have
 not dominated.

I have not been recognized,

but I myself have recognized

that all things which are composed shall be
 decomposed,

on earth and in heaven.'"

"Freed from this third climate, the soul
 continued its ascent,

and found itself in the fourth climate.

This has seven manifestations:

the first manifestation is Darkness;

the second, Craving;

the third Ignorance;

the fourth, Lethal Jealousy;

the fifth, Enslavement to the Body;

the sixth, Intoxicated Wisdom;

the seventh, Guileful Wisdom.

These are the seven manifestations of Wrath,

And they oppressed the soul with questions:

'Where do you come from, murderer?'

and 'Where are you going, vagabond?'

The soul answered:

'That which oppressed me has been slain;

that which encircled me has vanished;

my craving has faded,

and I am freed from my ignorance.'"

"'I left the world with the aid of another
 world;

a design was erased,

by virtue of a higher design.

Henceforth I travel toward Repose,

where time rests in the Eternity of Time;

I go now into Silence.'"

Having said all this, Mary became silent,

for it was in silence that the Teacher spoke
 to her.

Then Andrew began to speak, and said to
 his brothers:

"Tell me, what do you think of these things
 she has been telling us?

As for me, I do not believe

that the Teacher would speak like this.

These ideas are too different from those we
 have known."

And Peter added:

"How is it possible that the Teacher talked

in this manner with a woman

about the secrets of which we ourselves are
 ignorant?

Must we change our customs,

and listen to this woman?

Did he really choose her, and prefer her to
 us?"

Then Mary wept,

and answered him:

"My brother Peter, what can you be
 thinking?

Do you believe that this is just my own
 imagination,

that I invented this vision?

Or do you believe that I would lie about our
 Teacher?"

At this Levi spoke up:

"Peter, you have always been hot-tempered,

and now we see you repudiating a woman,

just as our adversaries do.

Yet if the Teacher held her worthy,

who are you to reject her?

Surely the Teacher knew her very well,

For he loved her more than us.

Therefore let us atone,

and become fully human [Anthropos],

so that the Teacher can take root in us.

Let us grow as he demanded for us,

and walk forth and spread the gospel,

without trying to lay down any rules
 and laws

other than those he witnessed."

When Levi had said these words,

they all went forth to spread the gospel.

THE GOSPEL ACCORDING TO MARY ✍

Magdalen and Two Flames (detail), Georges de La Tour, c.1640

The candle and its reflection are symbols of spiritual illumination. There were many pockets of Kabbalistic teaching (Jewish mysticism) in France from the Middle Ages that continued to grow in influence into the 17th century. These doctrines offered insight into the divine nature—the secret knowledge of God, the spheres of creation, and the very laws of Light. There is an undeniable relationship to Gnosticism in these esoteric teachings. As *Ean Begg* so wisely poses in The Cult of the Black Virgin, "Mary (Magdalene) may stand for something else which we have not yet considered and that is heretical Judaism. It is here that the origins of Gnosticism as a historical phenomenon are to be found, and it is here that Jew and Christian are at one." Is the candle merely an artistic devise used by de La Tour to dramatize his subject or does it reveal a deeper message about the Magdalene's inner visions and practices? Perhaps the two flames hold dual meanings.

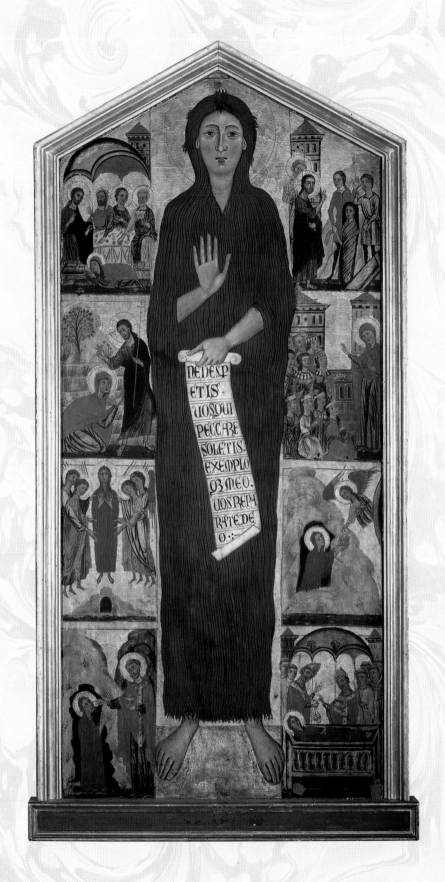

NE DESP
ET IS
UOS QUI
PECCARE
SOLETIS.
EXEMPLO
OЗ МЕО.
UOS REPA
RATE. DE
O

you are one whose heart is set on heaven's kingdom

Pistis Sophia

Pistis Sophia (Faith Wisdom) is a rather dense succession of Gnostic meditations discovered in 1945 that represent the female manifestation of the Divine. In Gnostic tradition this female power of light, Sophia, who through a form of separation from the True God, emanated the Demiurge (the less than perfect creator of the physical world). Her repentance and reunion are visited in the complete work—which was most likely composed in the late 3rd or 4th century. The document clearly shows the influence of Valentinian teachings. Also in these excerpts you will find examples of Peter's impatience with Mary, who is often praised by Jesus. The Pistis Sophia reveals the exalted position held by Mary Magdalene in the eyes of the Galilean.

The Valentinians taught that there was one original and unknowable God and pairs of lesser beings or Aeons that constituted the "Fullness" or "Pleroma" of the "All." Sophia was one of the lesser pairs responsible for instilling the pneumatic spark into the physical realm.

In this excerpt from Pistis Sophia, *the Magdalene wisely interprets passages from Isaiah to the delight of the Galilean.*

When Jesus had said these things to his disciples, he told them, "Whoever has ears to hear should hear."

Now it happened, when Mary heard these words as the savior was speaking, she gazed into the air for an hour and said, "My master, command me to speak openly."

The compassionate Jesus answered and said to Mary, "Blessed Mary, you whom I shall complete with all the mysteries on high, speak openly, for you are one whose heart is set on heaven's kingdom more than all your brothers."

The Magdalene, Maestro della Maddalena, 13th century

Then Mary said to the savior, "My master, when you said to us, 'Whoever has ears to hear should hear,' you said this so that we might understand what you have spoken. So listen, my master, and I shall speak openly. This is what you said: 'I have taken a third of the power of the rulers of all the realms, and I have turned their fate and the sphere they rule, so that when members of the human race invoke them in their mysteries, which the disobedient angels taught them to complete their evil and lawless deeds with the mystery of their magic, they may not be able to complete their lawless deeds from now on.' You have taken their power from them and from their astrologers and fortune-tellers and soothsayers, and from now on they will not understand or explain anything that happens. For you have turned their sphere, and you have made them spend six months oriented to the left to exert their influence, and six months oriented to the right to exert their influence.

"My master, the power within the prophet Isaiah has spoken concerning this saying and has explained it once in a spiritual parable, speaking about the vision of Egypt: Where, Egypt, where are your fortune-tellers and astrologers and moaners and groaners? Let them tell you now what the Lord Sabaoth will do.

"Before you came, the power within the prophet Isaiah prophesied about you, that you would take away the power of the rulers of the realms and turn their sphere and their fate, so that from now on they would know nothing. Concerning this it has also been said, You will not know what the Lord Sabaoth will do. That is to say, none of the rulers will know what you will do from now on. The rulers signify Egypt, for

The Prophet Isaiah, Marc Chagall, 1968

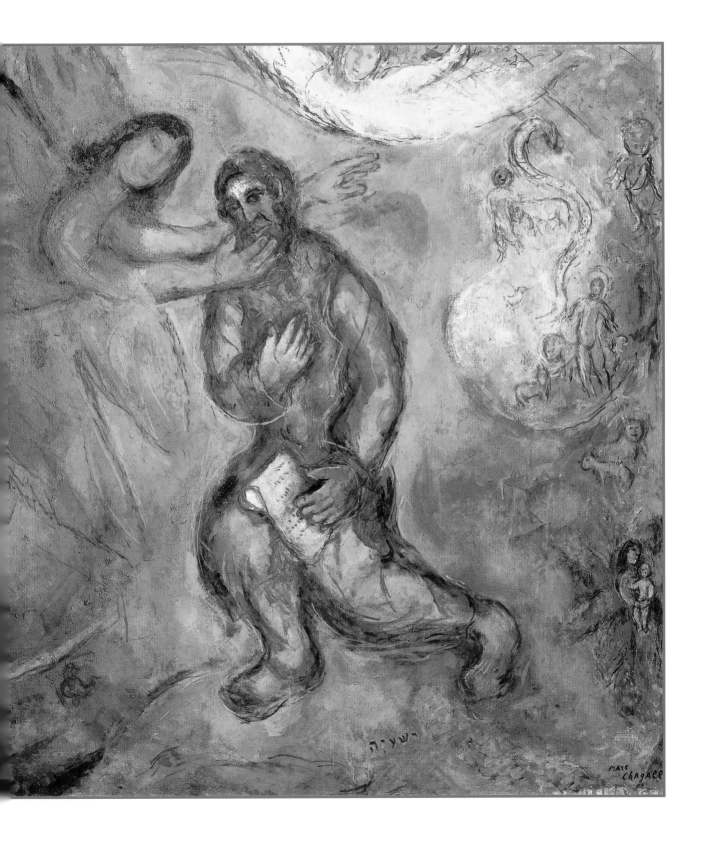

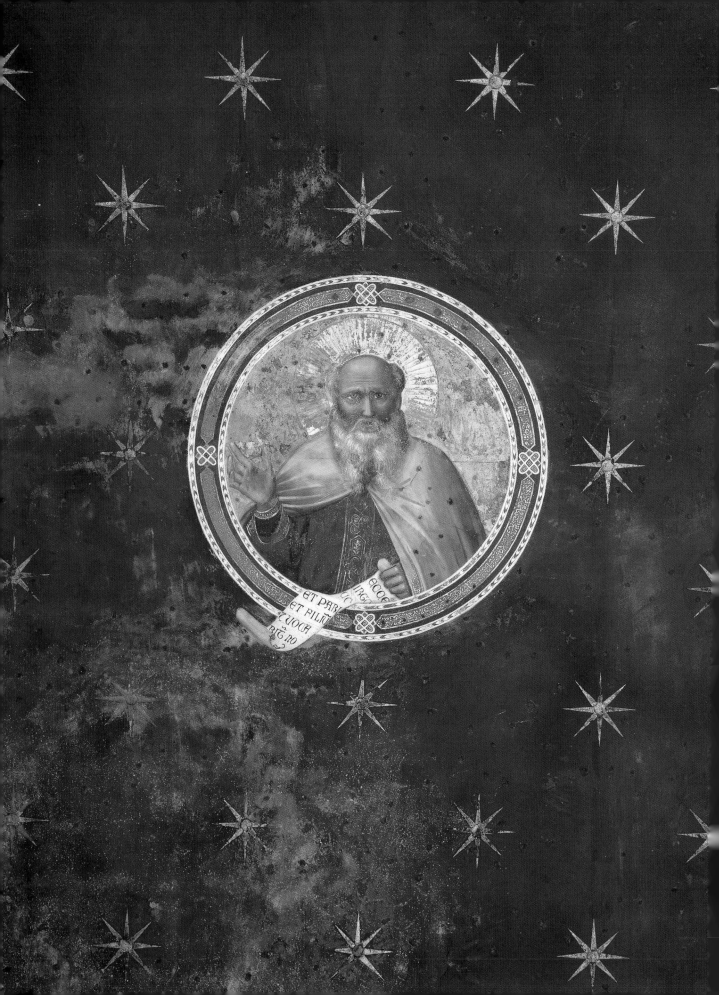

You are more blessed

they are matter. The power within Isaiah once prophesied about you and said, You will not know from now on what the Lord Sabaoth will do. Concerning the power of light that you have taken from good Sabaoth, who is on the right, and today is in your material body, concerning this, my master Jesus, you have said to us, 'Whoever has ears to hear should hear,' so that you may know whose heart is directed toward heaven's kingdom."

When Mary finished saying these things, Jesus said, "Well done, Mary. You are more blessed than all women on earth, because you will be the fullness of fullness and the completion of completions."

The Prophet Isaiah, Giotto, 1306

Isaiah—whose name literally means "Salvation is the Lord"—is believed to be the author of the Old Testament Book of Isaiah. His visionary and prophetic ministry was focused mainly on Judah and Jerusalem, and he was a man of uncompromising authority and courage. Isaiah prophesied numerous times about the coming of a Messiah, a descendent of Jesse, who would be preceded by a messenger (John the Baptist) and then be rejected and suffer. In Isaiah we can see the profound threads that inspire the gospels of the 1st and 2nd centuries.

Isaiah was a beloved subject of Renaissance artists. In this handsome fresco from the Scrovegi Chapel, Giotto di Bondone (1270–1337) executed this detail from his most important work done in Padua. Isaiah is placed in a celestial vault surrounded by stars—he is a very sun amid the heavens.

than all women on earth

When Jesus finished saying these things to his disciples, he asked, "Do you understand how I am speaking with you?"

Peter stepped forward and said to Jesus, "My master, we cannot endure this woman who gets in our way and does not let any of us speak, though she talks all the time."

Jesus answered and said to his disciples, "Let anyone in whom the power of the spirit arisen, so that the person understands what I say, come forward and speak. Peter, I perceive that your power within you understands the interpretation of the mystery of repentance that Pistis Sophia mentioned. So now, Peter, discuss among your brothers the thought of her repentance."

When the first mystery finished saying these things to the disciples, Mary came forward and said, "My master, I understand in my mind that I can come forward at any time to interpret what Pistis Sophia has said, but I am afraid of Peter, because he threatens me and hates our gender."

When she said this, the first mystery replied to her, "Any of those filled with the spirit of light will come forward to interpret what I say: no one will be able to oppose them."

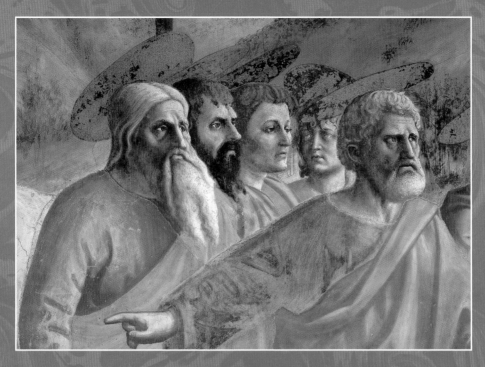

The Tribute Money (detail), Masaccio, 15th century

Italian master Masaccio (1401–1428) was nicknamed "Hulking Tom" or "Sloppy Tom" because, according to Vasari, he had no time for worldly matters such as wardrobe. In his brief twenty-seven years of life, he became a monumentally accomplished artist. In Helen Gardner's words from Art Through the Ages, "No other painter in history is known to have contributed so much to the development of a new style in so short a time as Masaccio." Overnight he directed painting away from the decorative sumptuous surfaces of the International Style to the monumental, dramatic forms of the Renaissance. He brilliantly incorporated the use of perspective as well as illumination from a specific source—rendering his subjects in full three dimensions. His work inspired not only Piero della Francesca but Leonardo da Vinci and Michelangelo, among others.

In this detail from a fresco in the Brancacci Chapel of Maria del Carmine we can observe a frowning Simon Peter at the right. What we know of Simon Peter is that he was a fisherman from Galilee, a Jew, and that the Nazarene nicknamed "Peter" meaning "the rock" or "rock like"—a moniker that suggests "tough,"

"solid," "stubborn," etc. Eusebius, the 4th century Christian historian, describes Peter as a man with wrinkled features, short beard and curly hair. From the gospels we know that armed he violently intervened in the Garden of Gethsemane when the soldiers came to take Jesus into custody and that he cut off the ear of an enemy of the Galilean.

Morphologically, Masaccio has drawn Peter as a peasant type, his features lack refinement or subtlety. He appears solid, if not beefy, and more like a pugilist than a philosopher or a thinker. His face suggests a man most likely to accept Jesus' teachings at face value—a literalist. This depiction also reveals a man capable of agitation and anger. Masaccio has created a psychological profile of Peter advancing art from Giotto's archetypes to a modern idea of portraiture. Masaccio's Peter is consistent with the Peter from our excerpt—a man who seems quite jealous of Mary Magdalene's intellect and understanding of the subtleties of Jesus' teachings. Here we can even imagine him to be a bully.

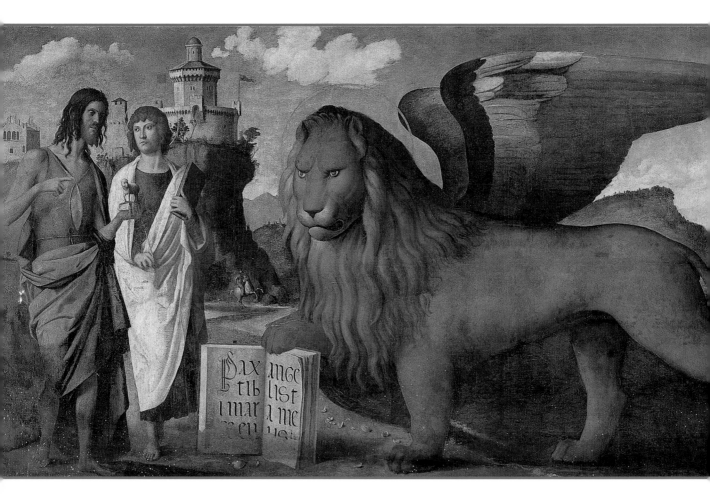

When Jesus finished saying these things, Mary
Magdalene stepped forward and said, "My master, my
enlightened person has ears, and I accept all the words
you speak. Now, my master, this is what you said: 'All
souls of the human race who will receive the mysteries of
the light will be first in the inheritance of the light,
before all the rulers who have repented, before the entire
place on the right, before the entire place of the treasury
of light.' Concerning this saying, my master, you once said
to us, 'The first will be last and the last will be first.' That
is to say, the last is the whole human race that will be first

Well done, Mary,

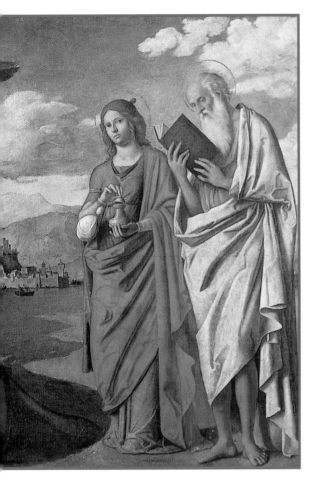

Lion of Saint Mark, Giovanni Buonconsiglio, 16th century

This painting by Venetian artist Giovanni Buonconsiglio of the late 15th and early 16th centuries draws on a number of compelling symbols of early Christianity. Here we see, from left to right: St. John the Baptist— who baptized Jesus and was thought to be the true Messiah by the Johannites; Mark the Evangelist— believed to be the chronicler of the earliest gospel narrative of the New Testament; the winged Lion—a representation of Mark, whose gospel begins in the wilderness where lions abound; Mary Magdalene— pictured holding the oil with which she anoints her "Rabboni" before his crucifixion; and St. Jerome—the hermit, scholar and translator of the Vulgate bible from the original Hebrew. The ensemble has deep roots in the Holy Land. Jerome established a monastery in Bethlehem, and Mark (who some scholars believe was the boy who followed Jesus into Gethsemane to flee before his arrest) preached in Alexandria and founded the first Christian church there.

within the kingdom of light, before the inhabitants of the places on high, which are first. For this reason, my master, you have said to us, 'Whoever has ears to hear should hear.' In other words, you wanted to know whether we have grasped all the sayings you spoke. My master, this is the word."

When Mary finished saying these things, the savior marveled greatly at the answers she gave, for she had become entirely pure spirit. Jesus answered and said to her, "Well done, Mary, pure spiritual woman. This is the interpretation of the word." ≈

pure spiritual woman

For "Mary" is the name of his sister, his mother, and companion

The Gospel of Philip

Light and darkness, life and death, right and left, are siblings of one another, and inseparable. For this reason the good are not good, the bad are not bad, life is not life, death is not death. Each will dissolve into its original nature, but what is superior to the world cannot be dissolved, for it is eternal.

—From the *Gospel of Philip*

The above quotation is just one of the meditations contained in the Gospel of Philip, which was written in the late 2nd century or conceivably a bit later. It is associated with Apostle Philip, a follower of John the Baptist and, later, Jesus. He hailed from Bethsaida along with brothers Andrew and Peter.

This anthology of sacramental and ethical statements shows the influence of Valentinus, the great mystic, teacher and author of the original version of the Gospel of Truth. Scholars say that his disciples were responsible for this collection of philosophical thoughts.

The Magdalene is mentioned briefly but significantly in this gospel. She is depicted as one of the three women who always walked with Jesus and she is specifically referred to as his "companion," from a Greek word meaning "partner" and "consort."

Three women always walked with the master: Mary his mother, [his] sister, and Mary Magdalene, who is called his companion. For "Mary" is the name of his sister, his mother, and his companion.

The Throne of Mercy, Colijn de Coter, 16th century

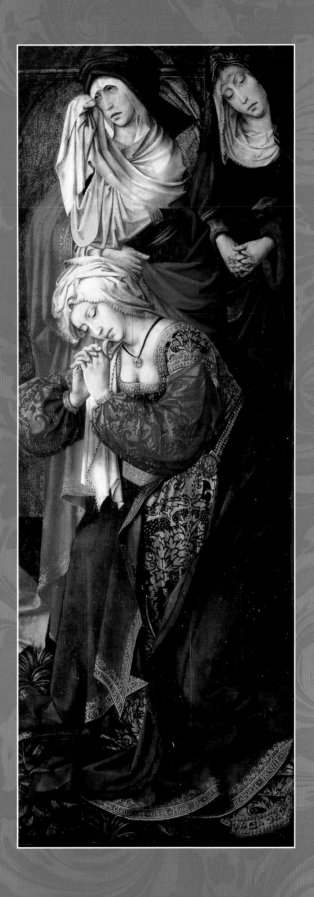

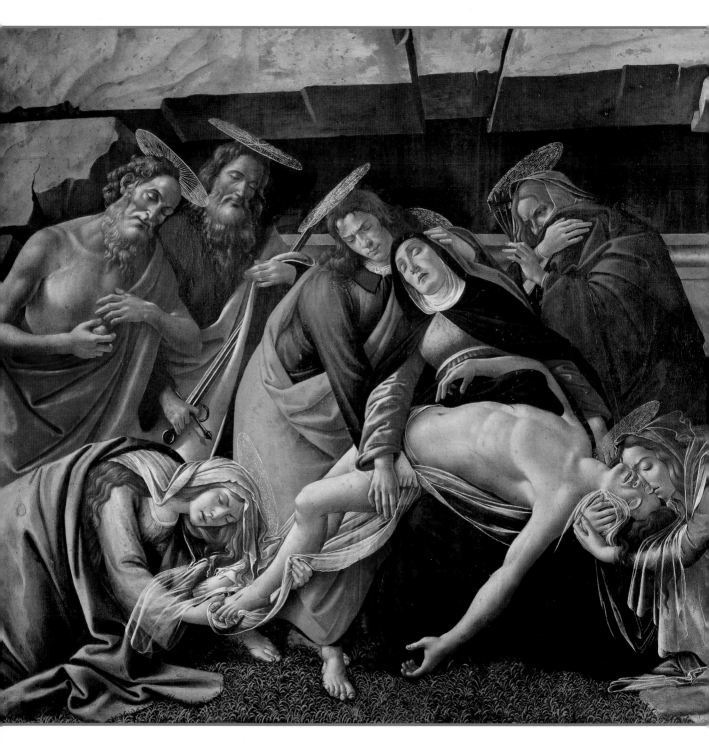

Why do you love her

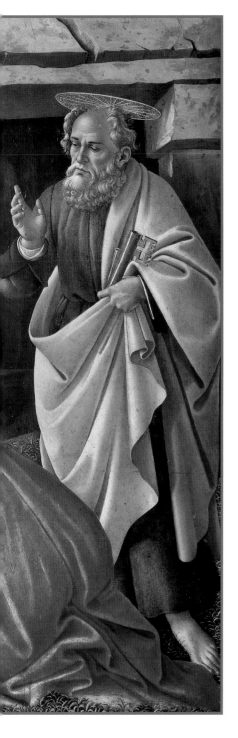

Wisdom, who is called barren, is the mother of the angels.

The companion of the [savior] is Mary Magdalene. The [savior loved] her more than [all] the disciples, [and he] kissed her often on her [mouth].

The other [disciples] . . . said to him, "Why do you love her more than all of us?"

The savior answered and said to them, "Why do I not love you like her? If a blind person and one who can see are both in darkness, they are the same. When the light comes, one whom can see will see the light, and the blind person will stay in darkness." ✑

Pietà, Sandro Botticelli, 16th century

more than all of us?

what is good will be taken up to the light

The Dialogue of the Savior

The Dialogue of the Savior *is a complex and dense intertestamental document that was set down in the latter half of the 2nd century (its source probably dates from the 1st century) and takes the form of a dialogue between Jesus and three of his disciples, Judas (the twin brother), Mariam (the Magdalene), and Matthew. In our excerpt Jesus is revealed as a teacher of divine wisdom challenging his students through an apocalyptic vision to find the source of revelation and salvation and make it their reality. Mary Magdalene, one of the chosen recipients of this significant message, shows herself as a woman who fully comprehends these profound teachings. "She spoke as a woman who knew the All."*

Mary and Other Disciples Have an Apocalyptic Vision

He [took] Judas, Matthew, and Mary [to show them the final] consummation of heaven and earth, and when he placed his [hand] on them, they hoped they might [see] it. Judas gazed up and saw a region of great height, and he saw the region of the abyss below.

Judas said to Matthew, "Brother, who can ascend to such a height or descend to the abyss below? For there is great fire there, and great terror."

At that moment a word issued from the height. As Judas was standing there, he saw how the word came [down].

He asked the word, "Why have you come down?"

The child of humanity greeted them and said to them, "A seed from a power was deficient, and it descended to the earth's abyss. The majesty remembered [it], and sent the [word to] it. The word brought the seed up into [the presence] of the majesty, so that the first word might not be lost."

[His] disciples marveled at everything he told them, and they accepted all of it in faith. And they understood that there is no need to keep wickedness before one's eyes.

Then he said to his disciples, "Did I not tell you that, like a visible flash of

Ascension to the Empyreum (right panel)
Hieronymus Bosch, 1504

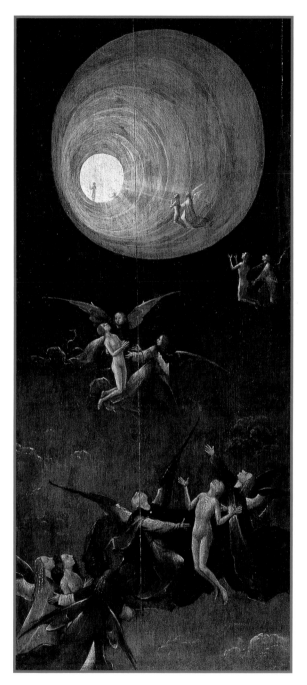

There are remarkable parallels between the excerpt from The Dialogue of the Savior *(a treasure from the Nag Hammadi Library discovered in 1945) and the panel by Hieronymous Bosch's (1450–1516) 16th-century* Vision of the Other World: Ascension to the Empyreum *now housed in the Ducal Palace in Venice. The* Dialogue *is an exchange between Jesus and three of his disciples—Matthew, Judas (most likely Judas Thomas, the twin brother of Jesus) and Mariam (Mary Magdalene) the companion. It concerns the Gnostic notion of the passage of the soul as it advances through the higher spheres towards heaven. Jesus, the wise teacher, reveals to his disciples through a revelatory vision that "like a visible flash of thunder or lightning, what is good will be taken up to the light."*

The Dutch master of the late 15th century is best known for his imaginative paintings of demons and monstrous creatures that often appear to be morphing from one frightful form into another. However, in this panel he focuses on the good souls—it is as though he knew this Gnostic text. Here we see the souls literally ascending into the light.

thunder and lightning, what is good will be taken up to the light?"

All his disciples praised him and said, "Master, before you appeared here, who was there to praise you, for all praises are because of you? Or who was there to bless [you], for all blessing comes from you?"

As they were standing there, he saw two spirits bringing a single soul with them, and there was a great flash of lightning. A word came from the child of humanity, saying, "Give them their garments," and the small became like the great. They were [like] those who were received up; [there was no distinction] among them.

Those [words convinced the] disciples to whom he [spoke].

She spoke this utterance as

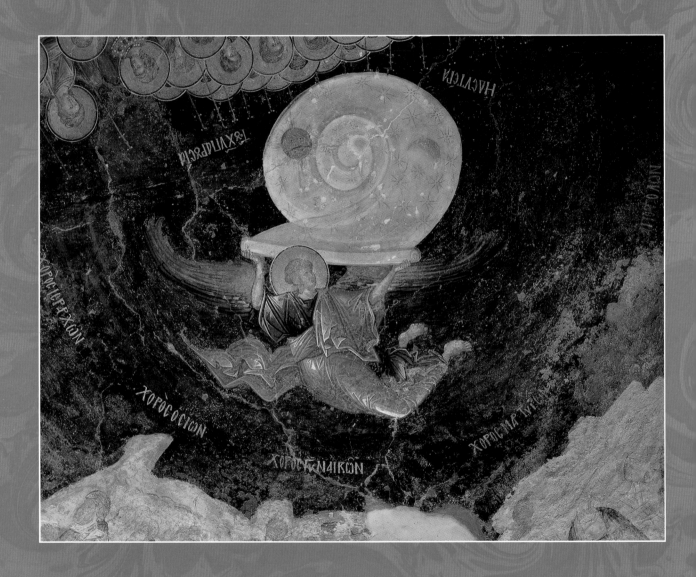

a woman who understood everything

Mary Asks About the Vision

Mary [said to him, "Look, I] see the evil [that affects] people from the start, when they dwell with each other."

The master said [to her], "When you see them, [you understand] a great deal; they will [not stay there]. But when you see the one who exists eternally, that is the great vision."

They all said to him, "Explain it to us."

He said to them, "How do you wish to see it, [in] a passing vision or in an eternal vision?"

He went on to say, "Do your best to save what can come after [me], and seek it and speak through it, so that whatever you seek may be in harmony with you. For I [tell] you the truth, the living God [is] in you, [as you also are] in God."

Judas Asks About the Rulers of the World, and the Garments

Judas [said], "I really want [to learn everything]."

The [master] said to him, "The living [God does not] dwell [in this] entire [region] of deficiency."

Judas [asked], "Who [will rule over us]?"

The master replied, "[Look here are]

all the things that exist [among] what remains. You [rule] over them."

Judas said, "But look, the rulers are over us, so they will rule over us."

The master answered, "You will rule over them. When you remove jealousy from yourselves, you will clothe yourselves in light and enter the bridal chamber."

Judas asked, "How will [our] garments be brought to us?"

The master answered, "There are some who will provide them for you and others who will receive [them], and they [will give] you your garments. For who can reach that place [of] honor? But the garments of life were given to these people because they know the way they will go. Indeed, it is even difficult for me to reach it."

Mary Utters Words of Wisdom

Mary said, "So:

The wickedness of each day [is sufficient].

Workers deserve their food.

Disciples resemble their teachers.

She spoke this utterance as a woman who understood everything.

An Angel Carries Heaven, artist unknown, 14th century

Whatever is from truth

The Disciples Ask About Fullness and Deficiency, Life, and Death

The disciples asked him, "What is fullness and what is deficiency?"

He answered them, "You are from fullness and you are in a place of deficiency. And look, his light has poured down on me."

Matthew asked, "Tell me, master, how the dead die and how the living live."

The master said, "[You have] asked me about a [true] saying that eye has not seen, nor have I heard it, except from you. But I say to you, when what moves a person slips away, that person will be called dead, and when what is living leaves what is dead, it will be called alive."

Judas asked, "So why, really, do some [die] and some live?"

The master said, "Whatever is from truth does not die. Whatever is from woman dies."

Mary asked, "Tell me, master, why have I come to this place, to gain or to lose?"

The master replied, "You show the greatness of the revealer."

Mary asked him, "Master, then is there a place that is abandoned or without truth?"

The Master said, "The place where I am not."

Mary said, "Master, you are awesome and marvelous, and [like a devouring fire] to those who do not know [you]."

Matthew asked, "Why do we not go to our rest at once?"

The master said, "When you leave these burdens behind."

Matthew asked, "How does the small unite with the great?"

The master said, "When you leave behind what cannot accompany you, then you will rest."

does not die

Separation of Light from Darkness and Fall of the Rebel Angels, Master Bertram, c.1383

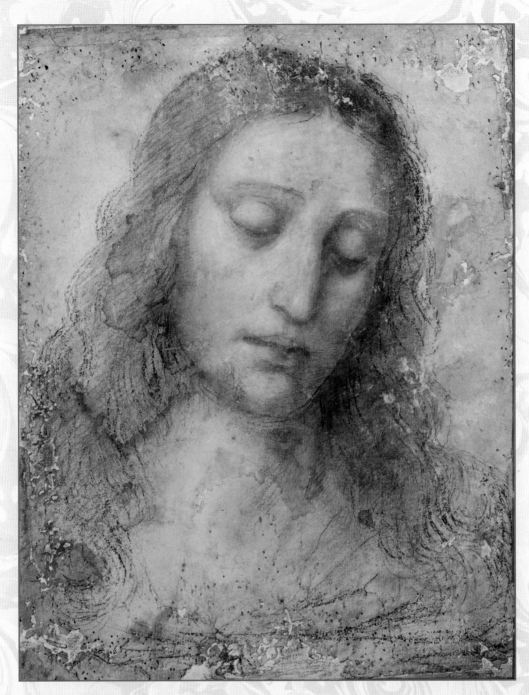

The Redeemer, Leonardo da Vinci, 15th century

Tell me, Master, what is
the beginning of the way?

Mary and the Other Disciples Discuss True Life With the Master

Mary said, "I want to understand all things, [just as] they are."

The master said, "Whoever seeks life, this is their wealth. For the world's [rest] is false, and its gold and silver are deceptive."

His disciples asked him, "What should we do for our work to be perfect?"

The master [said] to them, "Be ready, in every circumstance. Blessings on those who have found the [strife and have seen] the struggle with their eyes. They have not killed nor have [they] been killed, but they have emerged victorious."

Judas asked, "Tell me, master, what is the beginning of the way?"

He said, "Love and goodness. If one of these had existed among the rulers, wickedness would never have come to be."

Matthew said, "Master, you have spoken of the end of the universe with no difficulty."

The master said, "You have understood all the things I said to you and you have accepted them in faith. If you know them, they are yours. If not, they are not yours."

They asked him, "To what place are we going?"

The master said, "Stand in the place you can reach."

Mary asked, "Is everything established in this way visible?"

The master said, "I have told you, the one who can see reveals."

His twelve disciples asked him, "Teacher, [with] serenity…teach us…"

The master said, "[If you have understood] everything I have [told you], you will [become immortal, for] you…everything."

Mary said, "There is only one saying I shall [speak] to the master, about the mystery of truth. In this we stand and in this we appear to those who are worldly."

Judas said to Matthew, "We want to understand what sort of garments we are to be clothed with when we leave the corruption of the flesh."

The master said, "The rulers and the administers have garments that are given only for a while and do not last. But you, as children of truth, are not to clothe yourselves with these garments that last only for a while. Rather, I say to you, you will be blessed when you strip off your clothing. For it is no great thing [to lay aside what is] external."

…said, "Do I speak and do I receive…?"

The master said, "Yes, [one who receives] your father in [a reflective way]."

Mary Questions the Master About the Mustard Seed

Mary asked, "[Of what] kind is the mustard seed? Is it from heaven or from earth?"

The master said, "When the father established the world for himself, he left many things with the mother of all. That is why he speaks and acts."

Judas said, "You have told us this from the mind of truth. When we pray, how should we pray?"

The master said, "Pray in the place where there is no woman."

Matthew says, "He tells us, 'Pray in the place where there is no woman,' which means, destroy the works of the female, not because there is another form of birth but because they should stop [giving birth]."

Mary said, "Will they never be destroyed?"

The master said, "[You] know they will perish [once again], and [the works] of [the female here] will be [destroyed as well]."

Judas said [to Matthew], "The works of the [female] will perish. [Then] the rulers will [call upon their realms], and we shall be ready for them."

The master said, "Will they see [you and will they] see those who receive you? Look, a heavenly word is coming from the father of the abyss, silently, with a flash of lightning, and it is productive. Do they see it or overcome it? No, you know more fully [the way] that [neither angel] nor authority [knows]. It is the way of the father and the son, for the two are one. And you will travel the [way] you have come to know. Even if the rulers become great, they will not be able to reach it. [Look], I tell you, it is even difficult for me to reach it."

[Mary] asked [the master], "If the works [are destroyed what actually] destroys a work?"

[The master said], "You know. [On the day] I destroy [it, people] will go to their own places."

Judas said, "How is the spirit disclosed?"

The master said, "How [is] the sword [disclosed]?"

Judas said, "How is the light disclosed?"

The master said, "[It is disclosed] through itself eternally."

Judas asked, "Who forgives those works? Do the works [forgive] the world [or does the world] forgive the works?"

The master [answered], "Who is [it]? Really, whoever has come to know the works. For it is the responsibility of these people to do the [will] of the father." ≈

Christ with His Apostles, Bonifazio de' Pitati, 16th century

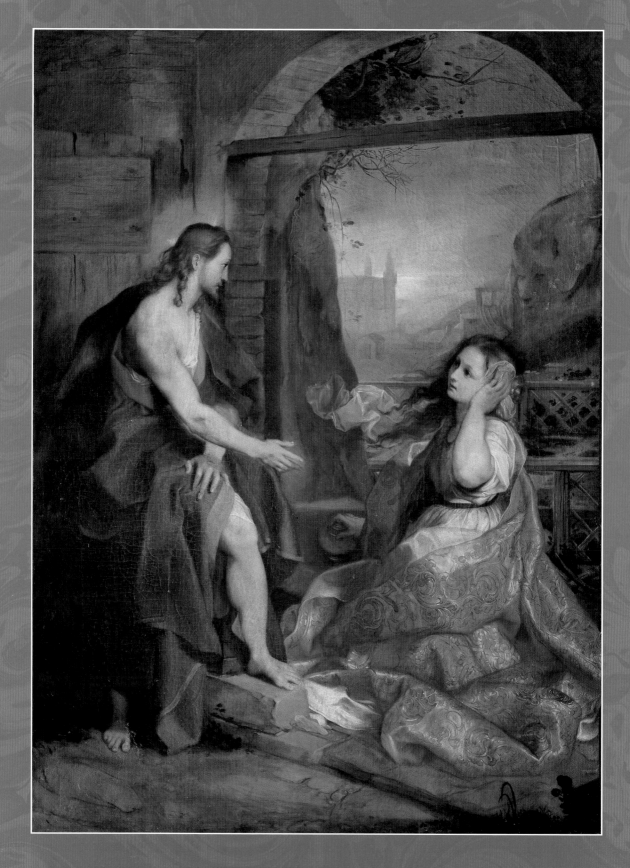

Mary, Mary, know me

The Manichaean Psalms of Heracleides

This lovely Manichaean psalm takes the form of a tender dialog that occurs between the risen Jesus and the Magdalene when she discovers him at the tomb. This once popular religion founded by the 3rd century prophet Mani is virtually extinct, but its original written works, such as this one, were preserved in Coptic manuscripts recently discovered in Egypt. As a young man, Mani received an angelic vision of a spirit that he called his heavenly "Twin." The Twin revealed profound spiritual wisdom that awakened Mani to his divine Self. Manichaeism incorporated many religious traditions (Zoroastrian, Buddhist and Christian) resulting in the spread of the religion throughout Persia and as far as Tibet, China and the British Isles. Manichaeans practiced non-violence, believed in the cycle of reincarnations, did not eat meat, and remained chaste. The Manichaean religion is based on the dualistic principle that the two natures of light and darkness have always existed.

In this psalm the structure reflects a dyadic balance between the Magdalene and Jesus that has Gnostic implications. Mary Magdalene is asked to bring the "lost orphans"—the eleven disciples—back to the Shepherd, and she is not only given this great responsibility but does it with "joy in her whole heart."

Mary, Mary, know me,
but do not touch [me].
[Dry] the tears of your eyes,
and know that I am your master,
only do not touch me,
for I have not yet seen my father's face.

Your God was not taken away,
as you thought in your pettiness.
Your god did not die;
rather, he mastered [death].
I am not the gardener.

Noli Me Tangere, Federico Barocci, 16th century

I shall not let my heart rest

I have given, I have received…
I did [not] appear to you
until I saw your tears and grief…for me.

Cast this sadness away
and perform this service.
Be my messenger to these lost orphans.
Hurry, with joy, go to the eleven.
You will find them gathered on the bank
 of the Jordan.
The traitor convinced them to fish
as they did earlier,
and to lay down their nets
in which they caught people for life.
Say to them, "Arise, let us go.
Your brother calls you."
If they disregard me as brother,
say to them, "It is your master."
If they disregard me as master,
say to them, "It is your lord."
Use all your skill and knowledge
until you bring the sheep to the shepherd.

If you see that they do not respond,
make Simon Peter come to you.

Say to him, "Remember my words,
between me and you. Remember what
I said,
between me and you, on the Mount
of Olives.
I have something to say,
I have no one to whom to say it."

Rabbi, my master, I shall carry out
your instructions
with joy in my whole heart.
I shall not let my heart rest,
I shall not let my eyes sleep,
I shall not let my feet relax
until I bring the sheep to the fold.

Glory to Mary,
because she has listened to her master,
[she has] carried out his instructions
with joy in her whole heart.

[Glory and] triumph to the soul of
blessed Mary. ≼

Mary Magdalen, Giulio Cesare Procaccini, 16th or 17th century

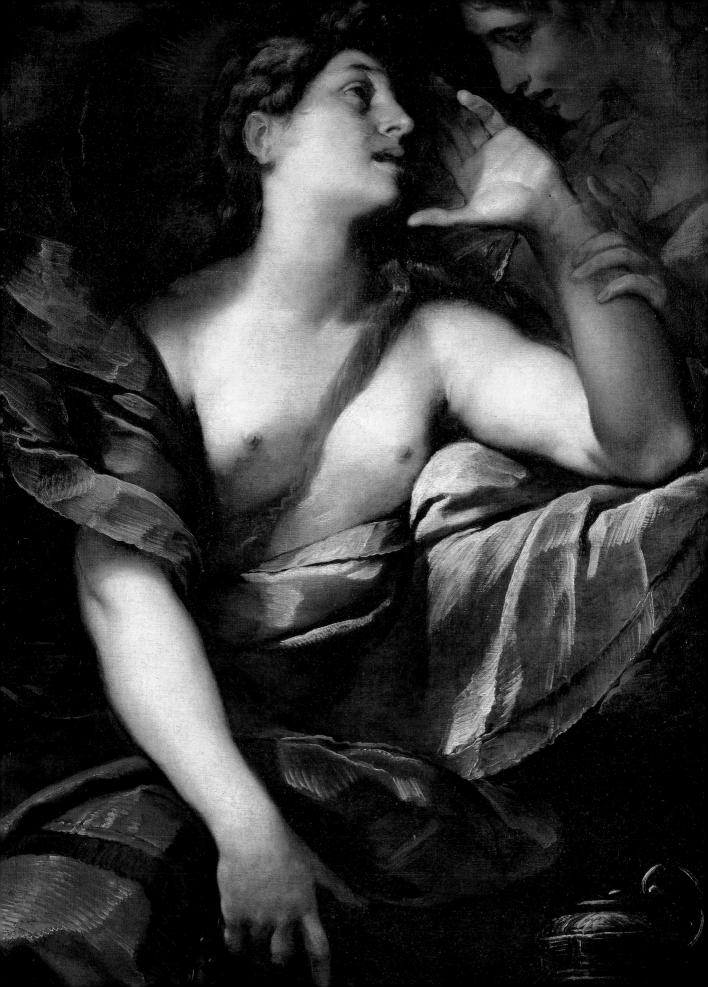

he is risen and is gone hither whence he was sent

The Gospel of Peter

But I mourned with my fellows, and being wounded in heart we hid ourselves, for we were sought after by them as evildoers and as persons who wanted to set fire to the temple. Because of all these things we were fasting and sat mourning and weeping night and day until the Sabbath.

—From the *Gospel of Peter*

The above fragment from the Gospel of Peter *takes place after the crucifixion while Peter is in hiding with the disciples from the enemies of the Galilean. A segment of the* Gospel of Peter *was discovered around 1886 at Akhmim in Upper Egypt and dates back to the late 2nd century. Ron Cameron, professor of Religion at Wesleyan University, in his book The Other Gospels informs us "the Gospel of Peter was dependant on a number of sources, but that the document as we have it antedates the four gospels of the New Testament and may have served as a source for their respective authors…it is the oldest extant writing produced and circulated under the authority of the apostle Peter."*

The content of the excerpt includes not only the passion and epiphany stories, but the discovery of the empty tomb and the prelude to the Resurrection. As the gospel is incomplete, it ends abruptly before what we can surmise will be a Resurrection encounter between Peter and Jesus. The Magdalene is named among the women who Peter describes fleeing the empty tomb after an encounter with the "young man sitting in the midst of the sepulcher." So it would appear that Peter is about to place himself in the key position in the Resurrection narrative, centralizing his role and minimizing the Magdalene's. This is more consistent with the gospels of Matthew, Mark and Luke and does not reflect Gnostic sensibilities.

Early in the morning of the Lord's day Mary Magdalene, a woman disciple of the Lord—for fear of the Jews, since (they) were inflamed with wrath, she had not done at the sepulchre of the Lord what women are wont to do for those beloved of them who die—took with her her women friends and came to the sepulchre where he was laid. And they feared lest the Jews should see them, and said, "Although we could not weep and lament on that day when he was crucified, yet let us now do so at his sepulchre. But who will roll away for us the stone also that is set on the entrance to the sepulchre, that we may go in and sit beside him and do what is due?—For the stone was great,—and we fear lest any one see us. And if we cannot do so, let us at

Women at the Tomb, artist unknown, 12th century

least put down at the entrance what we bring for a memorial of him and let us weep and lament until we have again gone home." So they went and found the sepulchre opened. And they came near, stooped down and saw there a young man sitting in the midst of the sepulchre, comely and clothed with a brightly shining robe, who said to them, "Wherefore are ye come? Whom seek ye? Not him that was crucified? He is risen and gone. But if ye believe not, stoop this way and see the place where he lay, for he is not here. For he is risen and is gone thither whence he was sent." Then the women fled affrighted. ⤚

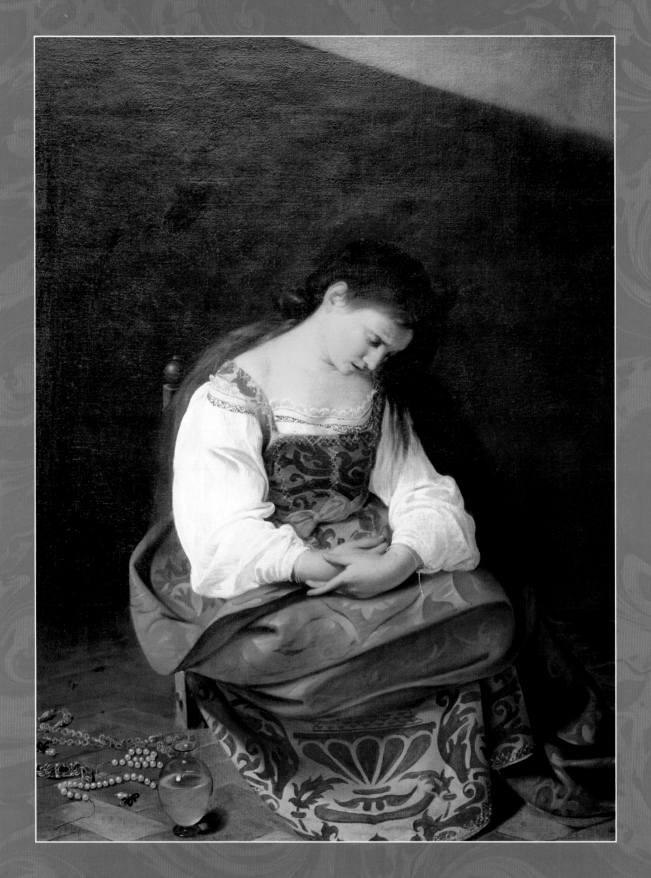

CHAPTER FOUR

Mary in Myth and Legend

It was in the month of June when I saw
him for the first time. He was walking in
the wheat field when I passed by with my
handmaidens, and he was alone.

The rhythm of his steps was different
from other men's, and the movement of

His body was like naught I had seen
before.

Men do not pace the earth in that
manner. And even now I do not know
whether

He walked fast or slow.

—Mary Magdalene's voice from
Jesus, The Son of Man, Kahlil Gibran, 1928

THE MAGDALENE HAS been a rich influence in legend, literature and lyric throughout history. The impact of Pope Gregory the Great's homily on Mary's reputation in the 6th century was both lasting and profound. You will see this effect in many of the excerpts

The Magdalen, Caravaggio, 16th century

from Abelard to Kazantzakis, from Dante Gabriel Rossetti to George McDonald and Kahlil Gibran to Tim Rice.

A large portion of this chapter is devoted to *The Golden Legend*. Jacobus de Voragine's work has profoundly impacted the ways in which sculptors and artists, writers and poets have rendered the Magdalene in form and content over the centuries. *The Golden Legend* is a work from the 1260s compiled by a Dominican who was to become Archbishop of Genoa in 1292. Originally titled *Readings on the Saints*, it was more widely read than the bible in the late Middle Ages. Composed primarily for the use of Dominican preachers it was written to be read over the Christian feast days of the saints as well as Advent, Lent, Easter, and Christmas. Jacobus utilized sources from the 2nd to the 13th centuries—some of which were considered apocryphal—to compose the work. The book contains approximately 200 biographies of the saints. Jacobus considered the saints to be agents of God and the book a sacred com-

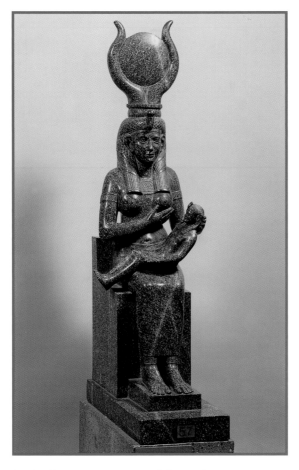

Isis Suckling Horus, artist and date unknown

pendium of salvation. The paintings visited here that illustrate Mary Magdalene are inspired by Voragine's history of the Magdalene and her journey to the South of France, where she spent her days in prayer, repentance, and spiritual ecstasy. *The Golden Legend* influenced literature as well as the visual arts. The Medieval mystery and miracle plays draw heavily on his compilation. Miracles and martyrdom were proof positive of sainthood, and although Mary was not a martyr, the biography is replete with miracles in her name.

You will notice in the paintings of Lefebvre and Sandys, in which Mary is weeping bitterly in her misery at the loss of her beloved, a tendency toward the overly sentimental. These works have been rendered with great skill, but do evoke the adjective *maudlin*, a word derived specifically from her name. We can thank Pope Gregory's homily for this aspect of the Magdalene's pictorial heritage.

The broad historic range and varied literary textures of the excerpts reveal a rich and vivid portrait of the Magdalene that emerges over the centuries. We begin with a selection from Kahlil Gibran's work *Jesus the Son of Man*, where we discover Mary as she gazes upon her beloved for the first time, the very first moment. In John Donne's 17th-century poem *To the Lady Magdalen Herbert: Of St. Mary Magdalen*, he teases us with his heretical line "That she once knew, more than the church did know." In Leonora Speyer's delightful poem *One Version*, written at the cusp of the roaring twenties, we witness a more modern Mary respond to "the stranger with the shining head." And there is the glorious poem by Rilke titled *The Risen One*, which contains love's great lesson of independence in its content. You will find with each selection an aspect of the Magdalene brought to light.

The Deposition (detail), Pieter Paul Rubens, 1602

Jesus the Son of Man

by Kahlil Gibran (excerpt), 1928

It was in the month of June when I saw Him for the first time. He was walking in the wheat field when I passed by with my handmaidens, and He was alone.

The rhythm of His steps was different from other men's, and the movement of His body was like naught I had seen before.

Men do not pace the earth in that manner. And even now I do not know whether He walked fast or slow.

My handmaidens pointed their fingers at Him and spoke in shy whispers to one another. And I stayed my steps for a moment, and raised my hand to hail Him. But He did not turn His face, and He did

Head of the Savior, Leonardo da Vinci, 15th century

This exquisite painting by Leonard da Vinci (1452–1519) of a youthful Jesus with shining forehead and ruddy hair resides in a small jewel of a museum in Madrid, Spain. Here we see a handsome young man, a descendant of King David VIII and son of Jesse—who was believed to have red hair and extraordinary eyes (1 Samuel—16:12, 17:42). In spite of some idealization by virtue of his sheer beauty, he is very much flesh and blood. This tender portrait could certainly be of the man that Magdalene beholds in her dream in Kahlil Gibran's Jesus the Son of Man.

Kahlil Gibran (1883–1931) was born in a small town in the northern hills of Lebanon while it was under the rule of the Ottoman Empire. Gibran was initially educated by a local priest but had no formal schooling as a child. His father was a drunk and a gambler whose eventual imprisonment for tax evasion left the family homeless and penniless. Gibran's mother moved the family first to Paris and then to Boston, where she became a street peddler in order

to support her children.

Despite the hardships of his childhood, Gibran developed into a celebrated poet, philosopher, artist, and author. His artistic gifts were nurtured when he spent two years in Paris studying with the sculptor Rodin from 1908 to 1910, and his sensitive poetic drawings resemble those of his teacher. His book The Prophet *was published in 1923 to poor reviews, but word of mouth transformed it into one of the best selling titles of all times.* Jesus the Son of Man *was published three years before Gibran's death and was very well received by critics. His untimely death from cancer was sadly aided by his inappropriate habit of self-medication with alcohol. Today he is considered by millions of Arabic-and-English speaking readers to be a genius of his era.*

Gibran believed in the continuity of life—much like the Gnostics and early Christians from the 1st and 2nd centuries. The following statement by Gibran could easily express the soul of da Vinci, as well: "There is neither religion nor science beyond beauty."

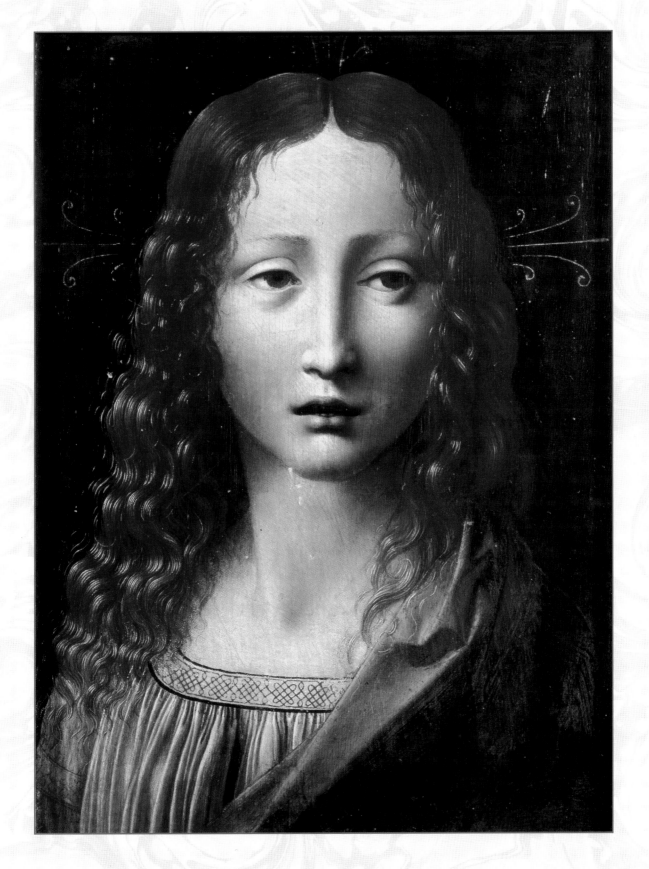

not look at me. And I hated Him. I was swept back into myself, and I was as cold as if I had been in a snow-drift. And I shivered.

That night I beheld Him in my dreaming; and they told me afterward that I screamed in my sleep and was restless upon my bed.

It was in the month of August that I saw Him again, through my window. He was sitting in the shadow of the cypress tree across my garden, and He was still as if He had been carved out of stone, like the statues in Antioch and other cities of the North Country.

And my slave, the Egyptian, came to me and said, "That man is here again. He is sitting there across your garden."

And I gazed at Him, and my soul quivered within me, for He was beautiful.

His body was single and each part seemed to love every other part.

Then I clothed myself with raiment of Damascus, and I left my house and walked towards Him.

Was it my aloneness, or was it His fragrance, that drew me to Him? Was it a hunger in my eyes that desired comeliness, or was it His beauty that sought the light of my eyes?

Even now I do not know.

I walked to Him with my scented garments and my golden sandals, the sandals the Roman captain had given me, even these sandals. And when I reached Him, I said, "Good-morrow to you."

And He said, "Good-morrow to you, Miriam."

And He looked at me, and His night-eyes saw me as no man had seen me. And suddenly I was as if naked, and I was shy.

Yet He had only said, "Good-morrow to you."

And then I said to Him, "Will you not come to my house?"

And He said, "Am I not already in your house?"

I did not know what He meant then, but I know now.

And I said, "Will you not have wine and bread with me?"

And He said, "Yes, Miriam, but not now."

Not now, not now, He said. And the voice of the sea was in those two words, and the voice of the wind and the trees. And when He said them unto me, life spoke to death.

For mind you, my friend, I was dead. I was a woman who had divorced her soul. I was living apart from this self which you now see. I belonged to all men, and to none. They called me harlot, and a woman possessed of seven devils. I was cursed, and I was envied.

But when His dawn-eyes looked into

my eyes all the stars of my night faded away, and I became Miriam, only Miriam, a woman lost to the earth she had known, and finding herself in new places.

And now again I said to Him, "Come into my house and share bread and wine with me."

And He said, "Why do you bid me to be your guest?"

And I said, "I beg you to come into my house." And it was all that was sod in me, and all that was sky in me calling unto Him.

Then He looked at me, and the noontide of His eyes was upon me, and He said, "You have many lovers, and yet I alone love you. Other men love themselves in your nearness. I love you in your self. Other men see a beauty in you that shall fade away sooner than their own years. But I see in you a beauty that shall not fade away, and in the autumn of your days that beauty shall not be afraid to gaze at itself in the mirror, and it shall not be offended.

"I alone love the unseen in you."

Then He said in a low voice, "Go away now. If this cypress tree is yours and you would not have me sit in its shadow, I will walk my way."

And I cried to Him and I said, "Master, come to my house. I have incense to burn

Martha Reproofs Her Vain Sister, Mary Magdalen (detail), Simon Vouet, c.1621

for you, and a silver basin for your feet. You are a stranger and yet not a stranger. I entreat you, come to my house."

Then He stood up and looked at me even as the seasons might look down upon the field, and He smiled. And He said again: "All men love you for themselves. I love you for yourself."

And then He walked away.

But no other man ever walked the way He walked. Was it a breath born in my garden that moved to the east? Or was it a storm that would shake all things to their foundations?

I knew not, but on that day the sunset of His eyes slew the dragon in me, and I became a woman, I became Miriam, Miriam of Mijdel. ✑

He needs me, calls me

At the Door of Simon the Pharisee

—DANTE GABRIEL ROSSETTI, 1858

"Why wilt thou cast the roses from thine hair?
Nay, be thou all a rose,—wreath, lips, and cheek.
Nay, not this house,—that banquet-house we seek;
See how they kiss and enter; come thou there.
This delicate day of love we two will share
Till at our ear love's whispering night shall speak.
What, sweet one,—hold'st thou still the foolish freak?
Nay, when I kiss thy feet they'll leave the stair."
"Oh loose me! Seest thou not my Bridegroom's face
That draws me to Him? For His feet my kiss,
My hair, my tears He craves to-day:—and oh!
What words can tell what other day and place
Shall see me clasp those blood-stain'd feet of His?
He needs me, calls me, loves me: let me go!"

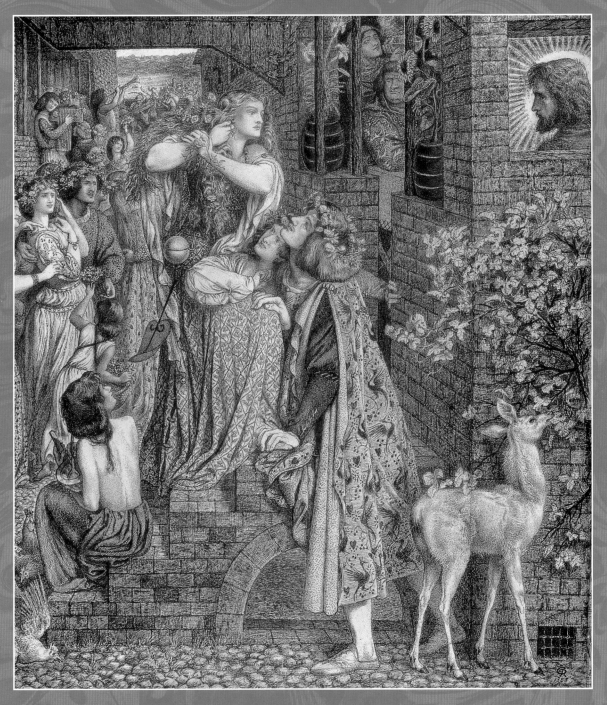

Mary Magdalene at the Door of Simon the Pharisee, Dante Gabriel Rossetti, 1859

DIVISERVNT MILITES VESTIMẼTA EIVS SORTEM MICTENTES. M̃. XXVI. C.

RESVREXI ET ADHVC TECVM SVM. PS̃. CXXXVIII.

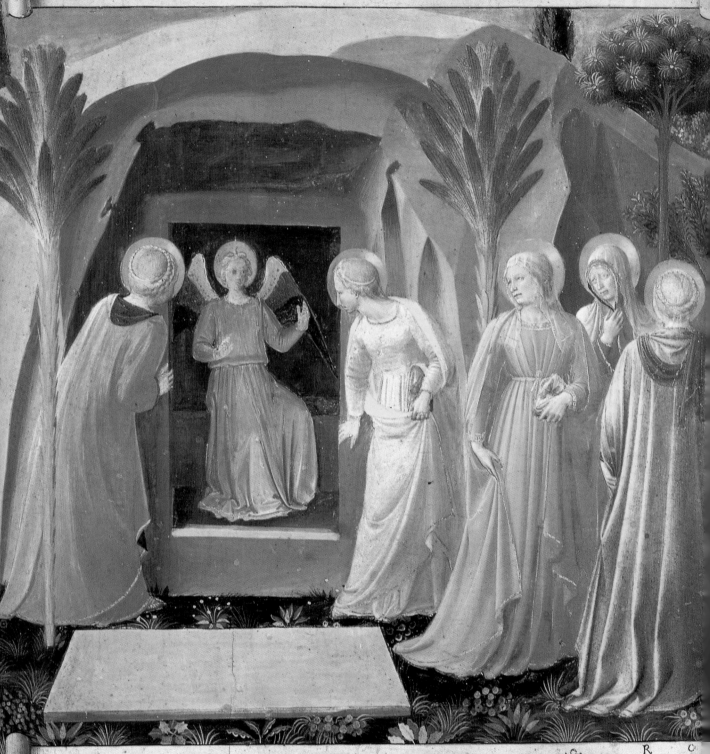

IHESVM QVERITIS NAᵹᵹARENVM SVRREXIT NON Ẽ HIC. M. VLT.

SEDEBIT SVP S̃EDẼ MAIESTATIS SVE ᵹIVDICBIT BONÍS MALỐ· M·XXV· C.

Blessed are they

"The First Ones Ever"

Excerpt from the hymn by Linda Wilberger Egan, 1983

The first ones ever, oh, ever to know
of the rising of Jesus, his glory to be,
were Mary, Joanna, and Magdalene,
and blessed are they are they who see.

are they who see

The Three Maries, Fra Angelico, 15th century

For the Magdalene

—WILLIAM DRUMMOND, 17TH CENTURY

'These eyes, dear Lord, once brandons of desire,
Frail scouts betraying what they had to keep,
Which their own heart, then others set on fire,
Their trait'rous black before thee here out-weep;
These locks, of blushing deeds the gilt attire,
Waves curling, wrackful shelves to shadow deep,
Rings wedding souls to sin's lethargic sleep,
To touch thy sacred feet do now aspire.
In seas of care behold a sinking bark,
By winds of sharp remorse unto thee driven,
O let me not be Ruin's aim'd-at-mark!
My faults confessed, Lord, say they are forgiven.'
Thus sighed to Jesus the Bethanian fair,
His tear-wet feet still drying with her hair. ✐

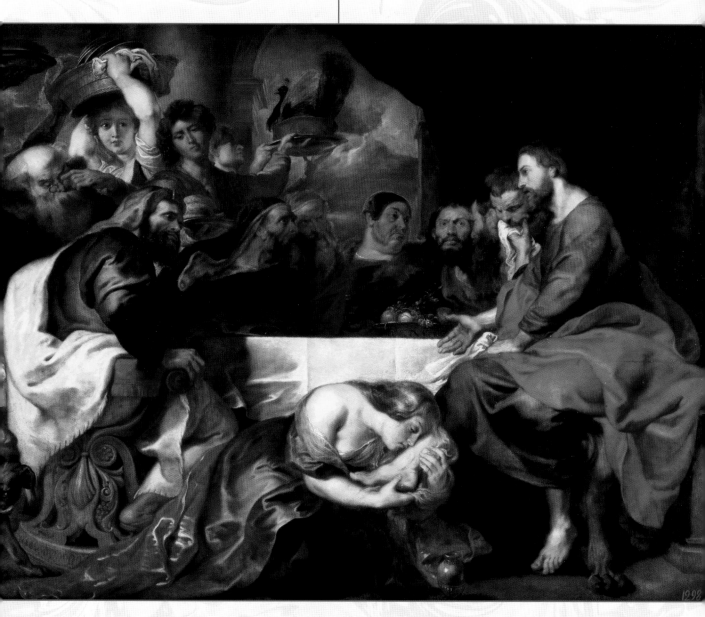

Feast in the House of the Pharisee, Pieter Paul Rubens, 16th or17th century

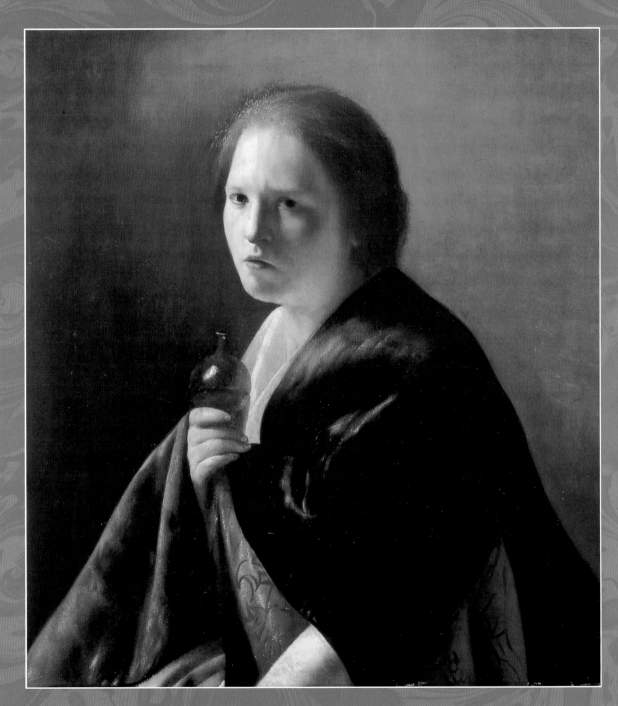

Magdalene, Paulus Bor, 17th century

she once knew, more than

To the Lady Magdalen Herbert, of St. Mary Magdalen

—JOHN DONNE, 17TH CENTURY

Her of your name, whose fair inheritance
 Bethina was, and jointure Magdalo,
An active faith so highly did advance,
 That she once knew, more than the Church did know,
The Resurrection; so much good there is
 Deliver'd of her, that some Fathers be
Loth to believe one woman could do this;
 But think these Magdalens were two or three.
Increase their number, Lady, and their fame ;
 To their devotion add your innocence;
Take so much of th' example as of the name,
 The latter half; and in some recompense,
That they did harbour Christ Himself, a guest,
 Harbour these hymns, to His dear Name address'd.

the church did know

I know the woman well

One Version

—LEONORA SPEYER, 1921

I think that Mary Magdalene
Was just a woman who went to dine,
And her jewels covered her empty heart
And her gown was the color of wine.

I think that Mary Magdalene
Sat by a stranger with shining head.
"Haven't we met somewhere?" she asked,
"Magdalene! Mary!" he said.

I think that Mary Magdalene
Fell at his feet and called his name;
Sat at his feet and wept her woe
And rose up clean of shame.

Nobody knew but Magdalene,
Mary, the woman who went to dine;
Nobody saw how he broke the bread
And poured for her peace the wine.

This is the story of Magdalene—
It isn't the tale the Apostles tell,
But I know the woman it happened to,
I know the woman well. ✐

Mary Magdalene, Frederick Sandys, c.1858

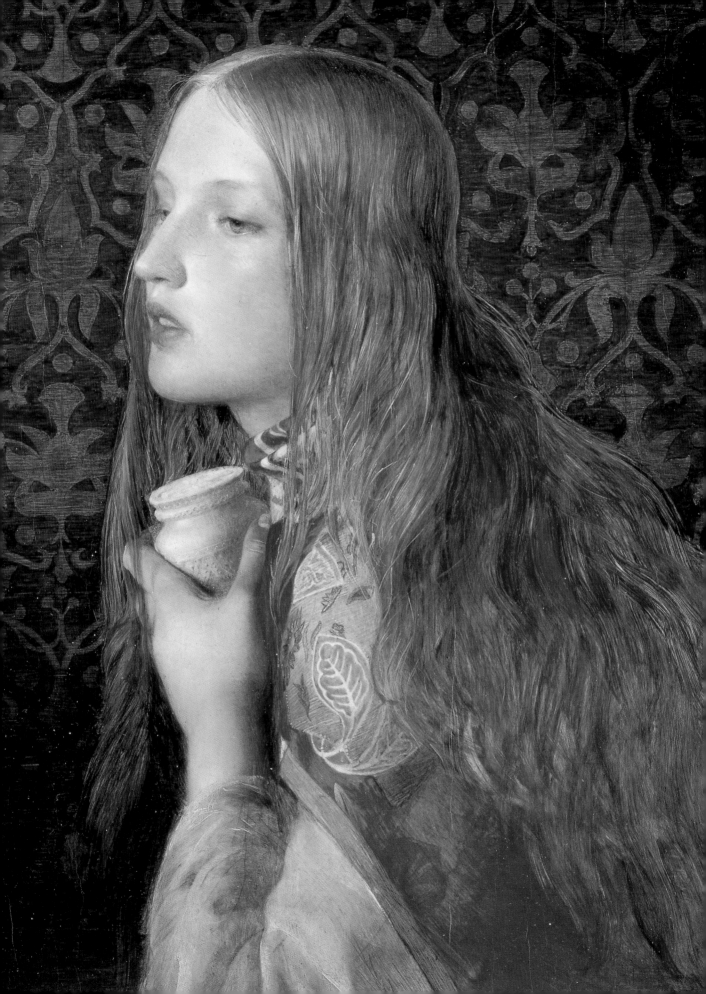

Our Master lies

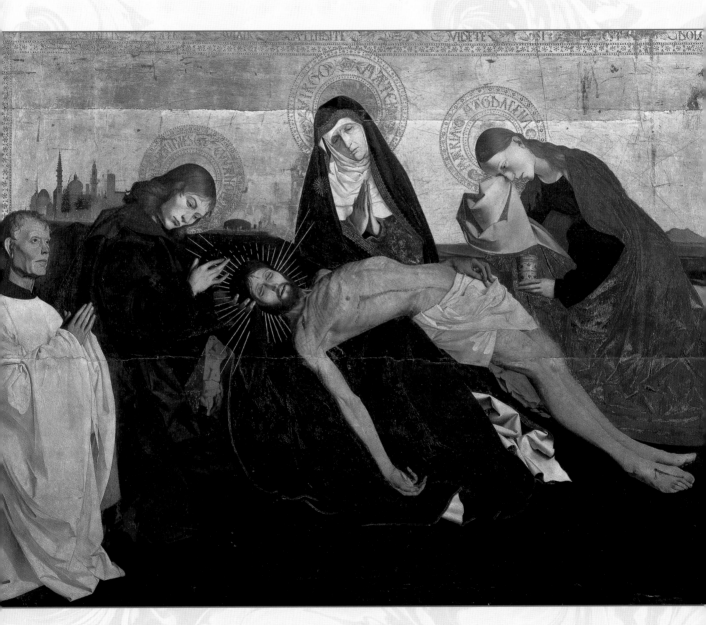

Pieta de Velleneuve-les-Avignon, Enguerrand Quarton, 15th century

asleep

Mary Magdalene and the Other Mary; A Song for VII Maries

—CHRISTINA GEORGINA ROSSETTI, 19TH CENTURY

Our Master lies asleep and is at rest;
 His Heart has ceased to bleed, His Eye to weep:
The sun ashamed has dropt down in the west:
 Our Master lies asleep.

 Now we are they who weep, and trembling keep
Vigil, with wrung heart in a sighing breast,
 While slow time creeps, and slow the shadows creep.

Renew Thy youth, as eagle from the nest;
 O Master, who hast sown, arise to reap: —
No cock-crow yet, no flush on eastern crest:
 Our Master lies asleep. �

The Risen One

—Rainer Maria Rilke, 1908

Until his final hour he had never
refused her anything or turned away,
lest she should turn their love to public praise.
Now she sank down beside the cross, disguised,
heavy with the largest stones of love
like jewels in the cover of her pain.

But later, when she came back to his grave
with tearful face, intending to anoint,
she found him resurrected for her sake,
saying with greater blessedness, "Do not—"

She understood it in her hollow first:
how with finality he now forbade
her, strengthened by his death, the oils' relief
or any intimation of a touch:

because he wished to make of her the lover
who needs no more to lean on her beloved,
as, swept away by joy in such enormous
storms, she mounts even beyond his voice. ✍

Noli Me Tangere, Maurice Denis, 1895

*Denis, a French artist born in 1870,
was well educated and studied
painting at the Ecole des Beaux–Arts.
He joined the Nabis movement,
appropriately named after the
Hebrew word meaning "prophets,"
whose intention it was to evoke
emotions through an approximation of
the physical world, not a duplication.
His canvases and drawings celebrate
the decorative and dazzle us with
light, color and dappled patterns.*

*In this sketch for a stained glass
window Denis makes real Mary's
vision of the Teacher by using panes
of glass through which light will
shine—giving the scene an unearthly
luminosity and placing it in the radi-
ant world of Light.*

He wished to make of her the lover

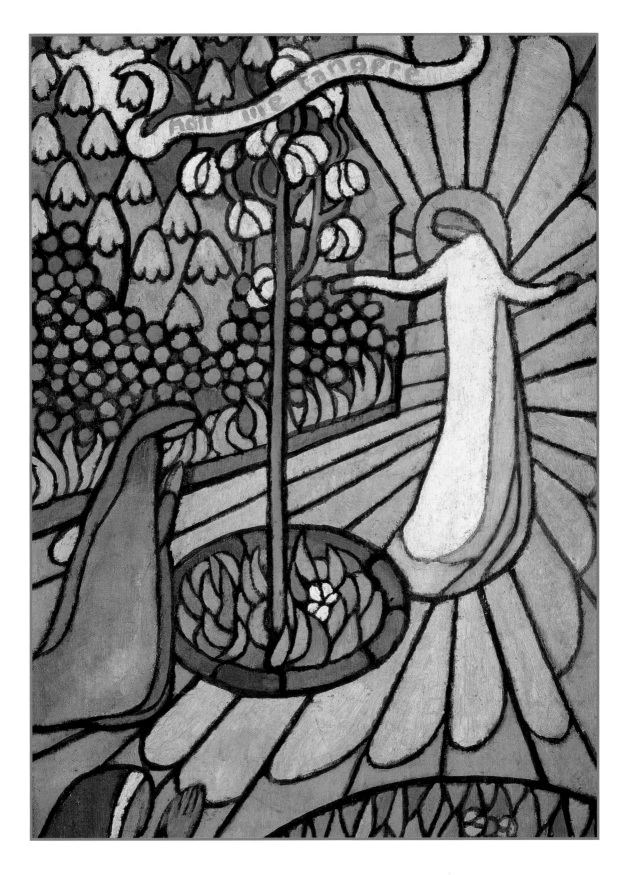

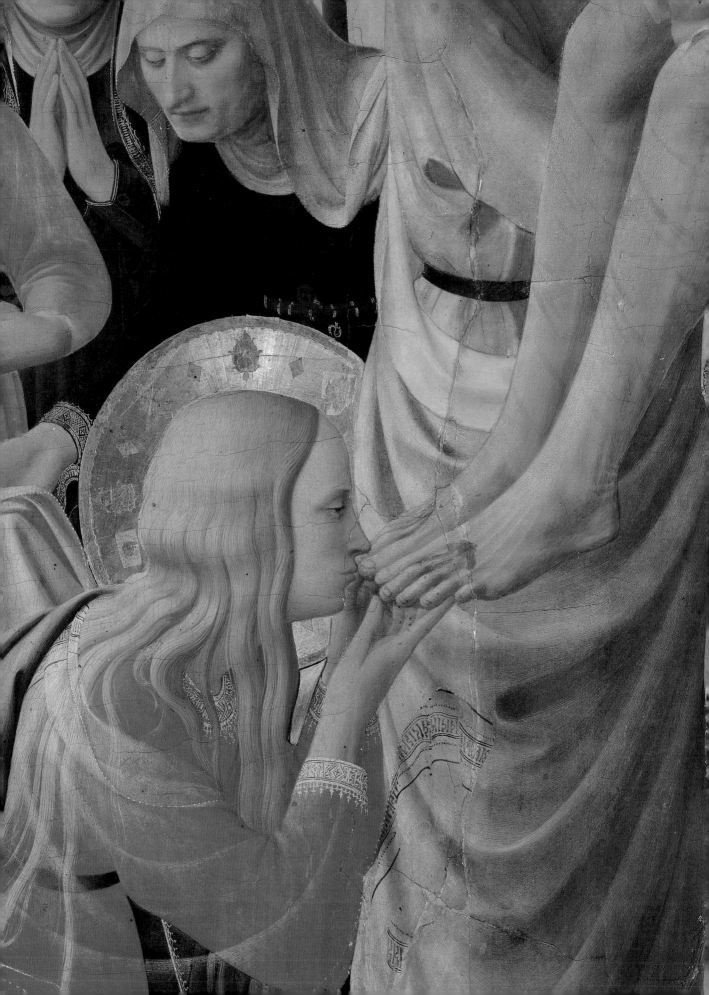

Mary Magdalene

—Christina Georgina Rossetti, 19th century

She came in deep repentance,
 And knelt down at His feet
Who can change the sorrow into joy,
 The bitter into sweet.
She had cast away her jewels
 And her rich attire,
And her breast was filled with a holy shame,
 And her heart with a holy fire.
Her tears were more precious
 Than her precious pearls —
Her tears that fell upon His feet
 As she wiped them with her curls.
Her youth and her beauty
 Were budding to their prime;
But she wept for the great transgression,
 The sin of other time.
Trembling betwixt hope and fear,
 She sought the King of Heaven,
Forsook the evil of her ways,
 Loved much and was forgiven. ☙

Trembling betwixt hope and fear

The Deposition (detail), Fra Angelico, c.1430

In this detail from the masterwork The Deposition *by Fra Angelico (1387–1455) we see Mary Magdalene kneeling at the foot of the cross and gently kissing the feet of the deceased Jesus. She is wearing red robes—their intense color representative of passion, blood, and life, and possibly symbolic of a lascivious past. To the left in this masterpiece is Mary the Mother (not pictured) in her traditional blue robes. The use of this equal, but different, vibrant color suggests the mutual importance of the two Marys. They represent the key women in the life of Jesus. And the Magdalene, with her red gown, chestnut hair, and almost mystical, reverential gaze, is the emotional and compositional adhesive that holds this great work together.*

It is not surprising—given the use of gold, detail, and brilliant colors—to note that Fra Angelico took his early training in miniature and illumination, although his work also reveals the influence of the Siennese school with its more medieval roots. His paintings have profound spiritual content beyond their religious subject—and it is in keeping that he joined the order of "Preachers" and entered the Dominican convent in Tuscany in 1407. Vasari offers that the painter always prayed before he began to work and believed that in order to depict Christ you needed to be Christlike.

I Am the Way

from *Speaking from the Heart* by Joan Grant (excerpt), 1968

"When I am Meri (the Beloved of), and do healing or blessing, as Meri used to do, Meri feels the anguish and loneliness which she suffered when after his death, by his instruction, she lived to be 65 years old. This is the loneliness of Meri who took 83 people, all friends, whom, in his dying breath, He told me to protect: by ship from Tyre to Cyprus: then by another ship to Syracuse, then to an African port whose name I can't remember, —I think it had no name, it was too small; then in three ships manned by Phoenicians who were seeking tin…,—who put us ashore because I could not pay the freight for the passengers, on a sandpit in the sea near what is now—Ste Marie de la Mar. The reason it is a Holy place for the gypsies is because I was known as the Egyptian." ✍

Mary Magdalene Travelling to France, Giotti, c.1300

This wonderful fresco by Giotto di Bondone (c.1270–1337) from the Mary Magdalene Chapel in the lower section of the Saint Francis Church in Assisi, Italy, is a segment from a masterpiece that records her life story as told in Voragine's Golden Legend. Here she travels to the South of France in a boat that lands near Marseilles. There has been speculation about the reclining lady in deep red on the little island to the left of the Magdalene's boat. It is certain that this references a section from Voragine's narrative where Magdalene saves the life of a new mother and her baby much to the joy of the father. Here we see him coming ashore on the island to be reunited with his wife and little boy.

Giotto, a Florentine artist, introduced aspects of realism and a convincing sense of pictorial space to fresco painting, thus modernizing the painting of his era. His rendering of the Magdalene in this beautiful chapel treats her as an individual—he takes great care to depict her as a beautiful and strong woman and breaks the stylistic Byzantine model of his teacher Cimabue.

The concept of reincarnation was very much a part of the diverse and vibrant early Christian communities

that preceded the council of Nicea. This idea flourished among the Gnostics, Essenes, and Nazarenes and later among the Albigensians and Cathari. The excerpt by Joan Grant is a fragment from a new book to be published in 2007, Speaking from the Heart—Ethics, Reincarnation, and What it Means to be Human. Grant authored 14 "Far Memory" books that were published as autobiographies of previous incarnations. Winged Pharaoh became an international bestseller upon publication in the early days of World War II. Her psychic gifts bear comparison with the American sleeping prophet and healer Edgar Cayce.

Among Grant's unpublished manuscripts are pieces from a work titled I Am the Way. Her first recollections of "Meri"—the Magdalene—preceded the publication of Elaine Pagel's important work The Gnostic Gospels by decades as well as translations of the Gospel of Mary. The material remarkably parallels Gnostic texts. Joan's "Meri" is Mary Magdalene and the wife of the Galilean. This fragment, dated 1968, is intriguing—from these bits and others the Magdalene is presented as the chosen disciple and part of a holy dyad that taught and healed together.

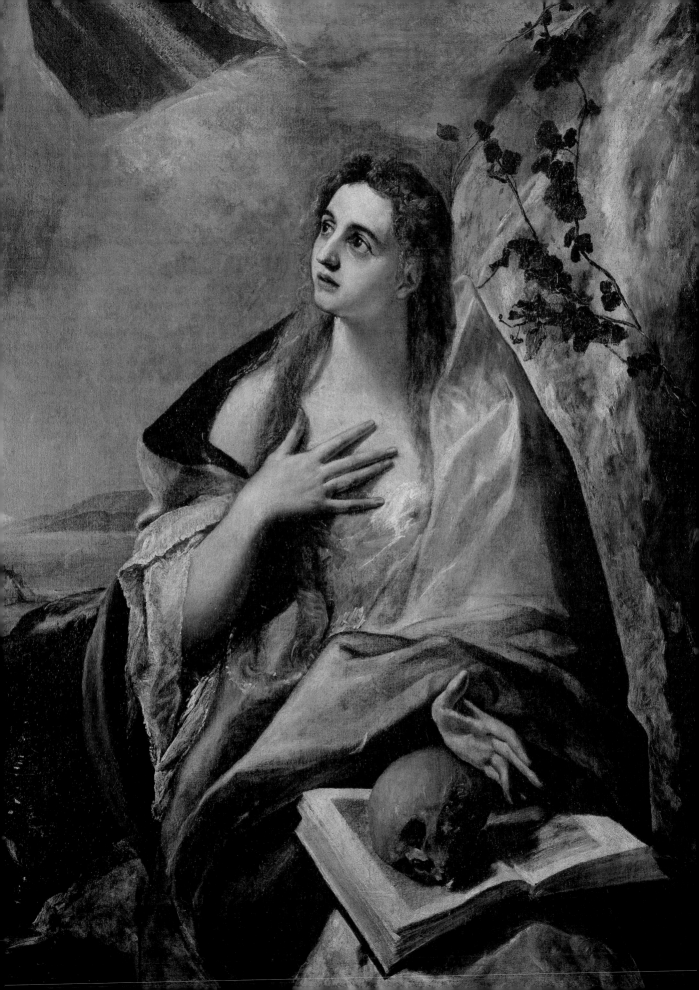

The Golden Legend

by Jacobus de Voragine (excerpt), 1260

This 13th century work by the Dominican Archbishop of Genoa, Jacobus de Voragine, was extremely popular in the Middle Ages. By the end of the era it was in fact more widely read than the Bible. The narrative is laced with numerous miracles and is in part fictitious; however, there are elements of truth to be uncovered. In The Golden Legend we witness Mary Magdalene and a number of the Galilean's disciples' journey to the south of France to an area near Marseilles where there were numerous Jewish settlements.

The name Mary, or Maria, is interpreted as *amarum mare*, bitter sea, or as illuminator, or illuminated. These three meanings are accepted as standing for three shares or parts, of which Mary made the best choices, namely, the part of penance, the part of inward contemplation, and the part of heavenly glory. This threefold share is what the Lord meant when he said: "Mary has chosen the best part, which shall not be taken away from her." The first part will not be taken away because of its end or purpose, which is the attainment of holiness. The second part will not be taken because of its continuity: contemplation during the earthly journey will continue in heavenly contemplation. And the third part will remain because it is eternal. Therefore, since Mary chose the best part, namely, penance, she is called bitter sea

The Penitent Magdalen, El Greco, 16th century

because in her penances she endured much bitterness. We see this from the fact that she shed enough tears to bathe the Lord's feet with them. Since she chose the best part of inward contemplation, she is called enlightener, because in contemplation she drew draughts of light so deep that in turn she poured out light in abundance: in contemplation she received the light with which she afterwards enlightened others. As she chose the best art of heavenly glory, she is called illuminated, because she now is enlightened by the lights of perfect knowledge in her mind and will be illuminated by the light of glory in her body.

Mary is called Magdalene, which is understood to mean "remaining guilty," or it means armed, or unconquered, or magnificent. These meanings point to the sort of woman she was before, at the time of, and after her conversion. Before her conversion she remained in guilt,

burdened with the debt of eternal
punishment. In her conversion she was
armed and rendered unconquerable by the
armor of penance: she armed herself the
best possible way—with all the weapons
of penance—because for every pleasure
she had enjoyed she found a way of
immolating herself. After her conversion
she was magnificent in the super-
abundance of grace, because where
trespass abounded, grace was
superabundant.

Mary's cognomen "Magdelene" comes
from Magdalum, the name of one of her
ancestral properties. She was wellborn,
descended of royal stock. Her father's
name was Syrus, her mother was called
Eucharia. With her brother Lazarus and
her sister Martha she owned Magdalum, a
walled town two miles from Genezareth,
along with Bethany, not far from
Jerusalem, and a considerable part of
Jerusalem itself. They had, however,
divided their holdings among themselves
in such a way that Magdalum belonged to
Mary (whence the name Magdelene),
Lazarus kept the property in Jerusalem,
and Bethany was Martha's. Magdalene
gave herself totally to the pleasures of the
flesh and Lazarus was devoted to the
military, while prudent Martha kept close
watch over her brother's and sister's estates
and took care of the needs of her armed

men, her servants, and the poor. After
Christ's ascension, however, they all sold
their possessions and laid the proceeds at
the feet of the apostles.

Magdalene, then, was very rich, and
the sensuous pleasure keeps company with
great wealth. Renowned as she was for her
beauty and her riches, she was no less
known for the way she gave her body to
pleasure—so much so that her proper
name was forgotten and she was
commonly called "the sinner." Meanwhile,
Christ was preaching here and there, and
she, guided by the divine will, hastened to
the house of Simon the leper, where, she
had learned, he was at table. Being a
sinner she did not dare mingle with the
righteous, but stayed back and washed the
Lord's feet with her tears, dried them with
her hair, and anointed them with precious
ointment. Because of the extreme heat of
the sun the people of that region bathed
and anointed themselves regularly.

Now Simon the Pharisee thought to
himself that if this man were a prophet,
he would never allow a sinful woman to
touch him; but the Lord rebuked him for
his proud righteousness and told the
woman that all her sins were forgiven.
This is the Magdalene upon whom Jesus
conferred such great graces and to whom
he showed so many marks of love. He cast
seven devils out of her, set her totally afire

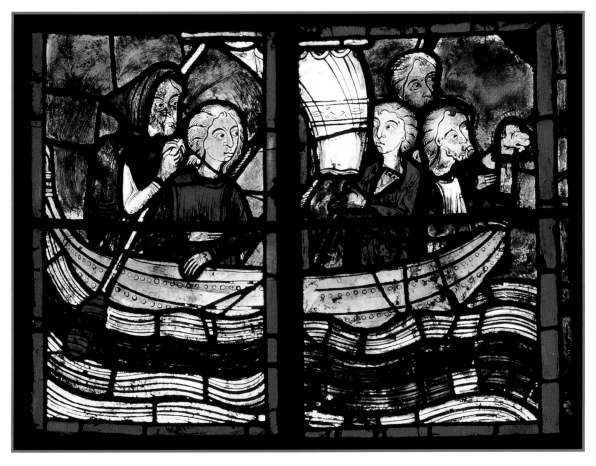

Saint Mary the Egyptian Arriving by Boat in France, artist unknown, 13th or 14th century

with love of him, counted her among his closest familiars, was her guest, had her do the housekeeping on his travels, and kindly took her side at all times. He defended her when the Pharisee said she was unclean, when her sister implied that she was lazy, when Judas called her wasteful. Seeing her weep, he could not contain his tears. For love of her he raised her brother, four days dead, to life, for love of her he freed her sister Martha from the issue of blood she had suffered for seven years, and in view of her merits he gave Martilla, her sister's

handmaid, the privilege of calling out those memorable words: "Blessed is the womb that bore you!" Indeed according to Ambrose, Martha was the woman with the issue of blood, and the woman who called out was Martha's servant. "She [Mary] it was, I say, who washed the Lord's feet with her tears, dried them with her hair and anointed them with ointment, who in the time of grace did solemn penance, who chose the best part, who sat at the Lord's feet and listened to his word, who anointed his head, who stood beside the cross at his

The Penitent Magdalene, Pedro de Mena, 1644

passion, who prepared the sweet spices with which to anoint his body, who, when the disciples left the tomb, did not go away, to whom the risen Lord first appeared, making her an apostle to the apostles."

Some fourteen years after the Lord's passion and ascension into heaven, when the Jews had long since killed Stephen and expelled the other disciples from the confines of Judea, the disciples went off into the lands of various nations and there sowed the word of the Lord. With the

apostles at the time was one of Christ's seventy-two disciples, blessed Maximin, to whose care blessed Peter had entrusted Mary Magdalene. In the dispersion Maximin, Mary Magdalene, her brother Lazarus, her sister Martha, Martha's maid Martilla, blessed Cedonius, who was born blind and had been cured by the Lord, and many other Christians, were herded by the unbelievers into a ship without pilot or rudder and sent out to sea so that they might all be drowned, but by God's will they eventually landed at Marseilles. There they found no one willing to give them shelter, so they took refuge under the portico of a shrine belonging to the people of that area. When blessed Mary Magdalene saw the people gathering at the shrine to offer sacrifice to the idols, she came forward, her manner calm and her face serene, and with well-chosen words called them away from the cult of idols and preached Christ fervidly to them. All who heard her were in admiration at her beauty, her eloquence, and the sweetness of her message…and no wonder, that the mouth which had pressed such pious and beautiful kisses on the Savior's feet should breathe forth the perfume of the word of God more profusely than others could.

Then the governor of that province came with his wife to offer sacrifice and pray the gods for offspring. Magdalene

preached Christ to him and dissuaded him from sacrificing. Some days later she appeared in a vision to the wife, saying: "Why, when you are so rich, do you allow the saints of God to die of hunger and cold?" She added the threat that if the lady did not persuade her husband to relieve the saints' needs, she might incur the wrath of God; but the woman was afraid to tell her spouse about the vision. The following night she saw the same vision and heard the same words, but again hesitated to tell her husband. The third time, in the silence of the dead of night, Mary Magdalene appeared to each of them, shaking with anger, her face afire as if the whole house were burning, and said: "So you sleep, tyrant, limb of your father Satan, with your viper of a wife who refused to tell you what I had said? You take your rest, you enemy of the cross of Christ, your gluttony sated with a bellyful of all sorts of food while you let the saints of God perish from hunger and thirst? You lie here wrapped in silken sheets, after seeing those others homeless and desolate, and passing them by? Wicked man, you will not escape! You will not go unpunished for your long delay in giving them some help!" And, having said her say, she disappeared.

The lady awoke gasping and trembling, and spoke to her husband, who was in like distress: "My lord, have you had the dream that I just had?" "I saw it," he answered, "and I can't stop wondering and shaking with fear! What are we to do?" His wife said: "It will be better for us to give in to her than to face the wrath of her God whom she preaches." They therefore provided shelter for the Christians and supplied their needs.

Then one day when Mary Magdalene was preaching, the aforesaid governor asked her: "Do you think you can defend the faith you preach?" "I am ready indeed to defend it," she replied, "because my

Saint Peter, Jusepe de Ribera, 17th century

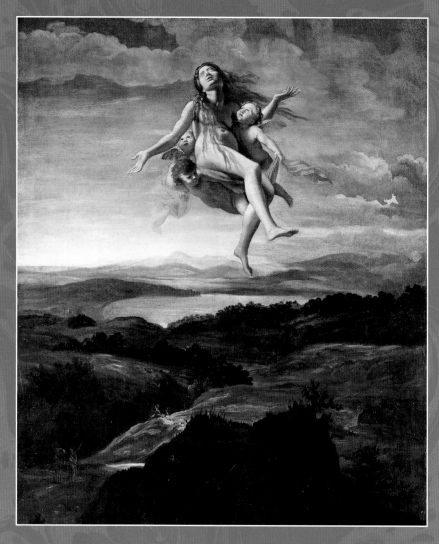

St. Mary Magdalene Transported to Heaven, Giovanni Lanfranco, 1605

Giovanni Lanfranco (1582–1647) the Italian painter of the High Baroque style was trained under Agostino Carracci in Parma. It is apparent in the painting St. Mary Magdalene Transported to Heaven painted in 1605 that his skill was honed by his many years of painting frescoes in Rome. In Magdalene's aloft body you can see his mastery of dramatic foreshortening— the stock and trade of Baroque fresco painting.

This rare and fascinating painting by Lanfranco has the unlikely overtones of surrealism, a movement still 300 years away. one witnesses a rapturous Magdalene being carried somewhat awkwardly heavenward by angels.

The work is graphic and yet a metaphor for Mary's spiritual authority and her profound attention to God. It is not every saint that is lifted into the divine realms by angels. In The Golden Legend she tells us that "everyday I am borne aloft seven times by angelic hands." The mystical number seven appears again in this manuscript. Could this be a reference to the seven energy centers of the body as exemplified in Eastern traditions or possibly a coded reference to the seventh chakra at the crown, which represents the highest spiritual connection—one of profound union with the Ultimate and the goal of meditation?

faith is strengthened by the daily miracles and preaching of my teacher Peter, who presides in Rome!" The governor and his wife then said to her: "See here, we are prepared to do whatever you tell us to if you can obtain a son for us from the God whom you preach." "In this he will not fail you," said Magdalene. Then the blessed Mary prayed the Lord to deign to grant them a son. The Lord heard her prayers and the woman conceived.

Now the husband began to want to go to Peter and find out whether what Magdalene preached about Christ was the truth. "What's this?" snapped his wife. "Are you thinking of going without me? Not a bit of it! You leave, I leave. You come back, I come back. You stay here, I stay here!" The man replied: "My dear, it can't be that way! You're pregnant and the perils of the sea are infinite. It's too risky. You will stay home and take care of what we have here!" But she insisted, doing as women do. She threw herself at his feet, weeping the while, and in the end won him over. Mary put the sign of the cross on their shoulders as a protection against the ancient Enemy's interference on their journey. They stocked a ship with all the necessaries, leaving the rest of their possessions in the care of Mary Magdalene, and set sail.

A day and night had not passed, however, when the wind rose and the sea became tumultuous. All aboard, and especially the expectant mother, were shaken and fearful as the waves battered the ship. Abruptly she went into labor, and, exhausted by her pangs and the buffeting of the storm, she expired as she brought forth her son. The newborn groped about seeking the comfort of his mother's breasts, and cried and whimpered piteously. Ah, what a pity! The infant is born, he lives, and has become his mother's killer! He may as well die, since there is no one to give him nourishment to keep him alive! What will the Pilgrim do, seeing his wife dead and the child whining plaintively as he seeks the maternal breast? His lamentations knew no bounds, and he said to himself: "Alas, what will you do? You yearned for a son, and you have lost the mother and the son too!"

The seamen meanwhile were shouting: "Throw that corpse overboard before we all perish! As long as it is with us, this storm will not let up!" They seized the body and were about to cast it into the sea, but the Pilgrim intervened. "Hold on a little!" he cried. "Even if you don't want to spare me the mother, at least pity the poor weeping little one! Wait just a bit! Maybe the woman has only fainted with pain and may begin to breathe again!"

Now suddenly they saw a hilly coast

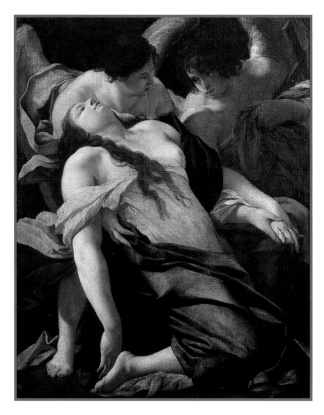

Mary Magdalene Carried by Angels
Simon Vouet, 17th century

not far off the bow, and the Pilgrim
thought it would be better to put the dead
body and the infant ashore there than
throw them as food to the sea monsters.
His pleas and his bribes barely persuaded
the crew to drop anchor there. Then he
found the ground so hard that he could not
dig a grave, so he spread his cloak in a fold
of the hill, laid his wife's body on it, and
placed the child with its head between the
mother's breasts. Then he wept and said:
"O Mary Magdalene, you brought ruin
upon me when you landed at Marseilles!
Unhappy me, that on your advice I set out
on this journey! Did you not pray to God

that my wife might conceive? Conceive she
did, and suffered death giving birth, and
the child she conceived was born only to
die because there is no one to nurse him.
Behold, this is what your prayer obtained
for me. I commended my all to you and do
commend me to your God. If it be your
power, be mindful of the mother's soul,
and by your prayer take pity on the child
and spare its life." Then he enfolded the
body and the child in his cloak and went
back aboard the ship.

When the Pilgrim arrived in Rome,
Peter came to meet him, and seeing the
sign of the cross on his shoulder, asked
him who he was and where he came from.
He told Peter all that had happened to
him, and Peter responded: "Peace be with
you! You have done well to trust the good
advice you received. Do not take it amiss
that your wife sleeps and the infant rests
with her. It is in the Lord's power to give
gifts to whom he will, to take away what
was given, to restore what was taken away,
and to turn your grief into joy."

Peter then took him to Jerusalem and
showed him all the places where Christ
had preached and performed miracles, as
well as the place where he had suffered
and the other from which he had ascended
into heaven. Peter then gave him thorough
instruction in the faith, and after two years
had gone by, he boarded ship, being eager

to get back to his homeland. By God's will, in the course of the voyage they came close to the hilly coast where he had left the body of his wife and his son, and with pleas and money he induced the crew to put him ashore. The little boy, whom Mary Magdalene had preserved unharmed, used to come down to the beach and play with the stones and pebbles, as children love to do. As the Pilgrim's skiff drew near to the land, he saw the child playing on the beach. He was dumbstruck at seeing his son alive and leapt ashore from the skiff. The child, who had never seen a man, was terrified at the sight and ran to his mother's bosom, taking cover under the familiar cloak. The Pilgrim, anxious to see what was happening, followed, and found the handsome child feeding at his mother's breast. He lifted the boy and said: "O Mary Magdalene, how happy I would be,

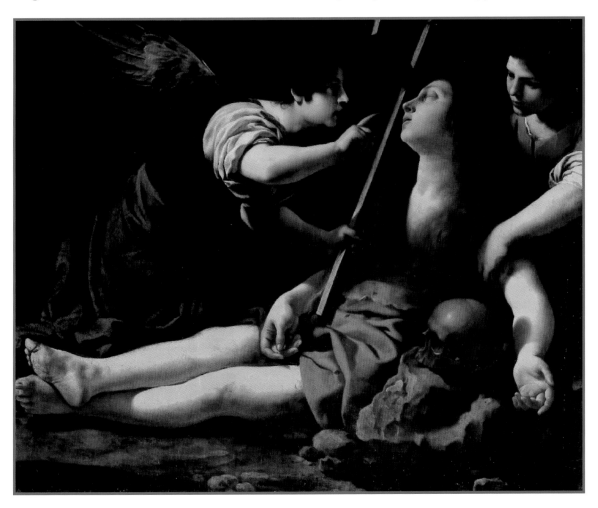

Mary Magdalen Assisted by Two Angels, Rutillo Manetti, 16th or 17th century

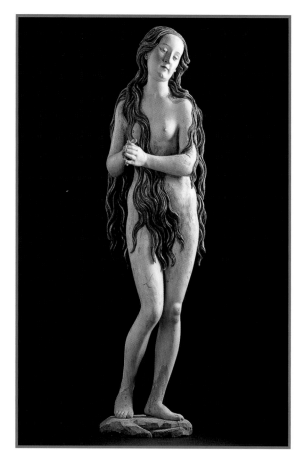

Saint Mary Magdalene, Gregor Erhart, c.1515

how well everything would have turned out for me, if my wife were alive and able to return home with me! Indeed I know, I know and believe beyond a doubt, that having given us this child and kept him alive for two years on this rock, you could now, by your prayers, restore his mother to life and health."

As these words were spoken, the woman breathed and, as if waking from sleep, said: "Great is your merit, O blessed Mary Magdalene, and you are glorious! As I struggled to give birth, you did me a midwife's service and waited upon my every need like a faithful handmaid." Hearing this, the Pilgrim said: "My dear wife, are you alive?" "Indeed I am," she answered, "and am just coming from the pilgrimage from which you yourself are returning. And as blessed Peter conducted you to Jerusalem and showed you all the places where Christ suffered, died, and was buried, and many other places, I, with blessed Mary Magdalene as my guide and companion, was with you and committed all you saw to memory." Whereupon she recited all the places where Christ had suffered, and fully explained the miracles and all she had seen, not missing a single thing.

Now the Pilgrim, having got back his wife and child, joyfully took ship and in a short time made port at Marseilles. Going into the city they found blessed Mary Magdalene with her disciples, preaching. Weeping with joy, they threw themselves at her feet and related all that had happened to them, then received holy baptism from blessed Maximin. Afterwards they destroyed the temples of all the idols in the city of Marseilles and built churches to Christ. They also elected blessed Lazarus as bishop of the city. Later by the will of God they went to the city of Aix, and, by many miracles, led the people there to accept the Christian faith. Blessed Maximin was ordained bishop of Aix.

At this time blessed Mary Magdalene, wishing to devote herself to heavenly contemplation, retired to an empty wilderness, and lived unknown for thirty years in a place made ready by the hands of angels. There were no streams of water there, nor the comfort of grass or trees: thus it was made clear that our Redeemer had determined to fill her not with earthly viands but only with the good things of heaven. Every day at the seven canonical hours she was carried aloft by angels and with her bodily ears heard the glorious chants of the celestial hosts. So it was that day by day she was gratified with these supernatural delights and, being conveyed back to her own place by the same angels, needed no material nourishment.

There was a priest who wanted to live a solitary life and built himself a cell a few miles from the Magdalene's habitat. One day the Lord opened this priest's eyes, and with his own eyes he saw how the angels descended to the already-mentioned place where blessed Mary Magdalene dwelt, and how they lifted her into the upper air and an hour later brought her back to her place with divine praises. Wanting to learn the truth about this wondrous vision and commending himself prayerfully to his Creator, he hurried with daring and devotion toward the aforesaid place; but when he was a stone's throw from the spot,

his knees began to wobble, and he was so frightened that he could hardly breathe. When he started to go away, his legs and feet responded, but every time he turned around and tried to reach the desired spot, his body went limp and his mind went blank, and he could not move forward.

So the man of God realized that there was a heavenly secret here to which human experience alone could have no access. He therefore invoked his Savior's name and called out: "I adjure you by the Lord, that if you are a human being or any rational creature living in that cave, you answer me and tell me the truth about yourself!" When he had repeated this three times, blessed Mary Magdalene answered him: "Come closer, and you can learn the truth about whatever your soul desires." Trembling, he had gone halfway across the intervening space when she said to him: "Do you remember what the Gospel says about Mary the notorious sinner, who washed the Savior's feet with her tears and dried them with her hair, and earned forgiveness for all her misdeeds?" "I do remember," the priest replied, "and more than thirty years have gone by since then. Holy Church also believes and confesses what you have said about her." "I am that woman," she said. "For a space of thirty years I have lived here unknown to everyone; and as you

were allowed to see yesterday, every day I am borne aloft seven times by angelic hands, and have been found worthy to hear with the ears of my body the joyful jubilation of the heavenly hosts. Now, because it has been revealed to me by the Lord that I am soon to depart from this world, please go to blessed Maximin and take care to inform him that next year, on the day of the Lord's resurrection, at the time when he regularly rises for matins, he is to go alone to his church, and there he will find me present and waited upon by angels." To the priest the voice sounded like the voice of an angel, but he saw no one.

The good man hurried to blessed Maximin and carried out his errand. Saint Maximin, overjoyed, gave fulsome thanks to the Savior, and on the appointed day, at the appointed hour, went alone into the church and saw blessed Mary Magdalene amidst the choir of angels who had brought her there. She was raised up a distance of two cubits above the floor, standing among the angels and lifting her hands in prayer to God. When blessed Maximin hesitated about approaching her, she turned to him and said, "Come closer, father, and do not back away from your daughter." When he drew near to her, as we read in blessed Maximin's own books, the lady's countenance was so radiant, due

to her continuous and daily vision of the angels, that one would more easily look straight into the sun than gaze upon her face.

All the clergy, including the priest already mentioned, were now called together, and blessed Mary Magdalene, shedding tears of joy, received the Lord's Body and Blood from the bishop. Then she lay down full length before the steps of the altar, and her most holy soul migrated to the Lord. After she expired, so powerful an odor of sweetness pervaded the church that for seven days all those who entered there noticed it. Blessed Maximin embalmed her holy body with aromatic lotions and gave it honorable burial, giving orders that after his death he was to be buried close to her.

Hegesippus (or, as some books have it, Josephus) agrees in the main with the story just told. He says in one of his treatises that after Christ's ascension Mary Magdalene, weary of the world and moved by her ardent love of the Lord, never wanted to see anyone. After she came to Aix, she went off into the desert, lived there unknown for thirty years, and every day at the seven canonical hours was carried up to heaven by an angel. He added, however, that the priest who went to her found her closed up in a cell. At her request he reached out a garment to her,

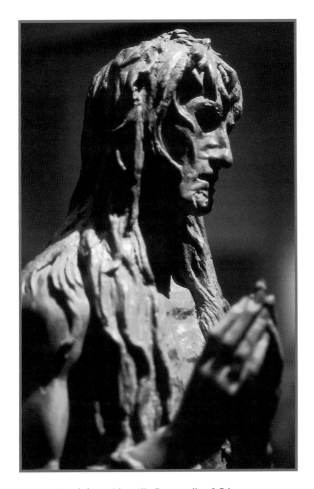

Mary Magdalene (detail), Donatello, 15th century

bring back the relics of Saint Mary Magdalene, if possible. When the monk arrived at the aforesaid city, however, he found that it had been razed to the ground by the pagans. Yet by chance he discovered a marble sarcophagus with an inscription which indicated that the body of blessed Mary Magdalene was contained inside, and her whole story was beautifully carved on the outside. The monk therefore broke into the sarcophagus by night, gathered the relics, and carried them to his inn. That same night blessed Mary appeared to him and told him not to be afraid but to go on with the work he had begun. On their way back to Vezelay the company, when they were half a league from their monastery, could not move the relics another step until the abbot and his monks came in solemn procession to receive them.

A certain knight, whose practice it was to visit the relics of Saint Mary Magdalene every year, was killed in battle. As he lay dead on his bier, his parents, mourning him, made pious complaint to the Magdalene because she had allowed her devotee to die without making confession and doing penance. Then suddenly, to the amazement of all present, the dead man rose up and called for a priest. He made his confession devoutly and received viaticum; then returned to rest in peace.

A ship crowded with men and women

and when she had put in on, she went with him to the church, received communion there, and, raising her hands in prayer beside the altar, died in peace.

In Charlemagne's time, namely, in the year of the Lord 769, Gerard, duke of Burgundy, being unable to have a son of his wife, openhandedly gave away his wealth to the poor and built many churches and monasteries. When he had built the monastery at Vezelay, he and the abbot sent a monk, with a suitable company, to the city of Aix in order to

was sinking, and one woman, who was pregnant and saw herself in danger of drowning, called upon Magdalene as loudly as she could, and vowed that if by Mary's merits she escaped death and bore a son, she would give him up to the saint's monastery. At once the woman of venerable visage and bearing appeared to her, held her up by the chin, and while the rest drowned, brought her unharmed to land. The woman in due time gave birth to a son and faithfully fulfilled her vow.

There are some who say that Mary Magdalene was espoused to John the Evangelist, who was about to take her as his wife when Christ called him away from his nuptials, whereupon she, indignant at having been deprived of her spouse, gave herself up to every sort of voluptuousness. But, since it would not do to have John's vocation the occasion of Mary's damnation, the Lord mercifully brought her around to conversion and penance; and, because she had had to forgo the heights of carnal enjoyment, he filled her more than others with the most intense spiritual delight, which consists in the love of God. And there are those who allege that Christ honored John with special evidences of his affection because he had taken him away from the aforesaid pleasures. These tales are to be considered false and frivolous. Brother Albert, in his

introduction to the gospel of John, says firmly that the lady from whose nuptials the same John was called away persevered in virginity, was seen later in the company of the Blessed Virgin Mary, mother of Christ, and came at last to a holy end.

A man who had lost his eyesight was on his way to the monastery at Vezelay to visit Mary Magdalene's body when his guide told him that he, the guide, could already see the church in the distance. The blind man exclaimed in a loud voice: "O holy Mary Magdalene, if only I could sometime be worthy in your church!" At once his eyes were opened.

There was a man who wrote a list of his sins on a sheet of paper and put it under the rug on the Magdalene's altar, asking her to pray that he might be pardoned. Later he recovered the paper and found that his sins had been wiped out.

A man who lay in chains for having committed the crime of extortion called upon Mary Magdalene to come to his aid, and one night a beautiful woman appeared to him, broke his fetters, and ordered him to be off. Seeing himself unshackled, he got away as fast as possible.

A clerk from Flanders, Stephen by name, had fallen into such a welter of sinfulness that, having committed every sort of evil, he could do no works of salvation nor even bear to hear of them.

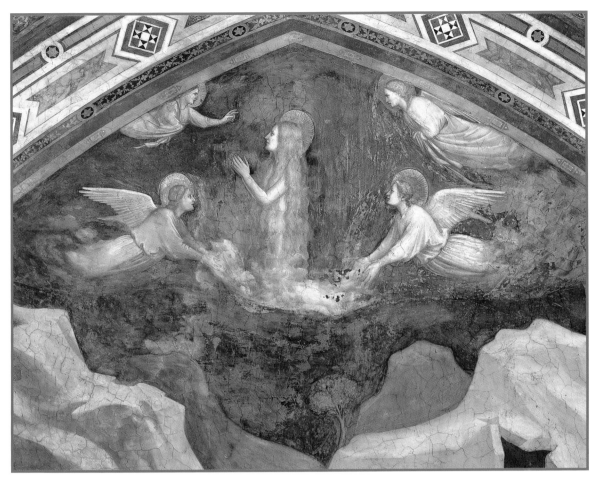

Mary Magdalene Conversing with Angels, Giotto School, c.1300

Yet he had deep devotion to blessed Mary Magdalene, observed her vigils by fasting, and celebrated her feast day. Once he was on a visit to her tomb and was half asleep and half awake, Mary Magdalene appeared to him as a lovely, sad-eyed woman supported by two angels, one on either side, and she said to him: "Stephen, I ask you, why do you repay me with deeds unworthy of my deserts? Why are you not moved with compunction by what my own lips insistently say? From the time when you began to be devoted to me I have always prayed the Lord urgently for you. Get up, then! Repent! I will never leave you until you are reconciled with God!" The clerk soon felt so great an inpouring of grace in himself that he renounced the world, entered the religious life, and lived a very holy life thereafter. At his death Mary Magdalene was seen standing with angels beside the bier, and she carried his soul, like a pure-white dove, with songs of praise into heaven. ≈

The Last Temptation of Christ

by Kazantzakis (excerpt), 1960

Purring, Mary Magdalene hugged the man, kept his body glued to hers. "No man has ever kissed me. I have never felt a man's beard over my lips and cheeks, nor a man's knees between my knees. This is the day of my birth!...Are you crying my child?"

"Beloved wife, I never knew the world was so beautiful or the flesh so holy. It too is a daughter of God, a graceful sister of the soul. I never knew that the joys of the body were not sinful."

"Why did you set out to conquer heaven, and sigh, and seek the miraculous water of eternal life? I am that water. You have stooped, drunk, found peace...Are you still sighing my child? What are you thinking about?"

"My heart is a withered rose of Jericho which revives and opens up again when placed in water. Woman is a fountain of immortal water. Now I understand." ⤜

Rose, from Saint Jerome's version of The Minor Prophets and Job, 13th century

A glorious red rose encircled by what might be the notes of celestial music adorns St. Jerome's translation of Minor Prophets. Although Jerome would have been distressed to read our excerpt as he praised virginity, the image is one that perfectly symbolizes and is in harmony with Kazantzakis.

The rose has a long history as symbolic feminine energies and in Christianity represents the Mother Mary as well as the Mary Magdalene. The red rose has also been associated with Jesus' blood at the crucifixion and possibly down the ages. In classical Rome, Cupid's (Eros) offer of a rose to the god Harpocrates as a bribe to silence him about the dalliances of Cupid's amorous mother (Venus) became a symbol of confidentiality, as in sub rosa or under the rose.

Mary Magdalene is the patron saint of perfume and gardens. Margaret Starbird, in her book The Woman with the Alabaster Jar, reminds us, "It was not accidental that the cult of the Rose (an anagram for Eros) flourished and bloomed in the garden of Provence...The idiom 'under the sign of the rose' actually meant something specific for the initiated. For them...the secret is the rose—the red rose of the other Mary, the Mary who represents Eros, the passionate bridal aspect of the feminine, which was denied by the established church."

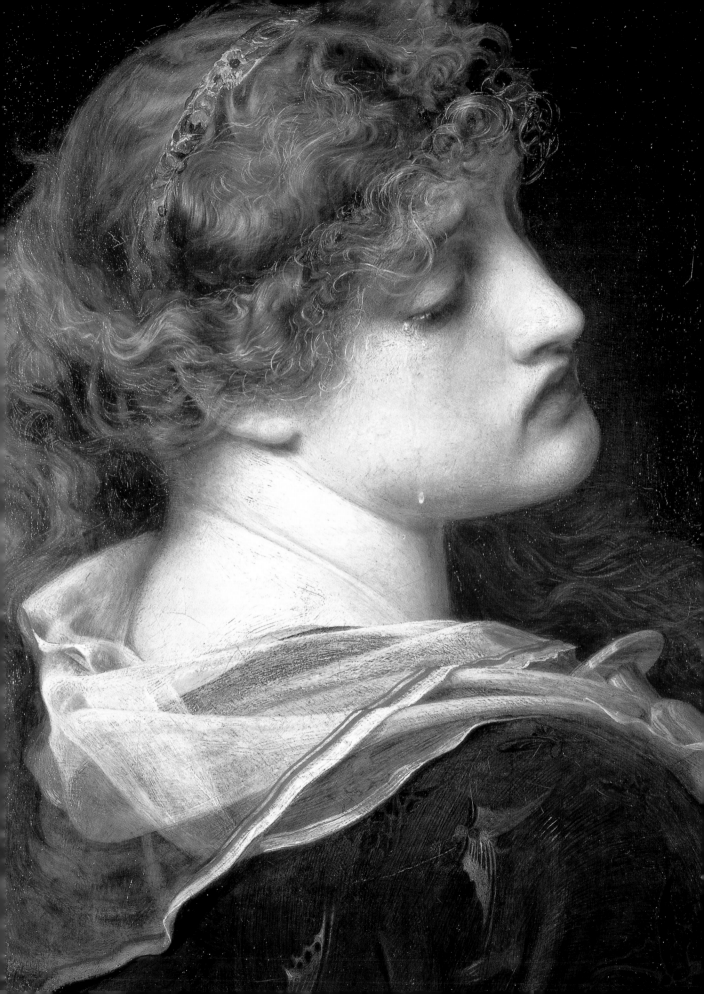

He's a man, he's just a man

I Don't Know How to Love Him

From *Jesus Christ Superstar*, Lyrics by Tim Rice, 1971

(Sung by Mary Magdalene)

I don't know how to love him
What to do, how to move him
I've been changed, yes really changed
In these past few days
When I've seen myself
I seem like someone else

I don't know how to take this
I don't see why he moves me
He's a man
He's just a man
And I've had so many men before
In very many ways
He's just one more

Should I bring him down
Should I scream and shout
Should I speak of love
Let my feelings out?
I never thought I'd come to this—
What's it all about?

Don't you think it's rather funny
I should be in this position?
I'm the one who's always been
So calm so cool, no lover's fool
Running every show
He scares me so

I never thought I'd come to this
What's it all about?
Yet if he said he loved me
I'd be lost I'd be frightened
I couldn't cope
Just couldn't cope
I'd turn my head I'd back away
I wouldn't want to know
He scares me so
I want him so
I love him so ⤜

Mary Magdalene, Frederick Sandys, 1862

Letter from Abelard to Heloise

—TWELFTH CENTURY

Abelard and Heloise were a pair of medieval lovers that can easily be compared with Romeo and Juliet or Dante and Beatrice. Their love is uniquely chronicled in an exchange of astonishing letters.

Peter Abelard, one of the most brilliant minds of his day, admired a young and attractive niece of a canon Fulbert by the name of Heloise. She was a very intelligent girl and, as Abelard writes, "in the extent of her learning she stood supreme." Fulbert foolishly gave Abelard complete charge over her and he moved in under the same roof, "and so with our lessons as a pretext we abandoned ourselves entirely to love." Heloise became pregnant and they married but that did not curtail Fulbert in his plan to castrate Abelard. Here Abelard cites Mary Magdalene in his discussion of faithful Christian women.

Let us return now to the subject of the faithful Christian women and marvel at the respect paid by God's mercy even to the abjectness of public prostitutes. What could be more abject that the original state of life of Mary Magdalene or Mary the Egyptian? Yet divine grace raised them by honour or merit to sublime heights: "I say unto you that the harlots go into the kingdom of God before you." "Who does not know that women have embraced the exhortation of Christ and the counsel of the apostles with such great zeal for their chastity that they have offered themselves to God as a burnt sacrifice through martyrdom? Preserving equally the wholeness of the body and the mind, they triumph with a double crown. They strive to follow the Bridegroom of virgins, 'The Lamb of God whithersoever he goeth.' We know that such perfection of virtue is rare in men but common in women." We even read that some women have not hesitated to lay hands on themselves, rather than lose the virtue which they have vowed to God, so that they might come as virgins to the virgin Bridegroom. ✍

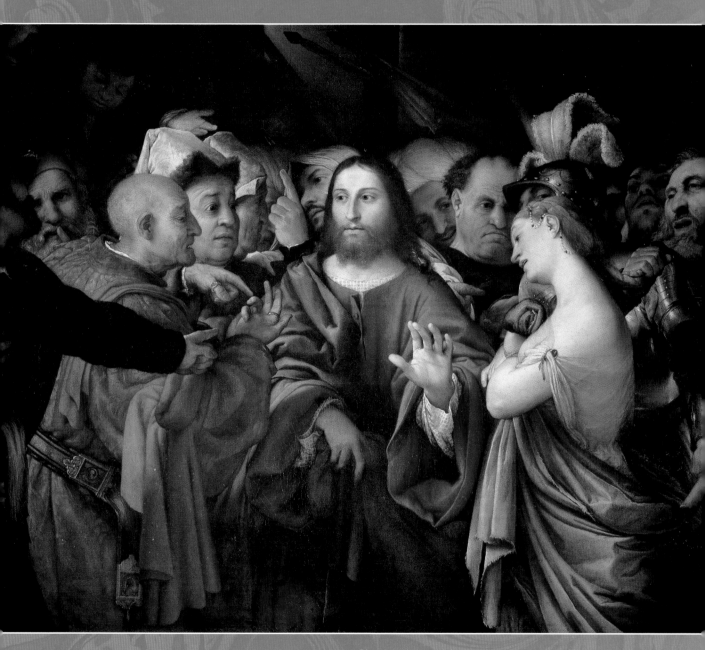

Christ and the Adulteress, Lorenzo Lotto, 16th century

And the burning eyes of men

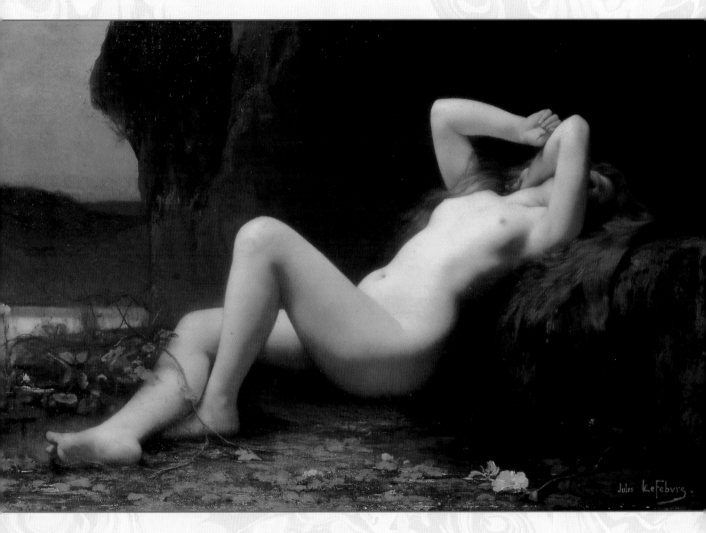

Mary Magdalene in the Cave, Jules Joseph Lefebvre, 1876

The New Magdalene

—JOHN COWPER POWYS, 1916

She turns her with sick heart
From the crowd with the burning eyes.

She flees to the woods apart
Where the old world's shadow lies.

And there in the leafy gloom,
With her white face hid in her hair,

She moans the unpitied doom
Of the flesh that's born too fair.

Softly with amorous tread
From the dark doth a Satyr creep

And standing close to her head
Watches the wanton weep.

Like the mask of a thousand years
The lust in him drops away,

And big immortal tears
Make a grave for it in the clay.

And gently on bended knees
He worships the wanton there,

Pouring old heathen litanies
Into her drooping hair.

And the heart of the old world then
Flings forth its ancient balm,

And the burning eyes of men
Can work her no more harm. ✎

Can work her no more harm

Mary Magdalene

From *The Gospel Women* by George MacDonald, 19th century

With wandering eyes and aimless zeal,
She hither, thither, goes;

Her speech, her motions, all reveal
A mind without repose.

She climbs the hills, she haunts the sea,
By madness tortured, driven;

One hour's forgetfulness would be
A gift from very heaven!

She slumbers into new distress;
The night is worse than day:

Exulting in her helplessness,
Hell's dogs yet louder bay.

The demons blast her to and fro;
She has no quiet place,

Enough a woman still, to know
A haunting dim disgrace.

A human touch! a pang of death!
And in a low delight

Thou liest, waiting for new breath,
For morning out of night.

Thou risest up: the earth is fair,
The wind is cool; thou art free!

Is it a dream of hell's despair
Dissolves in ecstasy?

That man did touch thee! Eyes divine
Make sunrise in thy soul;

Thou seëst love in order shine:—
His health hath made thee whole!

Thou, sharing in the awful doom,
Didst help thy Lord to die;

Then, weeping o'er his empty tomb,
Didst hear him Mary cry.

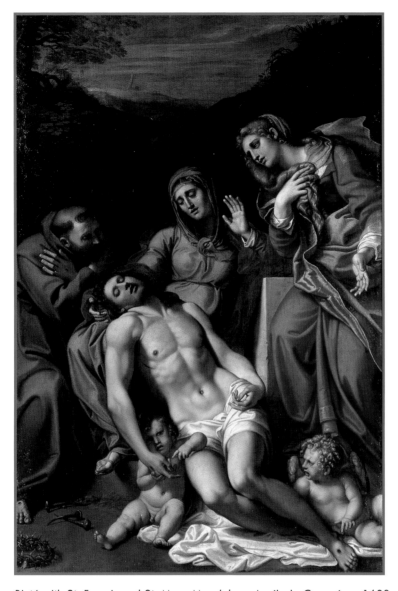

Pietá with St. Francis and St. Mary Magdalene, Annibale Carracia, c.1602

He stands in haste; he cannot stop;
Home to his God he fares:

"Go tell my brothers I go up
To my Father, mine and theirs."

Run, Mary! lift thy heavenly voice;
Cry, cry, and heed not how;

Make all the new-risen world rejoice—
Its first apostle thou!

What if old tales of thee have lied,
Or truth have told, thou art

All-safe with him, whate'er betide—
Dwell'st with him in God's heart! ✍

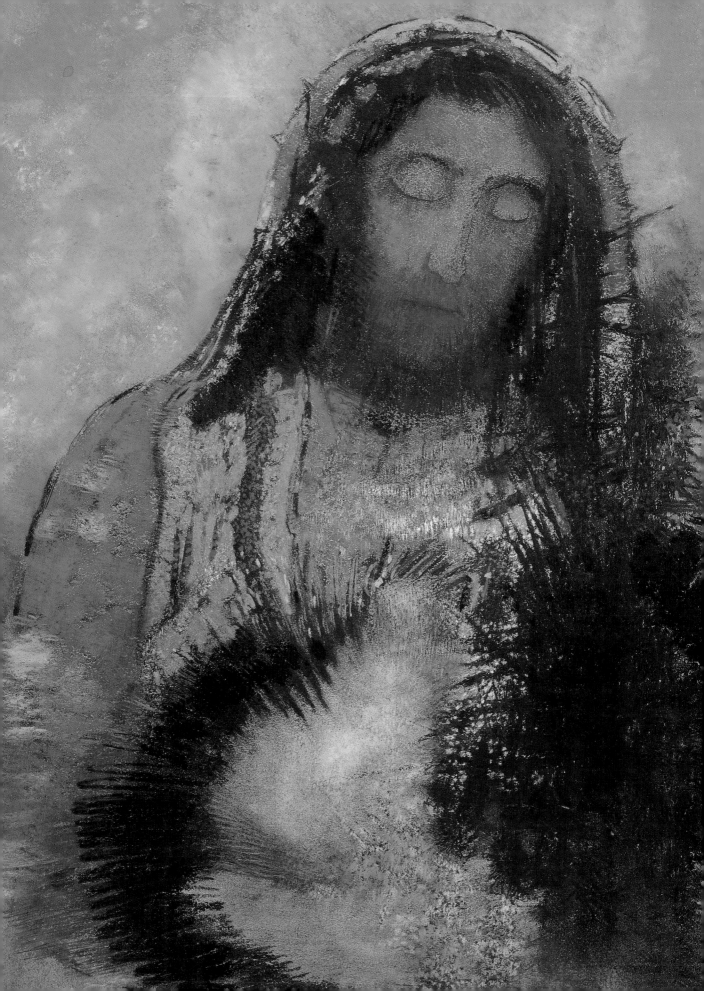

Jesus the Son of Man

Mary Magdalene (Thirty Years Later) **by Kahlil Gibran (excerpt), 1928**

Once again I say that with death Jesus conquered death, and rose from the grave a spirit and a power. And He walked in our solitude and visited the gardens of our passion.

He lies not there in that cleft rock behind the stone.

We who love Him beheld Him with these our eyes which He made to see; and we touched Him with these our hands which He taught to reach forth.

I know you who believe not in Him. I was one of you, and you are many; but your number shall be diminished.

Must you break your harp and your lyre to find the music therein?

Or must you fell a tree ere you can believe it bears fruit?

You hate Jesus because someone from the North Country said He was the Son of God. But you hate one another because each of you deems himself too great to be the brother of the next man.

You hate Him because someone said He was born of a virgin, and not of man's seed.

But you know not the mothers who go to the tomb in virginity, nor the men who go down to the grave choked with their own thirst.

You know not that the earth was given in marriage to the sun, and that earth it is who sends us forth to the mountain and the desert.

There is a gulf that yawns between those who love Him and those who hate Him, between those who believe and those who do not believe.

But when the years have bridged that gulf you shall know that He who lived in us is deathless, that He was the Son of God even as we are the children of God; that He was born of a virgin even as we are born of the husbandless earth.

It is passing strange that the earth gives not to the unbelievers the roots that would suck at her breast, nor the wings wherewith to fly high and drink, and be filled with the dews of her space.

But I know what I know, and it is enough. ✐

The Sacred Heart, Odilon Redon, c.1906

I am black, but comely,

Song of Solomon

Chapter One

The song of songs, which is Solomon's.

Let him kiss me with the kisses of his mouth: for thy love is better than wine.

Because of the savour of thy good ointments thy name is as ointment poured forth, therefore do the virgins love thee.

Draw me, we will run after thee: the king hath brought me into his chambers: we will be glad and rejoice in thee, we will remember thy love more than wine: the upright love thee.

I am black, but comely, O ye daughters of Jerusalem, as the tents of Kedar, as the curtains of Solomon.

Look not upon me, because I am black, because the sun hath looked upon me: my mother's children were angry with me; they made me the keeper of the vineyards; but mine own vineyard have I not kept.

Tell me, O thou whom my soul loveth, where thou feedest, where thou makest thy flock to rest at noon: for why should I be as one that turneth aside by the flocks of thy companions?

If thou know not, O thou fairest among women, go thy way forth by the footsteps of the flock, and feed thy kids beside the shepherds' tents.

I have compared thee, O my love, to a company of horses in Pharaoh's chariots.

Thy cheeks are comely with rows of jewels, thy neck with chains of gold.

We will make thee borders of gold with studs of silver.

While the king sitteth at his table, my spikenard sendeth forth the smell thereof.

A bundle of myrrh is my wellbeloved unto me; he shall lie all night betwixt my breasts.

My beloved is unto me as a cluster of camphire in the vineyards of Engedi.

Behold, thou art fair, my love; behold, thou art fair; thou hast doves' eyes.

Behold, thou art fair, my beloved, yea, pleasant: also our bed is green.

The beams of our house are cedar, and our rafters of fir.

O ye daughters of Jerusalem

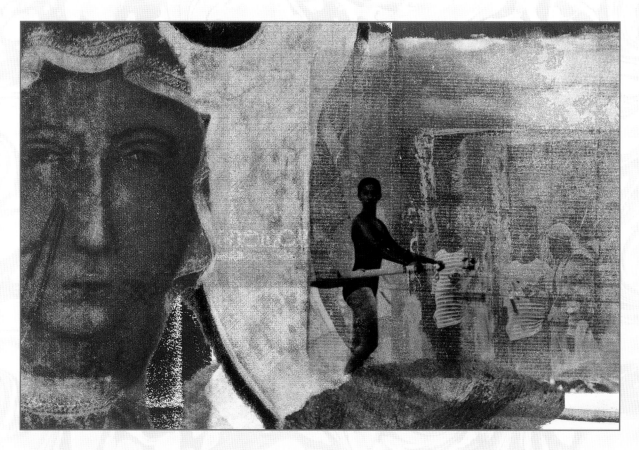

The Black Madonna, Joan Brooks Baker, 2004

Throughout the world there are 450 black Madonnas that strongly suggest a link between earlier pagan spiritual traditions and Christianity. Many are conjoined to shrines that celebrate Mary Magdalene. The sculptures and murals of the Egyptian Goddess Isis, the goddess of alchemy, and her son Horus inspired these early black representations and icons of the Madonna and child. Both the words "alchemy" and "Egypt" are derivative of the word "Khem" meaning "black earth."

The cult of the Black Virgins points to the alternative spiritual schools of Gnosticism, which include the Cathars and the Mary Magdalene cult. Also included are the Templars, the protectors of the Grail and the hermetical disciples of alchemy. Given the tendency of nobility to align themselves to the gods, the French monarchs of the Mergovingian line regarded Mary Magdalene as an ancestor in an attempt to trump the Holy Roman church and its political and spiritual authority. Lacordaire, who after the French Revolution rebuilt the Dominican Order in France, claimed that Loius the XI revered the Black Madonnas and considered the Magdalene his ancestor, linking him by way of Jesus and Mary Magdalene to God. The Black Virgins had other notable devotees, among them Joan of Arc, the alchemist Fulcanelli and Anatole France, to name just a few.

Photographic artist Joan Brook Baker has created works inspired by and incorporating these compelling Madonnas. The Black Madonnas and the mysteries they hold are awakening into the consciousness of the 21st century. There is a transformation of spiritual consciousness at hand. The outcome of this new alchemy is yet to be fully realized or understood, but it is clear that an essential element is Mary Magdalene.

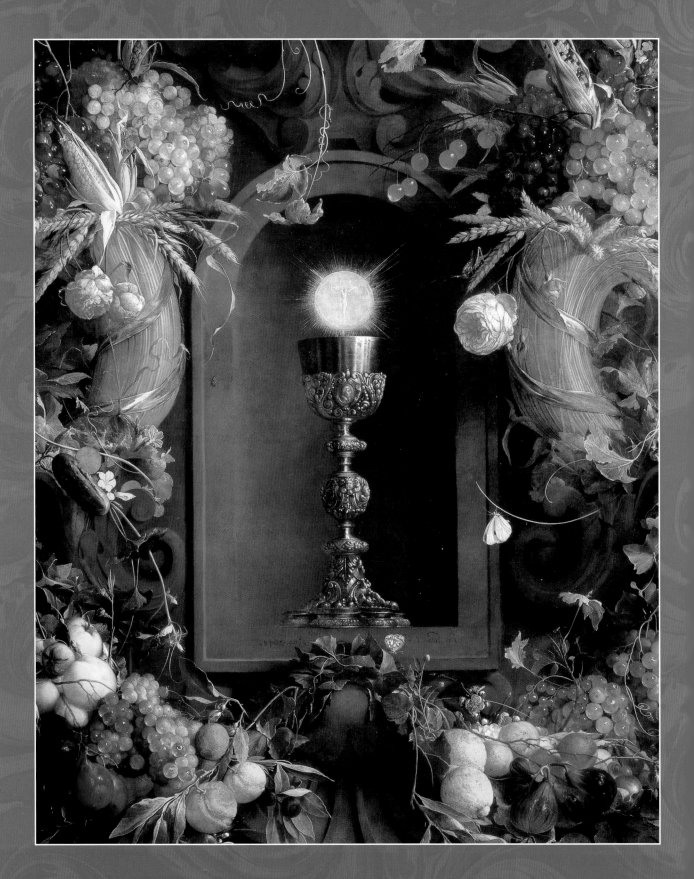

CHAPTER FIVE

Mary and the Mystery of the Holy Grail

And as they were eating, Jesus took bread, and blessed it, and broke it, and gave it to the disciples, and said, Take, eat; this is my body.

And he took the cup, and gave thanks, and gave it to them, saying, Drink ye all of it; which is shed for many for the remission of sins.

—Matthew 26:26–28

OUR JOURNEY IN search of the Magdalene now brings us to the Middle Ages, a great era of Christianity in Europe, when Our Lady appears to change form yet again. Quite tangible in both the gospels from the New Testament and those found at Nag Hammadi, by the 11th, 12th and 13th centuries she has undergone a substantive change. It is as though what seemed real was transmuted into an image not unlike a stained glass window—mysteriously illuminated with light from above. The

Chalice and Host, Jan Davidsz de Heem, c.1650

Magdalene has split into numerous elusive forms, each part a separate piece of an over-arching whole. This fragmented image, when fully revealed, symbolizes all our longing for the divine as experienced in the Feminine—The Holy Grail.

In this chapter we will visit these individual panes as they relate to the Feminine through our various authors— each one shedding light on an aspect of the Magdalene's meaning that has been encoded in Grail legend. It is not surprising that she went underground and changed form as her gospels were destroyed and her followers and champions were deemed heretic and often killed. The burning of thousands of irreplaceable volumes and scrolls by a Christian mob at the great library in Alexandria in the 4th century consumed masterpieces of theology. Many other works, including those by Maimonides and the Cathars were destroyed in bonfires that continued throughout the 12th and 13th centuries, taking with them the very books that would have informed our search. In an

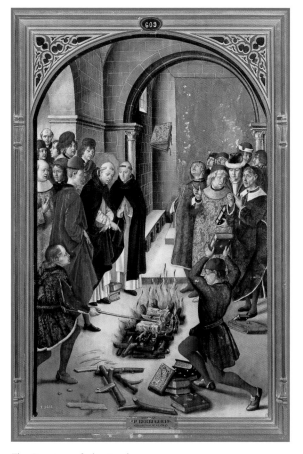

The Burning of the Books
Pedro Berruguete, 15th century

world, she was forced to find new forms that were hidden and secret. The grail is the most significant role she assumed in the Middle Ages.

Before moving forward into the Mystery of the Holy Grail we must return briefly to the pre-Christian Mediterranean cultures that antecede the Mary and Jesus narrative because the secret of this new transformation lies within the religions of these communities. From Egypt to Mesopotamia, in ancient times, the feminine principle was honored and wor-shipped as divine. Even as late as the Roman era, there were pockets where a religion flourished that was based on the universal goddesses of Cybele and Isis, who resembled earlier goddesses such as Ishtar and Mari.

When we recall the moment that an unnamed woman (associated with the Magdalene) anoints Jesus before his death and burial, we must consider the earlier goddess traditions that informed this sacred act. In ancient cultures Mari anoints her doomed consort god as he descends to the underworld, from which he will arise again. It can be argued that the above episode in Matthew reflects the Magdalene's relationship to this ancient rite and explains Jesus' unusual and power-ful response to the blessing of the oil. It would seem quite credible that Mary Magdalene has deep roots in these early religions that worshipped the Divine

attempt to make Christianity the religion of the empire, Rome had pro-duced a version that would appeal to its broad and varied population—and in so doing, kept it simple. With all due respect, this early Romanized Christian religion was one that seemed to suit the lowest common denominator—a religion for the literal minded—an exoteric philosophy. And with Constantine's proclivity for the male-oriented cult of Sol Invictus, it follows that his church excluded the femi-nine altogether. For the Magdalene, therefore, the die was cast. In this new

Feminine, and as we move into the Grail territory, her outline becomes conjoined to that of the great Feminine Principle.

In an attempt to explain one of the primary sources of how the Grail became associated with the Magdalene, we need to visit the Languedoc in the South of France, the area that gave rise to the Cathars from the 11th to the 13th centuries and near to where Mary is purported to have traveled and lived after Jesus' death. The Cathars, (derived from the Greek word *katharos* meaning "pure") held the Magdalene in high esteem and were believed to be the guardians of the Grail. They were basically a Gnostic sect that held that they carried the torch of the true teachings—inheritors of the words of Jesus—and that their form of Christianity was of a purer nature than that of Rome. The holy-initiated men and women were called *Parfait* ("Perfect") and often traveled in pairs to teach. Female Parfait held high positions and blessed, and healed, essentially functioning as priests. Philosophically, the faith was dualistic. The Cathars believed the earth was not the creation of a good god—matter had been corrupted and worldly authority was also considered corrupt. The Church was believed to be less than holy. They refused to honor secular laws. They taught a way to the Divine light through diet (vegans all) and good deeds so that upon death they would ascend to the True God. If not,

they would return and be reincarnated into another life until they could achieve saintlike perfection. They repudiated the significance of the crucifixion and did not feel that the brutal murder of Jesus was an appropriate focus for worship. The Cathari chose to see Jesus as the great teacher of *Amor* (love), and that *Roma* (Rome), was but King of the material world (*Rex Mundi*) and had corrupted this great principle of love. And so a crusade was waged by Rome to wipe out the heretic Cathari. Given that Cathars were pacifists the outcome was inevitable. By 1215, the Council of Lateran established the Inquisition, which ultimately killed over a million of Cathari. They and all their books and documents were burned in the holocaust.

The 11th-century Cistercian monk Bernard Clairvaux brought to the attention of Rome that "no one could be more Christian. As to their conversation, nothing can be less reprehensible, and what they speak they prove by deeds. As for the morals of the heretics, they cheat no one, they oppress no one, they strike no one." Despite recognizing their true Christian character, Bernard was in support of their destruction.

The connection between the Grail and the Magdalene is rooted with the Cathars of the Languedoc. There are numerous legends that link the Grail to the Cathars. It has been maintained that the Grail romances, excerpts of which are included

here, from Chretien de Troyes, Wolfram von Eschenbach, and others, are interpolations of Cathari philosophy. These teachings are hidden through elaborate symbolism and in this disguise concealed in the very center of Christian orthodoxy. In Baigent, Leigh and Lincoln's successful book *Holy Blood, Holy Grail*, the authors confirm that "during the Albigensian (Cathar) Crusade ecclesiastics fulminated against the Grail romances, declaring them to be pernicious if not heretical. And in some of these romances there are isolated passages that are not only highly unorthodox but quite unmistakably dualistic—in other words, Cathar." They also mention that Eschenbach places the Grail Castle in the Pyrenees in proximity to the Cathar Castle of Montesegur, the castle in which they made their heroic last stand.

So the sacred Feminine as honored in the Cathar traditions becomes enmeshed and encoded into the Grail romances. But what is the Grail? The etymology of the word is most likely from the Latin *gradalis* and can be interpreted to mean "by degrees." Certainly in the *Gospel of Mary* the Magdalene's revelatory vision of ascending toward the Fullness—the All— is attained by degree. And the guardian knights of the Grail—be they Templars or of King Arthur's court—developed spiritually by degree as they sought the supreme mystical experience through rite and ritual. In Chretien de Troyes' 12th-century work *Conte del Graal* (*The Story of the Grail*), the Grail is described as a large platter; while in Parzival, the great Bavarian medieval narrative poem by Wolfram von Eschenbach, it is revealed as a stone of plenty. These excerpts demonstrate a strong Celtic influence in the plentitude of food offered by the grail. It is also described as the chalice that was used to catch the Galilean's blood at the crucifixion in an excerpt from *Joseph of Arimathea* by Robert de Boron of Burgundy. Boron, in this tremendously influential work written between 1190 and 1200, was the first to associate the Grail with the Last Supper. From its role in the Celtic myth of fertility as the symbolic cauldron of the god Dagda, whose shape resembles the female organ of regeneration, to the secret treasure of the Cathars hidden in a cave in the Pyrennes, the Grail has been an object that has fired the hearts and souls of men and women from the Middle Ages through the present.

The Magdalene and the history of the Holy Grail begins with Troyes' *Conte del Graal*. It was composed for Philip Count of Flanders (Netherlands) in approximately 1180. Chretien died before its completion, but there is a strong indication of Cathari influence. At the time it was written, France was in an intellectual and literary renaissance. Eleanor of Aquitaine was patroness to poets and troubadours. Roger Sherman Loomis, in his informative book

The Grail: From Celtic Myth to Christian Symbol, informs us that "at no period in the history of Western Europe have the arts and the zest for knowledge attained a higher level…The Grail romances belong to a great experimental and creative epoch." Chretien's tale is the first literary encounter with the magical Grail, and we can see the influence of the Welsh and Irish traditions as our hero Percival ends up a guest in the mysterious castle of the Fisher King in what is clearly a visit to the echtrae or otherworld of the faerie. In about 1200 C.E. Wolfram von Eschenbach, a brilliant Bavarian lyric poet, picks up the torch and finishes the tale.

In pursuit of the Grail, we will call on the work of Irish poet Ella Young, best known for her contribution to the Celtic Revival of the late 19th and early 20th centuries. Her poem "San-Grail" captures the element of transformative and dyadic love in the mystical union of the Grail. Also, you will find an excerpt from T.S. Eliot's "The Waste Land," the title of which suggests the alternative to the presence of the Grail and of the feminine— for the land of the lost Grail is a dry and deathlike landscape.

Included as well in this chapter is an explanation of the popular hypothesis that the Magdalene may have carried Jesus' child to the South of France and the presumption of a bloodline—a royal bloodline that could have threatened the authority of

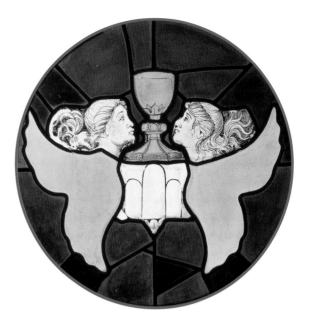

Glass Chalice with Two Angels
Francesco Cossa, 15th century

the Church. You will see marvelous works of art that show the Magdalene journeying to France and with child. The book finishes with the masterpiece Da Vinci's *Last Supper*.

The Magdalene's human qualities— her fully human qualities—have inspired some of the greatest paintings in the history of art. They are present in the Georges de La Tour on the back cover of this volume. She is never afraid to look into the flame, to cleave to the light—she looks deep within. You will find her qualities not only in the painting and sculptures but also in the literature that gives her a voice and a depth and dimension. I have attempted to synthesize the myriad legends, gospels, and stories along with these great works of art so you too can be visited by the woman who knows the All.

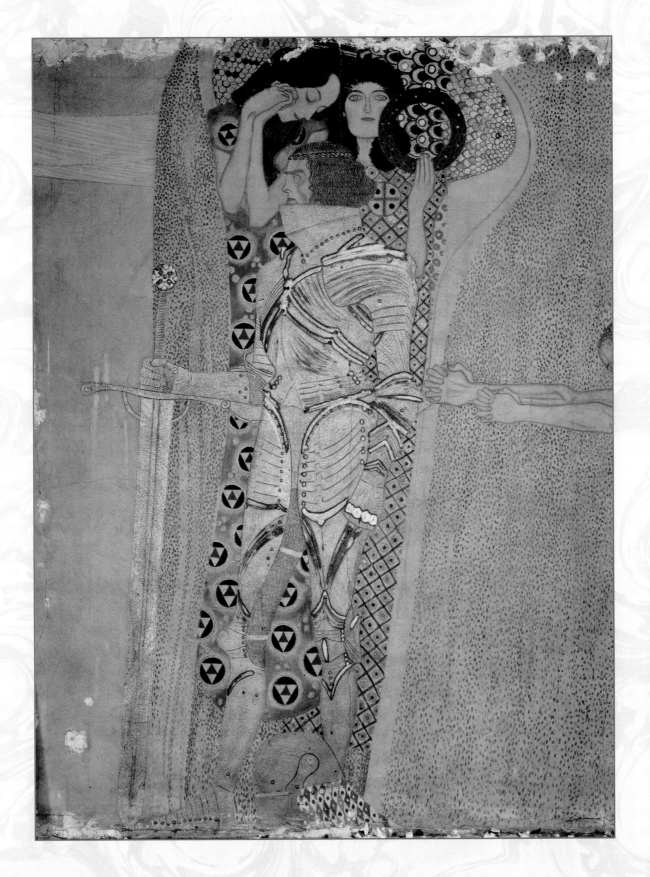

The Story of the Grail

by Chretien de Troyes (excerpt), 12th century

He rode along the bank till he came to a cliff washed by the stream, so that he could not pass. Then he caught sight of a boat floating downstream, and two men in it. He waited, expecting them to come up to him. But they stopped in the middle of the river and dropped anchor. The man in the bow had a line and was baiting his hook with a fish somewhat larger than a minnow. The knight, not knowing where to find passage, greeted them and asked: "Sirs, tell me if there's a ford or a bridge on this river."

The fisherman answered: "No brother, on my faith there is not for twenty leagues, up or down, a boat larger than this, which would not carry five men, and one cannot cross on horseback, for there is no ferry, bridge, or ford."

"Then tell me, in God's name, where I may find shelter."

The fisherman replied: "Indeed you will have need of that and more. I will myself give you lodging tonight. Ride up

by the cleft in this rock, and when you have reached the top, you will see before you in a valley a house where I dwell, near the river and near the wood."

Without further pause the knight ascended, and at the top of the hill he gazed long ahead without seeing anything but sky and earth. He exclaimed: "What has brought me here? Stupidity and trickery. God bring shame on him today who sent me here! Truly he put me on the right path when he said at the top I would spy a house! Fisherman, you foully deceived me if you spoke out of malice!"

At that instant he spied before him in a valley the top of a tower. One might seek as far as Beirut without finding one as noble or as well situated. It was square, built of dark stone, and flanked by two lesser towers. The hall stood in front of the tower, and before the hall an arcade. As the youth descended he confessed that the fisherman had given him good directions, and praised him and no longer called him

The Knight (detail of the *Beethoven Frieze*), Gustav Klimt, 1902

Good sir, this was destined for you

a treacherous liar, since now he had found harbourage. So he proceeded to the gate, before which there was a lowered drawbridge. As he crossed, four squires came to meet him; two removed his arms; a third led his horse away to give him fodder and oats; the fourth clad the youth in a scarlet mantle, fresh and new. Then they led him to the arcade, and be assured that none as splendid could be found as far as Limoges.

There he waited till the lord of the castle sent two squires to fetch him, and he accompanied them to the square hall, which was as long as it was wide. In the middle he saw, sitting on a couch, a handsome nobleman with grizzled locks, on his head a sable cap, black as a mulberry, with a crimson lappet below and a robe of the same. He was reclining on his elbow, and in front of him a great fire of dry branches blazed between four columns. Four hundred men could seat themselves comfortably around it. The four strong columns which supported the hood of the fireplace were of massive bronze.

The squires brought the youth before his host and stood on either side of him. When the lord saw him approach, he promptly greeted him, saying: "Friend, do

not take it amiss if I do not rise to meet you, but I cannot do so easily."

"In God's name, sire, do not speak of it, for, as God may give me joy and health, it does not offend me."

The nobleman raised himself with difficulty, as much as he could, and said: "Friend, draw nearer; do not be ashamed but sit here at my side, for so I bid you."

As the youth sat beside him, the nobleman inquired: "Friend, from what place did you come today?"

"Sire, this morning I left the castle called Belrepeire."

"So help me God," exclaimed the nobleman, "you have had a long day's ride. You must have departed before the watchman blew his horn at dawn."

"No," the youth answered, "prime had already been ring, I assure you."

As they talked, a squire came in at the door, a sword suspended from his neck. He handed it to the rich host who drew it halfway from the sheath and observed where it was forged, for it was written on the blade. He saw too that it was of such fine steel that it could not break save only in one peril which no one knew but him who had forged and tempered it. The squire who had brought it announced: "Sire, the fair-haired maiden, your

and I desire for you to have it

beautiful niece, sends you this gift. You have never seen one lighter for its length and breadth. You may present it to whom you please but my lady would be glad if you would bestow it where it would be well employed. He who forged it made only three, and he will die before he can make another."

At once the lord, taking the sword by the hangings, which were worth a great treasure, gave it to the newcomer. The pommel was of the best gold of Arabia or Greece, and the sheath was covered with Venetian gold embroidery. This richly mounted sword the lord gave to the youth, saying: "Good sir, this was destined for you, and I desire you to have it. Gird it on and then draw it."

The youth thanked him and fastened the girdle so that it was not too tight. Then he drew out the naked blade from the sheath and after holding it a little, put it back. Rest assured that it became him well, hanging at his side, and better still when gripped in his fist; and it surely seemed that it would do him knightly service in time of need. Looking about, he noted standing behind him around the brightly burning fire some squires, and he entrusted the sword to the keeping of the one who had charge of his arms. Then he

returned to his seat beside the lord, who showed him great honour. The light of the candles was the brightest that one could find in any mansion.

While they were talking of this and that, a squire entered from a chamber, grasping by the middle a white lance, and passed between the fire and those seated on the couch. All present beheld the white lance and the white point, from which a drop of red blood ran down to the squire's hand. The youth who had arrived that night watched this marvel, but he refrained from asking what this meant, for he was mindful of the lesson which Gornemant gave him, warning him against too much speech, and he feared that if he asked, it would be considered rude. So he held his peace.

Then two other squires came in, right handsome, bearing in their hands candelabra of fine gold and niello work, and in each candelabrum were at least ten candles. A damsel came in with these squires, holding between her two hands a grail (graal). She was beautiful, gracious, splendidly garbed, and as she entered with the grail in her hands, there was such a brilliant light that the candles lost their brightness, just as the stars do when the moon or the sun rises. After her came a

he did not dare to ask concerning the

damsel holding a carving-dish (tailleor) of silver. The grail which preceded her was of refined gold; and it was set with precious stones of many kinds, the richest and the costliest that exist in the sea or in the earth. Without question those set in the grail surpassed all other jewels. Like the lance, these damsels passed before the couch and entered another chamber.

The youth watched them pass, but he did not dare to ask concerning the grail and whom one served with it, for he kept in his heart the words of the wise nobleman. I fear that harm will come of this because I have heard say that one can be too silent as well as be too loquacious. But, for better or for worse, the youth put no question.

The lord then ordered the water to be brought and the cloths to be spread, and this was done by those whose duty and custom it was. The lord and his guest washed their hands with lukewarm water. Two squires brought a wide table-top of ivory, which, according to the story, was all of a piece, and they held it a moment before the lord and the youth, till two other squires came bringing trestles. The wood of which they were made possessed two virtues which made them last forever. Of what were they made? Of ebony. What

is the property of that wood? It cannot rot and it cannot burn; these two dangers it does not heed. The table-top was placed on the trestles, and the cloth was laid. What should I say of the cloth? No legate, cardinal, or even pope ever ate on one so white.

The first course was a haunch of venison, peppered and cooked in fat. There was no lack of clear wine or grape juice to drink from a cup of gold. Before them a squire carved the peppered venison, which he had set on a silver carving-dish, and then he placed the slices of large pieces of bread in front of them.

Meanwhile the grail passed again before them, and still the youth did not ask concerning the grail, whom one served with it. He restrained himself because the nobleman had so gently charged him not to speak too much, and he had treasured this in his heart and remembered it. But he was silent longer than was proper, for as each course was served, he saw the grail pass before him in plain view, and did not learn whom one served with it, though he would have liked much to know. Instead he said to himself that he would really ask one of the squires of the court before he departed, but would wait till the morning when he took leave of the lord and his

grail and whom one served with it

attendants. So he postponed the matter and put his mind on eating and drinking; in no stingy fashion were the delicious viands and wines brought to the table. The food was excellent; indeed, all the courses that king or count or emperor are wont to have were served to that noble and the youth that night.

After the meal the two passed the evening in talk, while the squires made up the beds for the night and prepared the rarest fruits: dates, figs, nutmegs, cloves, pomegranates, electuaries, gingerbread of Alexandria, aromatic jelly, and so forth. Afterwards they had many draughts of piment without honey or pepper, of mulberry wine and clear syrup. At all this the youth wondered, for he had never experienced the like. At last the nobleman said: "Friend, it is time to go to bed and do not take it amiss that I depart to my chamber to sleep. And when you please, you may lie here. Because of my infirmity I must be carried."

Four nimble and strong servants came out of a chamber, took by the four corners the coverlet of the couch on which the nobleman was lying, and carried him away. Other squires remained with the youth to serve him as was needed. When he wished, they removed his hose and other clothing

and put him to bed in white linen sheets.

He slept till break of day, but the household had already risen. When he looked about, he saw no one, and was obliged to get up alone; though he was annoyed, he rose since he must, drew on hose without help, and took his arms, which he found at the head of the dais, where they had been brought. When he had armed himself well he walked past the doors of chambers which he had seen open the night before. But all in vain, for he found them closed. He shouted and knocked. No one opened; there was no response. When he had called long enough, he went to the door of the hall, found it open, descended the steps, and found his horse saddled and his lance and shield leaning against the wall. He then mounted and searched about the courtyard, but saw neither servant nor squire. He rode to the gate and found the drawbridge lowered, for it had been so left that nothing should prevent him from passing it freely at any hour. Then he thought, since the bridge was down, that the squires must have gone into the forest to examine the nets and traps. So, having no reason to wait longer, he said to himself that he would follow after them and learn, if possible, from one of them why the

did you lie then at the dwelling

lance bled and whither the grail was carried. He passed out through the gate, but before he had crossed the drawbridge, he felt that the feet of his horse were rising, and the animal made a great leap, and if he had not done so, both he and his rider would have come to grief. The youth turned his head to see what had happened and perceived that someone had raised the drawbridge. He called out, but no one answered.

"Speak," said he, "you who have raised the bridge! Speak to me! Where are you, for I do not see you? Show yourself, and I would ask you a question."

Thus he wasted his words, for no one would reply. So he rode toward the forest and entered on a path where there were fresh hoofprints of horses. "This is the way," said he to himself, "which the men I am seeking have taken."

Then he galloped through the forest as long as the tracks lasted, until he spied by chance a maiden under an oak tree, crying and lamenting in her distress, "Alas, wretch that I am, in an evil hour was I born! Cursed be that hour and that in which I was begotten! Never before has anything happened to enrage me so. Would that God had not pleased to make me hold my dead lover in my arms! He

would not have done better to let me die and let my lover live. O Death, why did you take his soul rather than mine? When I see him whom I loved best dead, what is life worth? Without him I care nothing for my life and my body. Death, cast out my soul that it may, if his soul deigns to accept it, be its handmaid and companion."

Thus she was mourning over the headless body of a knight which she clasped. The youth did not stop when he saw her, but approached and greeted her. She returned his greeting with head lowered, but did not cease her lament. The youth asked: "Who killed this knight who lies in your lap?"

"Good sir," the maiden replied, "a knight killed him this morning. But one thing I see which amazes me. For people say that one may ride twenty-five leagues in the direction from which you came without finding an honest and clean lodging place, and yet your horse's flanks are smooth and his hide is curried. Whoever it was who washed and combed him, fed him on oats and bedded him with hay, the beast could not have a fuller belly and a neater hide. And you yourself look as if you had enjoyed a night of comfortable repose."

"By my faith, fair lady," said he, "I had

of the rich Fisher King?

indeed as much comfort last night as was possible, and if it appears so, there is a good reason. If anyone gave a loud shout here where we are, it would be heard clearly where I lay last night. You cannot know this country well, for without doubt I have had the best lodging I ever enjoyed."

"Ah sir, did you lie then at the dwelling of the rich Fisher King?"

"Maiden, by the Saviour, I do not know if he is fisherman or king, but he is very rich and courteous. I can say no more than that late last evening I met two men floating slowly in a boat. One was rowing, the other was fishing with a hook, and he directed me to his house and there gave me lodging."

The maiden said: "Good sir, he is a king, I assure you, but he was wounded and maimed in a battle, so that he cannot move himself, for a javelin wounded him through the two thighs. He is still in such pain that he cannot mount a horse, but when he wishes to divert himself, he has himself placed in a boat and goes fishing with a hook; therefore he is called the Fisher King. He can endure no other pastime, neither hunting nor hawking, but he has his fowlers, archers, and huntsman to pursue game in his forests. Therefore he enjoys this place; in all the world no better

dwelling could be found for his purposes, and he has built a mansion befitting a rich king."

"Damsel," said he, "by my faith, what you say is true, for last evening I was filled with wonder as soon as I came before him. I stood at a little distance, but he told me to come and sit beside him, and bade me not think that he did not rise out of pride, for he had not the strength."

"Surely he did you a great honour when he seated you beside him. Tell me, when you were sitting there, did you see the lance of which the point bleeds, though there is no flesh or vein there?"

"Did I see it? Yes, by my faith."

"Did you ask why it bled?"

"I said nothing about it."

"So help me God, learn, then, that you have done ill. Did you see the grail?"

"Yes, indeed."

"And who held it?"

"A maiden."

"And whence did she come?"

"From a chamber."

"Whither did she go?"

"Into another chamber."

"Did no one precede the grail?"

"Yes."

"Who?"

"Only two squires."

"What did they hold in their hands?"

"Candelabra full of candles."

"Who came after the grail?"

"Another maiden."

"What did she hold?"

"A little carving-dish [tailleor] of silver."

"Did you not ask anyone where they were going?"

"No question came from my mouth."

"So help me God, that was worse. What is your name, friend?"

Then he, who did not know his name, divined it and said that his name was Perceval of Wales. He did not know whether he told the truth or not, but it was the truth, though he did not know it. When the damsel heard it, she rose and faced him, saying angrily: "Your name is changed, good friend."

"What is it?"

"Perceval the wretched! Ah, unfortunate Perceval, how unlucky it was that you did not ask all those things! For you would have cured the maimed King, so that he would have recovered the use of his limbs and would have ruled his lands and great good would have come of it! But now you must know that much misery will come upon you and others. This has happened to you, understand, because of your sin against your mother; she died of grief for you. I know you better than you

know me, for you do not know who I am. I was reared with you in the house of your mother long ago. I am your first cousin and you are mine. I grieve no less because you have had the misfortune not to learn what is done with the grail and to whom it is carried than because of this knight whom I loved dearly, seeing he called me his dear mistress and loved me as a brave and loyal knight."

"Ah, cousin," said Perceval, "if what you say is true, tell me how you know it."

"I know it," the damsel answered, "as truly as one who saw her laid in the earth."

"Now may God of his goodness have mercy on her soul!" cried Perceval. "It is a sorrowful tale you have told. Now that she is laid in earth, what is there left for me to seek? For I was journeying only to see her. I must now take another road. If you are willing to accompany me, I should be pleased. He who lies dead here can no longer serve you, I warrant. The dead to the dead, the living to the living. Let us go together. For it seems very foolish for you to watch here alone over this body. Let us pursue the slayer, and I promise and swear that, if I overtake him, either he will force me to surrender, or I will force him." ◅

Parsifal in Quest of the Holy Grail
Ferdinand Leeke, 1912

I shall tell you now

Joseph of Arimathea

by Robert de Boron (excerpt), 13th century

At the time when Our Lord was upon the Earth, most of the land of Judaea was answerable to Rome. The Romans held sway over the region where Our Lord dwelt, and the governor's name was Pilate. This Pilate had in his service a soldier named Joseph (Of Arimathea), who followed Jesus Christ to many places and loved him deeply in his heart, but dared not show it for fear of the other Jews, for Our Lord had many enemies and adversaries set against him—and also one disciple who was not as a follower should be. And because this man was not as gracious towards his fellow disciples as they were towards each other, he began to distance himself from them in his actions, misbehaving and being more cruel towards them than he had been before; they were very wary of him. But Our Lord, being God, knew all. This disciple's name was Judas, and his hatred towards Our Lord was conceived on account of an ointment; I shall tell you now of his treachery.

At this time it was the custom that a chamberlain received a tenth of all moneys that came into his lord's purse, and when my lady Saint Mary Magdalene poured an ointment upon Our Lord's feet Judas was enraged, counting in his heat that the ointment was worth three hundred pence. He did not want to lose his due; he reckoned his tenth was worth thirty pence, and was determined to recover that amount.

of his treachery

Pontius Pilate, Italian School, 16th century

The Elders Paying Judas, Barna da Siena, 14th century

Take the man that I shall kiss

Three nights before the Passover, Christ's enemies were at the house of a man named Caiaphas, discussing how they could capture Him. Joseph of Arimathea was present as they talked, and to him their words were sinful: they grieved him terribly. In the middle of their discussion Judas appeared, and when they saw him they fell silent, for they distrusted him, believing him to be a good disciple of Jesus. Judas, seeing them fall silent, spoke out and asked them: "Why are you assembled here?"

And they replied: "Where is Jesus?"

And he told them where He was and why he had come to them. And when the Jews heard Judas's disloyalty they were overjoyed and said: "Tell us how we can take him prisoner!"

And Judas replied: "I'll sell him to you if you wish."
"Yes indeed," they said, "most gladly!"

And he said he would give them Jesus for thirty pence. One of them had the money in hand, and paid it. And so Judas recovered a tenth of the three hundred pennies' worth of ointment.

Then they discussed how they would capture Jesus: they fixed the day and an early hour; Judas would inform them where Jesus would be, and they would be armed and ready to seize Him. And Judas warned them to be sure they did not seize James, for he looked very much like Jesus—understandably, for James was His cousin. And they asked him: "How then will we recognize Jesus?" And he replied: "Take the man that I shall kiss."

The Last Supper, artist unkown, 6th century

I cannot and should not tell you everything

On the Thursday evening Our Lord was at the house of Simon the Leper. I cannot and should not tell you everything He said to His disciples, but this much I can say for sure: He told them that eating and drinking with Him was one who would betray Him. Hearing Our Lord's words, some of the disciples were afraid and swore they were not guilty. But Christ assured them it was true, and Judas asked Him: "Am I the one you mean?"

And Jesus answered: "You say so."

May his blood be scattered upon us

Then all those whom Judas had informed gathered at the house of Simon the Leper, and when the disciples realized this they were filled with fear. And once the house was full, and Judas was sure they had the upper hand, he stepped forward and kissed Jesus. Seeing this the Jews seized Him from all sides, and Judas cried to them: "Hold him fast!", for he knew how great was Christ's strength. And they led Jesus away, leaving the disciples filled with grief.

And the vessel in which He had made the sacrament was at Simon's house, and one of the Jews took it and kept it until the next day.

Jesus was taken before Pilate, and many words were spoken there, the Jews charging Him with everything they could...Then he spoke as governor saying: "To which of you shall I refer if my lord [the emperor] asks me abut this matter? For I can see no reason for this man to suffer death."

And they all cried out together: "May his blood be scattered upon us and all our children!"

and all our children

Judas Betrays Him, William Blake, c.1805

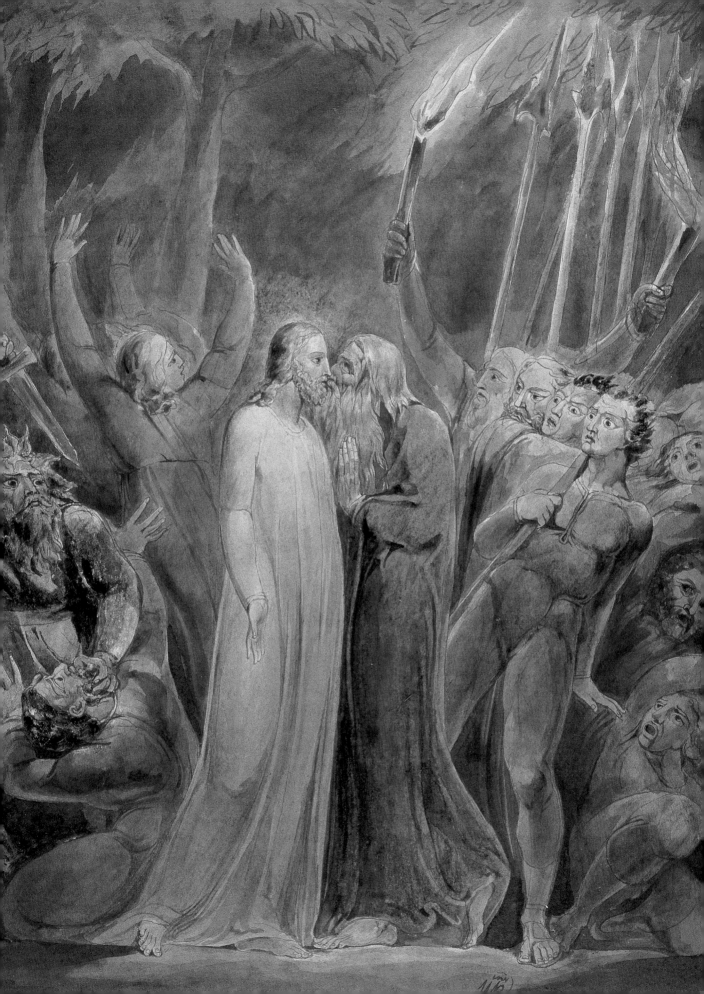

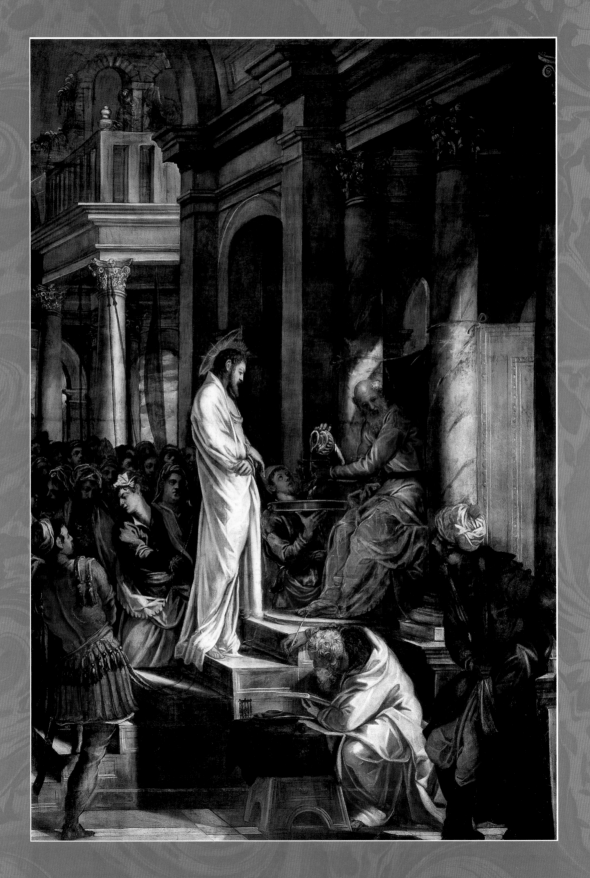

I ask for the body of the prophet

Then the Jews seized Him and led Him away. Pilate stayed, and
called for water and washed his hands, and said that, just as his
hands were clean, so was he clean of responsibility for that man's
death. Thereupon the Jew who had taken the vessel from Simon's
house came to Pilate and gave it to him. Pilate took it and kept
it safe.

When the news came that they had put Jesus to death, Joseph
was filled with grief and anguish, and he came to Pilate and said:
"Sir, my knights and I have served you for a long while and you've
given me nothing for my service."

"Ask," said Pilate, "and I'll give you whatever you wish in
payment."

And Joseph replied: "Many thanks, sir. I ask for the body of the
prophet whom the Jews have wrongfully put to death."

Pilate was astonished that he should ask for such a poor reward,
and said: "I thought you'd ask for a greater gift. If that's the
payment you desire, you shall have it."

And Joseph answered. "Many thanks, sir. Give orders that it
should be mine."...

When he saw Jesus Christ he was filled with pity and wept most
tenderly, for he loved Him deeply. He came to the Jews who were
guarding Him and said: "Pilate has given me permission to remove
the prophet's body from this shameful place."

But all the Jews together said: "You're not having it, for his
disciples say he's going to revive. But however often he comes back
to life, we'll kill him!"

"Let me take him, sirs," said Joseph, "for Pilate has granted him
to me."

But the Jews said: "We'd sooner kill you!"

Christ Before Pilate, Jacopo Robusti Tintoretto, c.1567

and Pilate said:

Joseph left them and returned to Pilate and told him of the Jews' response. Pilate was amazed; but he saw before him a man named Nichodemus, and he commanded him to go with Joseph and take Christ's body from the cross himself. And then he remembered the vessel that the Jew had given him, and he called Joseph and said: "Joseph, you love that prophet dearly."

"Yes indeed, sir," Joseph answered, and Pilate said: "I have a vessel of his, given to me by one of the Jews who were present at his capture, and I've no wish to keep anything that belonged to him."

And he gave the vessel to Joseph, who received it with great joy. Joseph and Nichodemus departed together, and Nichodemus went to a smith to get pincers and a hammer; then they came to the place where Christ was on the cross, and Nichodemus said to the people there: "You've done wrong in dealing with this man as you demanded of Pilate. But now he's clearly dead, and Pilate has granted the body to Joseph and has commanded me to give it to him."

They all replied that he was sure to come back to life, and refused to let the body go; but Nichodemus said nothing they could do would stop him taking it. So they all marched off to Pilate while Joseph and Nichodemus climbed up and took Jesus from the cross.

'I have a vessel of his...'

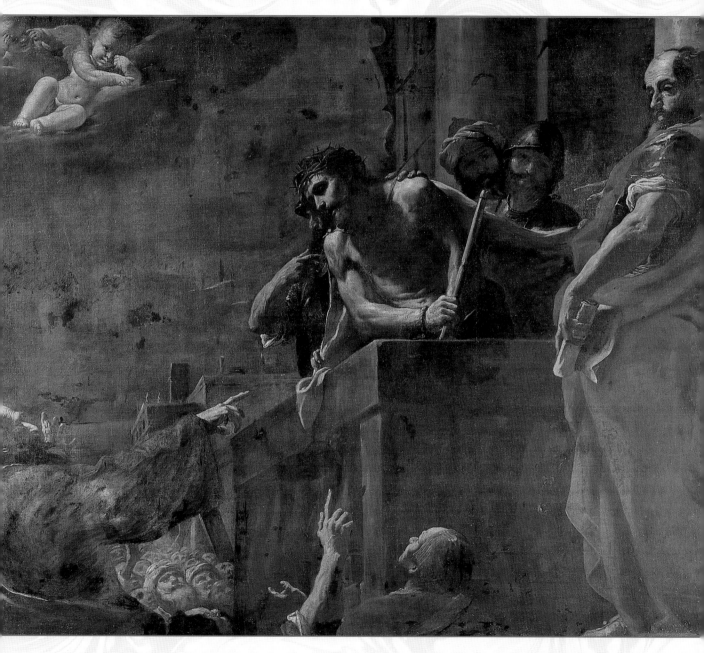

Ecce Homo, Mattia Preti, 17th century

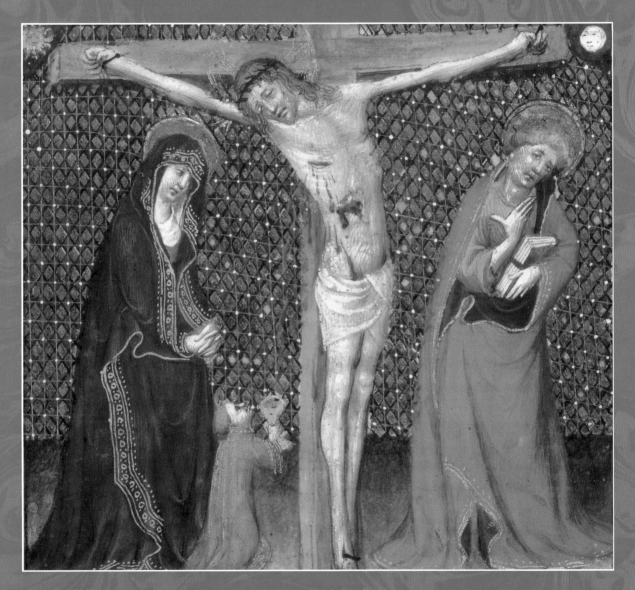

Joseph of Arimathea Collecting the Blood of the Crucified Christ, artist unknown, 14th century

*blood from the wounds
of His hands and His feet*

Joseph held Him in his arms and laid Him on the ground, cradling Him tenderly and washing Him most gently. And when he had washed Him, he saw His wounds still bleeding and was dismayed remembering the stone that had split at the foot of the cross when the drop of blood fell.

And then he remembered his vessel, and thought the drops of blood that were falling would be better in the vessel than elsewhere. So he placed it beneath Christ's wounds; and blood from the wounds in His hands and His feet dripped into the vessel. After gathering the blood in the vessel Joseph set it to one side, and took the body of Jesus Christ and wrapped it in a sheet that he had bought for his own use and covered it.

Meanwhile the crowd who had gone to Pilate gained his agreement that, wherever Joseph might put the body, it should be closely watched in case it came back to life, and they arranged for a large armed guard. When Joseph departed, they remained.

While all this was happening, Our Lord descended into Hell, broke in and set free Adam and Eve and as many others as He pleased. And He returned to life, unknown and unseen by those who were standing guard, and He went forth and appeared to Saint Mary Magdalene and to other disciples where He chose. ✎

dripped into the vessel

The San-Grail

—ELLA YOUNG, 1918

Sir Lancelot rode between the trees,
The evening sun was red:
He thought upon Queen Guinevere
With hair outspread.

He thought upon the Holy Grail
That he had come to win,
And knew his love of Guinevere
Was deadly sin.

Then from his horse he lighted down
Beneath the treen
And prayed that God would sain his soul
Of Arthur's queen.

A sudden glory filled the wood,
And there his eyes
Beheld a wonder that had come
From Paradise.

He saw the Grail-Maid with the Grail
Between her hands,
The sight that is most beautiful
In the world's lands.

Full humbly Lancelot bowed himself
Shamed and afraid
But the Grail-Maiden said to him
"Be not dismayed."

"Look up," she said, "and see the Grail
If thine eyes endure
And if thy heart hath flame of love
Through Love made pure."

He lifted up his eyes if so
The San-Grail might be found:
The splendour smote him to the earth
Deep in a swound.

But through the swound Sir Lancelot knew
The Grail-Maid stood
Like a bright-coloured bird of Heaven
In a dark wood.

And he besought of Christ the Lord
To lend him grace,
Although he might not see the Grail,
To see her face.

"Look up," she said, "and see my face,
The grace is won:
Quenched in me now the moon-fire is
And the fire of the sun."

He looked upon the Grail-Maid's face
Enshadowed by her hair:
He knew her, wan, and white, and still,
Queen Guinevere! �

Sancta Lilias, Dante Gabriel Rossetti, 1874

Dante Gabriel Rossetti (1828–1882), the British poet and painter and one of the founders of the Pre-Raphaelite brotherhood, was born into an exceptional family. His father was a Dante scholar and taught at London University, his sister was the poet Christina Rossetti and his brother William was an art critic.

The Pre-Raphaelites, as the name suggests, honored artworks up to the time of the youthful Raphael. They were history painters who sought to edify by utilizing naturalism and were drawn to subjects with strong moral themes such as Arthurian Legends and biblical stories. This painting is likely to be a portrait of the Magdalene, who is often rendered with chestnut or red hair. Although the woman portrayed holds the lily and not a rose, the lily is a flower rich with mystical associations, as in the Fleur de Lis. The stars at her crown could well symbolize Mary's visionary gifts as witnessed in the Gospel of Mary and The Golden Legend.

Holy Blood, Holy Grail

by Michael Baigent, Richard Leigh, and Henry Lincoln (excerpt), 1983

Again and again the Grail romances had confronted us with a pattern of a distinctly mundane and unmystical nature. Again and again there was a callow knight who, by dint of certain tests that proved him "worthy," was initiated into some monumental secret. Again and again this secret was closely guarded by an order of some sort, apparently chivalric in composition. Again and again the secret was in some way associated with a specific family. Again and again the protagonist—by intermarriage with this family, by his own lineage, or by both—became lord of the Grail and everything connected with it. On this level, at least, we seemed to dealing with something of a concrete historical character. One can become heir to certain lands or even certain heritage. But one cannot become lord or heir to an experience....

In many of the earlier manuscripts the Grail is called the Sangraal; and even in the later version by Malory it is called the Sangreal. It is likely that some form—Sangraal or Sangreal—was in fact the original one. It is also likely that one word was subsequently broken in the wrong place. In other words, "Sangraal" or "Sangreal" may have not been intended to divide into "San Graal" or "San Greal"—but into "Sang Raal" or "Sang Real." Or, to employ the modern spelling, Sang Royal, Royal Blood.

In itself such wordplay might be provocative but hardly conclusive. Taken in conjuncture with the emphasis on genealogy and lineage, however, there is not much room for doubt. And for that matter, the traditional associations—the cup that caught Jesus' blood, for instance—would seem to reinforce this supposition. Quite clearly, the Grail would appear to pertain in some way to blood and bloodline.

That raises, of course, certain obvious questions. Whose blood? And whose bloodline?

Whose blood?

The Women Find Jesus' Tomb Empty, Maurice Denis, 1894

And whose bloodline?

Their lips glowed red as fire

Parzival

by Wolfram von Eschenbach (excerpt), 12th century

At the far end of the Palace a steel door was thrown open. Through it came a pair of noble maidens such—now let me run over their appearances for you—that any who had deserved it of them they would have made Love's payment in full, such dazzling young ladies were they. For head-dress each wore a garland of flowers over her hair and no other covering, and each bore a golden candelabra. Their long flaxen hair fell in locks, and the lights they were carrying were dazzling-bright. But let us not pass over the gowns those ladies made their entry in! The gown of the Countess of Tenabroc was of fine brown scarlet, as was that of her companion, and they were gathered together above the hips and firmly clasped by girdles round their waists.

Then there came a duchess and her companion, carrying two trestles of ivory. Their lips glowed red as fire. All four inclined their heads, and then two set up their trestles before their lord. They stood there together in a group, one as lovely as the other, and gave him unstinting service. All four were dressed alike.

But see, four more pairs of ladies have not missed their cue! Their function was that four were to carry large candles whilst the other four were to apply themselves to bringing in a precious stone through which the sun could shine by day. Here is the name it was known by—it was a garnet-hyacinth! Very long and broad it was, and the man who had measured it for a table-top had cut it thin to make it light. The lord of castle dined at it as a mark of opulence. With an inclination of their heads all eight maidens advanced in due order into their lord's presence, then four placed the table on the trestles of snow-white ivory that had preceded it, and decorously returned to stand beside the first four. These eight ladies were wearing robes of samite of Azagouc greener than

Parsifal, Odilon Redon, 1891

the Gral was the very fruit of bliss, a

grass, of ample cut for length and breadth, and held together at their middles by long narrow girdles of price. Each of these modest young ladies wore a dainty garland of flowers above her hair.

The daughters of Counts Iwan of Nonal and Jernis of Ryl had been taken many a mile to serve there, and now these two princely ladies were seen advancing in ravishing gowns! They carried a pair of knives keen as fish-spines, on napkins, one apiece, most remarkable objects.—They were of hard white silver, ingeniously fashioned, and whetted to an edge that would have cut through steel! Noble ladies who had been summoned to serve there went before the silver, four faultless maidens, and bore a light for it. And so all six came on.

Now hear what each of them does. They inclined their heads. Then two carried the silver to the handsome table and set it down, and at once returned most decorously to the first twelve, so that if I have totted it up correctly we should now have eighteen ladies standing there.

Just look! You can now see another six advancing in sumptuous gowns, half cloth-of-gold, half brocade of Niniveh. These and the former six already mentioned were wearing their twelve gowns cut parti-

wise, of stuffs that had cost a fortune.

After these came the Princess. Her face shed such refulgence that all imagined it was sunrise. This maiden was seen wearing brocade of Araby. Upon a green achmardi she bore the consummation of heart's desire. Its root and its blossoming—a thing called "The Gral," paradisal, transcending all earthly perfection! She who the Gral suffered to carry itself had the name of Repanse de Schoye. Such was the nature of the Gral that she who had the care of it was required to be of perfect chastity and to have renounced all things false.

Lights moved in before the Gral—no mean lights they, but six fine slender vials of purest glass in which balsam was burning brightly. When the young ladies who were carrying the vials with balsam had come forward the right distance, the Princess courteously inclined her head and they theirs. The faithful Princess then set the Gral before his lordship. (This tale declares that Parzival gazed and pondered on that lady intently who had brought in the Gral, and well he might, since it was her cloak that he was wearing.) Thereupon the seven went and rejoined the first eighteen with all decorum. They then opened their ranks to admit her who was noblest, making twelve on either side of

cornucopia of the sweets of this world

her, as I am told. Standing there, the maiden with the crown made a most elegant picture.

Chamberlains with bowls of gold were appointed at the rate of one to every four of the knights sitting there throughout the hall, with one handsome page carrying a white towel. What a luxury was displayed there!…

The host—the man crippled in his pride—washed hands, as did Parzival too, which done, a count's son hastened to offer them a fine silk towel on bended knee.

At every table there were pages with orders to wait assiduously on those who were seated at them. While one pair knelt and carved, the other carried meat and drink to table and saw to the diners' other needs.

Let me tell you more of their high living. Four trolleys had been appointed to carry numerous precious drinking-cups of gold, one for each knight sitting there. They drew the trolleys along the four walls. Knights were seen by fours to stretch their hands and stand the cups on their tables. Each trolley was dogged by a clerk whose job it was to check the cups on the trolley again after supper. Yet there is more to come.

A hundred pages were bidden to receive loaves into white napkins held with due respect before the Gral. They came on all together, then fanned out on arriving at the tables. Now I have been told and I am telling you on the oath of each single one of you—so that if I am deceiving anyone you must all be lying with me—that whatever one stretched out one's hands for in the presence of the Gral, it was waiting, one found it already and to hand—dishes warm, dishes cold, new-fangled dishes and old favourites, the meat of beasts both tame and wild…

"There never was any such thing!" many will be tempted to say. But they would be misled by their ill temper, for the Gral was the very fruit of bliss, a cornucopia of the sweets of this world and such that it scarcely fell short of what they tell us of the Heavenly Kingdom.

In tiny vessels of gold they received sauces, peppers, or pickles to suit each dish. The frugal man and the glutton equally had their fill there served to them with great ceremony.

For whichever liquor a man held out his cup, whatever drink a man could name, be it mulberry wine, wine or ruby, by virtue of the Gral he could see it there in his cup. The noble company partook of the Gral's hospitality. ✎

Perhaps the Magdalene

Holy Blood, Holy Grail

by Michael Baigent, Richard Leigh, and Henry Lincoln (excerpt), 1983

According to certain medieval legends the Magdalen brought the Holy Grail—or "Blood Royal"—into France. The Grail is closely associated with Jesus. And the Grail, on one level at least, relates in some way to blood—or, more specifically, to a bloodline and lineage. The Grail romances are for the most part, however, set in Merovingian times. But they were not composed until after Godfroi de Bouillon—fictional scion of the Grail family and actual scion of the Merovingians—was installed, in everything but name, as king of Jerusalem.

If we had been dealing with anyone other than Jesus—if we had been dealing with a personage such as Alexander, for example, or Julius Caesar—these fragmentary shreds of evidence alone would have led, almost ineluctably, to one glaring self-evident conclusion. We drew that conclusion, however controversial and explosive it might be. We began to test it at least as a tentative hypothesis.

Perhaps the Magdalen—that elusive woman in the Gospels—was in fact Jesus' wife. Perhaps their union produced offspring. After the Crucifixion perhaps the Magdalen, with at least one child, was smuggled to Gaul—where established Jewish communities already existed and where, in consequence, she might have

was in fact Jesus' wife

The Elevation of the Cross (detail), Pieter Paul Rubens, 1602

found refuge. Perhaps there was, in short, a hereditary bloodline descended directly from Jesus. Perhaps this bloodline, this supreme sang real, then perpetuated itself, intact and incognito, for some four hundred years—which is not, after all, a very long time for an important lineage. Perhaps there were dynastic intermarriages not only with other Jewish families but with Romans and Visigoths as well. And perhaps in the fifth century Jesus' lineage became allied with the royal line of the Franks, thereby engendering the Merovingian dynasty.

If this sketchy hypothesis was in any sense true, it would serve to explain a great many elements in our investigation. It would explain the extraordinary status accorded the Magdalen and the cult significance she attained during the Crusades. It would explain the sacred status accorded to the Merovignians. It would explain the legendary birth of Merovee—child of two fathers, one of them a symbolic marine creature from beyond the sea, a marine creature which, like Jesus, might be equated with the mystical fish. It would explain the pact between the Roman Church and Clovis' bloodline—for would not a pact with Jesus' lineal descendents be the obvious pact for a church founded in his name? It would explain the apparently

incommensurate stress laid on the assassination of Dagobert II—for not only of regicide, but according to its own tenets, of deicide as well. It would explain the attempt to eradicate Dagobert from history. It would explain the Carolingians' obsession to legitimize themselves as Holy Roman Emperors by claiming Merovingian pedigree.

A bloodline descended from Jesus through Dagobert would also explain the Grail family in the romances—the secrecy that surrounds it, its exalted status, the impotent Fisher King unable to rule, the process whereby Parzival or Perceval becomes heir to the Grail castle. Finally, it would explain the mystical pedigree of Godfroi de Bouillon—son or grandson of the Grail family. And if Godfroi were descended from Jesus, his triumphant capture of Jerusalem in 1099 would have entailed far more than simply rescuing the Holy Sepulchre from the infidel. Godfroi would have been reclaiming his own rightful heritage.

We had already guessed that the references to viticulture throughout our investigation symbolized dynastic alliances. On the basis of our hypothesis viticulture now seems to symbolize the process whereby Jesus—who identifies himself repeatedly with the vine—perpetuated his lineage. As if in confirmation, we

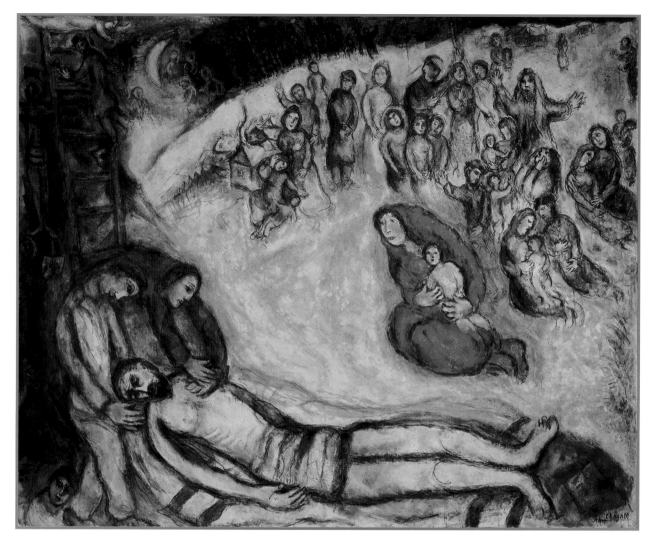

Descent from the Cross, Marc Chagall, 1876

discovered a carved door depicting Jesus as a cluster of grapes. This door was in Sion, Switzerland.

Our hypothetical scenario was both logically consistent and intriguing. As yet, however, it was also preposterous. Attractive though it might be, it was, as yet, much too sketchy and rested on far too flimsy a foundation. Although it explained many things, it could not yet in itself be supported. There were still too many holes in it, too many inconsistencies and anomalies, too many loose ends. Before we could seriously entertain or consider it, we would have to determine whether there was any real evidence to sustain it. In an attempt to find such evidence we began to explore the Gospels, the historical context of the New Testament, and the writings of the early Church fathers. ✍

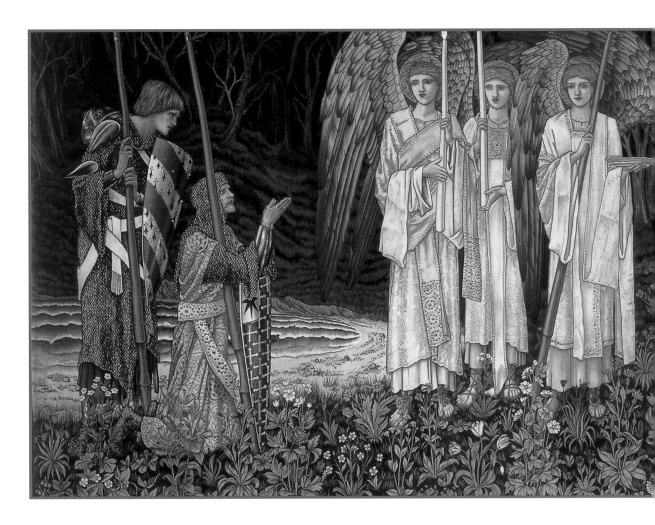

Le Morte Darthur

from *Le Morte Darthur: The Book of King Arthur and his Knights of the Round Table* by Sir Thomas Malory (excerpt), 15th century

But as soon as they were there Our Lord sent them the Sangreal, through whose grace they were always fulfilled while that they were in prison. So at the year's end it befell that this King Estorause lay sick, and felt that he should die. Then he sent for the three knights, and they came afore him; and he cried them mercy of that he had done to them, and they forgave it him goodly; and he died anon. When the king was dead all the city was dismayed, and wist not who might be their king. Right so as they were in counsel there came a voice among them, and bade them choose the youngest knight of them three to be their king: For he shall well maintain you and all

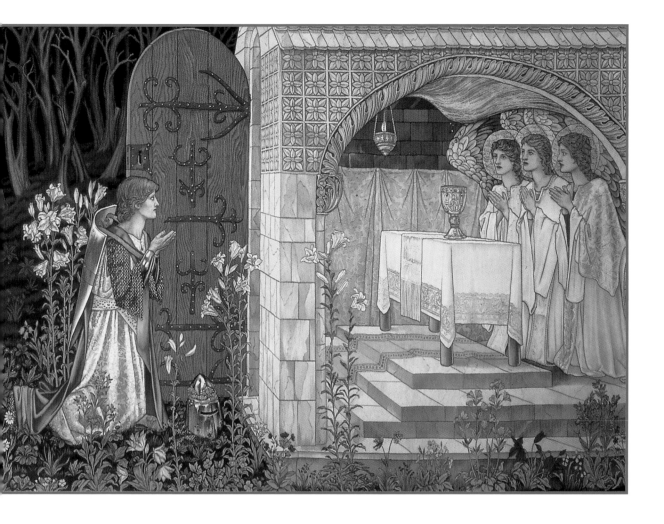

The Achievement by Sir Galahad, Edward Burne-Jones, 1894

Sir Edward Burne-Jones (1833–1898) was attracted to the frieze-like compositions of the early northern Renaissance masters, a predilection evident in his marvelous stain glass windows as well as his paintings. Botticelli was another important influence, whose elegant elongated figures Burne-Jones often emulated.

When Burne-Jones left Oxford University without a degree he took with him something of equal value— his friendship with artist and craftsman William Morris. Settling in London, he studied informally with his mentor Rossetti but was largely self-taught. With little formal artistic education his overnight success

from an exhibit of eight majestic paintings at the Grosvenor Gallery in 1877 caused quite a sensation.

In The Achievement by Sir Galahad *from the series* Quest for the Holy Grail *we can see Burne-Jones' interest in Renaissance art eloquently manifested. The classical composition and lyrical figures of angels and knights lend an appropriate balance as the Grail, depicted as a chalice, is revealed. The kneeling Galahad is surrounded by lilies—symbols of his purity. The tapestry of flowers reminds us yet again of the ornate and decorative late medieval and early Renaissance works, resplendent in detailed flora.*

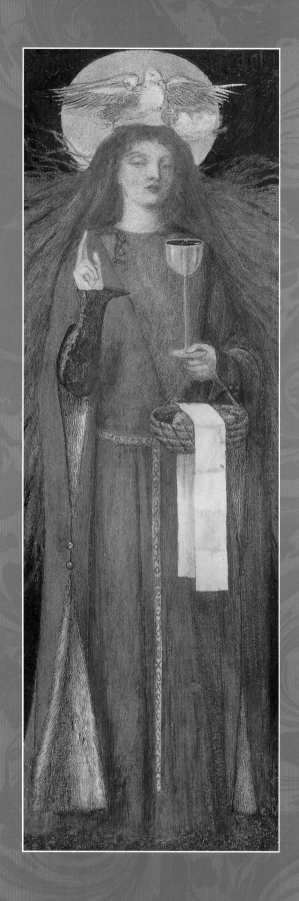

yours. So they made Galahad king by all the assent of the holy city, and else they would have slain him. And when he was come to behold the land, he let make above the table of silver a chest of gold and of precious stones, that hilled the Holy Vessel. And every day early the three fellows would come afore it, and make their prayers.

Now at the year's end, and the self day after Galahad had borne the crown of gold, he arose up early and his fellows, and came to the palace, and saw to-fore them the Holy Vessel, and a man kneeling on his knees in likeness of a bishop, that had about him a great fellowship of angels, as it had been Jesu Christ himself; and then he arose and began a mass of Our Lady. And when he came to the sacrament of the mass, and had done, anon he called Galahad, and said to him: Come forth the servant of Jesu Christ, and thou shalt see that thou hast much desired to see. And then he began to tremble right hard when the deadly flesh began to behold the spiritual things. Then he held up his hands toward heaven and said: Lord, I thank thee, for now I see that that hath been my desire many a day. Now, blessed Lord, would I not longer live, if it might please thee, Lord. And therewith the good man

The Damsel of Sanct Grael
Dante Gabriel Rossetti, 1857

took Our Lord's body betwixt his hands, and proffered it to Galahad, and he received it right gladly and meekly. Now wottest thou what I am? said the good man. Nay, said Galahad. I am Joseph of Aramathie, the which Our Lord hath sent here to thee to bear thee fellowship; and wottest thou wherefore that he hath sent me more than any other? For thou hast resembled me in two things; in that thou hast seen the marvels of the Sangreal, in that thou hast been a clean maiden, as I have been and am.

And when he had said these words Galahad went to Percivale and kissed him, and commended him to God, and so he went to Sir Bors and kissed him, and commended him to God and said: Fair lord, salute me to my lord, Sir Launcelot, my father, and as soon as ye see him, bid him remember of this unstable world. And therewith he kneeled down to-fore the table and made his prayers, and then suddenly his soul departed to Jesu Christ, and a great multitude of angels bare his soul up to heaven, that the two fellows might well behold it. Also the two fellows saw come from heaven an hand, but they saw not the body. And then it came right to the Vessel, and took it and the spear, and so bare it up to heaven. Sithen was there never man so hardy to say that he had seen the Sangreal. ✺

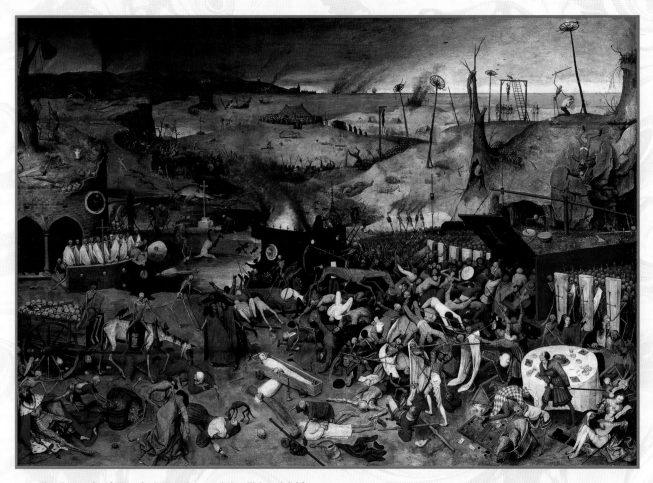

The Triumph of Death, Pieter Bruegel the Elder, 1562

Grail legends have influenced and inspired writers ever since the first Celtic legends of magical cauldrons were disseminated. In Irish and Welsh mythology the regenerative process of the land is associated with these womb shaped cauldrons of rebirth and plenty. These tales influenced not only writers of the 12th and 13th centuries but have impacted literature well into the 21st century. The Waste Land, by T.S. Eliot, which transformed the poetry of the 20th century, was no exception. In a footnote to the great poem, Eliot sites a book by Jessie Weston, From Ritual to Romance, which identifies these Celtic myths. The poem, written at the end of World War I, a time that conjoined the destruction of much of Europe with Eliot's disastrous marriage due to his wife's mental illness, was a work born of suffering. In The Waste Land, Eliot reveals a world bereft of the feminine, one in which Mars has turned to dust. The land of the lost grail becomes la terra gaste—the waste land.

The Triumph of Death by the Flemish artist Peter Bruegel was painted in 1562, six years before the beginning of the Eighty Years' War. Artistically, Bruegel is a master of prophetic narrative who not unlike Eliot has rendered a masterpiece in a panoramic deathscape bereft of the great Female principle—the essence of the Grail.

I will show you fear
 in a handful of dust

The Waste Land

By T.S. Eliot (excerpt), 1922

April is the cruellest month, breeding
 Lilacs out of the dead land, mixing
 Memory and desire, stirring
 Dull roots with spring rain.
 Winter kept us warm, covering
 Earth in forgetful snow, feeding
 A little life with dried tubers…

What are the roots that clutch, what branches grow
 Out of this stony rubbish? Son of Man,
You cannot say, or guess, for you know only
 A heap of broken images, where the sun beats,
 And the dead tree gives no shelter, the cricket no relief,
 And the dry stone no sound of water. Only
 There is shadow under this red rock,
(Come in under the shadow of this red rock),
 And I will show you something different from either
 Your shadow at morning striding behind you
 Or your shadow at evening rising to meet you;
 I will show you fear in a handful of dust.

matthew 26:20–24

Now when the even was come, he sat down with the twelve. And as they did eat, he said, Verily I say unto you, that one of you shall betray me.

And they were exceeding sorrowful, and began every one of them to say unto him, Lord, is it I?

And he answered and said, He that dippeth his hand with me in the dish, the same shall betray me. ≈

The Last Supper (detail, see overleaf), Leonardo da Vinci, 1498

No other man had been born who knew as much about sculpture, painting and architecture, but still more he is a very great philosopher.

 —Francis I, King of France

A good painter has two chief objects, man and the motion of his soul, the former is easy the latter hard.

 All our knowledge has its foundation in our senses.

 —Leonardo da Vinci

Leonardo da Vinci was born on April 15, 1452, in a farmhouse near the Tuscan town Vinci, located just a day's journey from Florence. The illegitimate son of a notary and peasant girl, he was initially raised by his mother before going to live with his father, Ser Piero, in his adolescence. It was Piero who recognized the breadth of his son's talent and brought his drawings to the attention of close friend Andrea del Verrocchio, the prominent Florentine painter and sculptor. Verrocchio was astonished by the young Leonardo's gifts and accepted him as an apprentice in his workshop at the age of 14. (Verrochio's most famous students include Botticelli, Perugino and Leonardo.) Verrochio's ascendancy as an artist was due not only to his exceptional gifts but also to the support and

encouragement of Piero de Medici and his son Lorenzo, with whom he had a close friendship. In addition to being a master artist, Verocchio was known to be an alchemist and a proponent of hermetic thought.

The Medicis were a Florentine banking family of extraordinary wealth that had an incomparable influence on the arts and culture of the Italian Renaissance. One of their astonishing ventures in their "Palazzo" was a library and school in which family members, relatives, and heirs were educated by hand-picked poets, philosophers, and artists. Marsilio Ficino was librarian, translator, teacher and self-proclaimed magician. His students at the Medici court soon incorporated Kabbala into their studies. It is clear that this period marks the blossoming of a passion for esoteric hermetic thought and mysteries and we need to see Verrochio in the context of the Medicis' vibrant and heady court. It is reasonable to assume that this climate of new and hermetic ideas must have also found influence in the mind of his brilliant apprentice Leonardo.

Da Vinci began The Last Supper *in 1495 and completed it in 1498. It was commissioned as a mural for the walls of the refectory of the Monastery S. Maria delle Grazie in Milan. Unlike the traditional fresco technique of painting on wet plaster, Leonardo*

chose to use a mixture of egg yolk and vinegar (tempera) and oil paint which he applied to a dry plaster wall. Fresco painting required a speed that Leonardo was not characteristically suited for—his profound concentration required time to function successfully. The choice of medium was unfortunate and da Vinci's experiment began to crumble by 1517. In spite of the damage (now repaired) the painting is indeed a masterpiece not only of one-point perspective but also of subtle spiritual and psychological qualities.

The twelve disciples that are seated at the Passover meal express a variety of emotions upon hearing from their savior that one among them will betray him. Dynamically rendering this moment from Matthew 26:21 appears to be Leonardo's broadest objective for the work. The drama is powerfully expressed through the sophisticated use of perspective in which all lines converge at Christ's right eye, viscerally pulling us toward the figure of Jesus. The expressions and movements of Leonardo's disciples reveal a trove of emotional and psychological nuance, no better exemplified by his rendering of the betrayer Judas in profile as he subtlety fingers a sack of gold coins.

But are there other levels, iconographic mysteries and secrets hidden in this great work that we must wrestle from its depths? Registering the magnetic centrality of the Galilean in The Last Supper, we find ourselves visually engaged in the strong horizontal movement of the painting. Iconographically there are symbols present that we have come to expect in a rendering of the Last Supper such as the bread and the wine—but here the chalice for the wine is noticeably missing. Why? Of special interest is also Leonardo's portrayal of Peter (the fifth figure from left) whose countenance is clearly hostile. Is Peter expressing anger at the words he has just heard, or is he in fact threatening the figure to his right? Such aggression would be consistent with the vehemence Peter shows toward the Magdalene in the Gnostic Gospels.

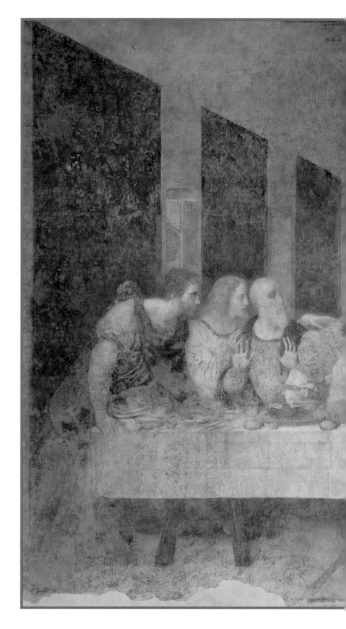

And what of the Magdalene? There is no question that the figure to the left of the Galilean resembles a woman. Though one can find any number of very feminine male figures painted by Leonardo, this figure appears womanly in the extreme and wears a mirror image of Jesus' robes. Unconsciously, given their identically reflected clothing, we cannot help but perceive these figures as complementary—a kind of yin and yang relationship to one another. One can also observe the "feminine" in relationship to the

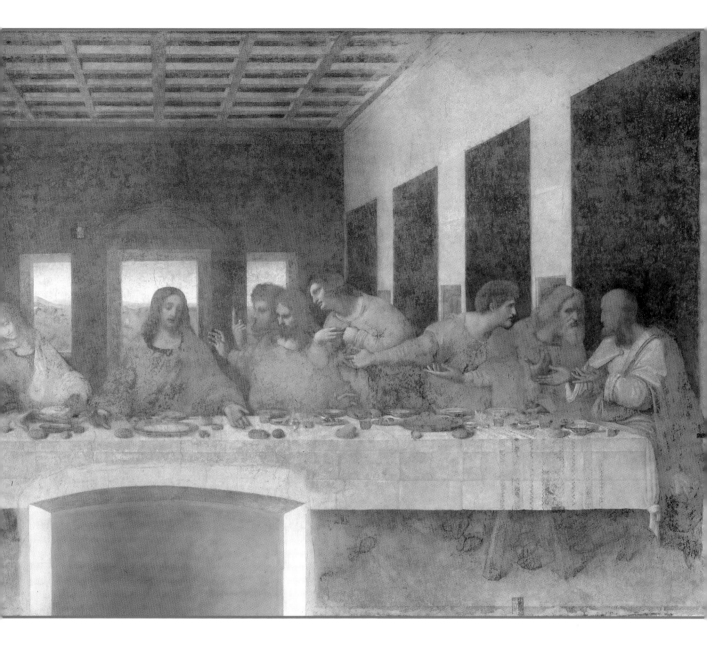

"masculine" in the "V" shape they form—signifying a unity of the two—a central concept not only in Kabbalah, but also in Gnosticism and alchemy.

Many unanswered questions about the Magdalene arise from this exploration. Is the feminine figure placed where the disciple John should be in fact Mary Magdalene? Was she Jesus' companion and/or wife, the one next to him in all things, in life and at the Last Supper, beneath the cross and at his Resurrection? Is the chalice therefore absent because

Mary is the carrier of Jesus' blood—the very grail chalice herself? Mined by artists, writers and philosophers for centuries, this fertile field of questions continues to provoke serious debate and examination among students, scholars, and artists.

And all shall be well and

All manner of thing shall be well

When the tongues of flame are in-folded

Into the crowned knot of fire

And the fire and the Rose are one. ✍

—T. S. ELIOT, from *Four Quartets: Little Gidding*